WHEN THE MINES CLOSED

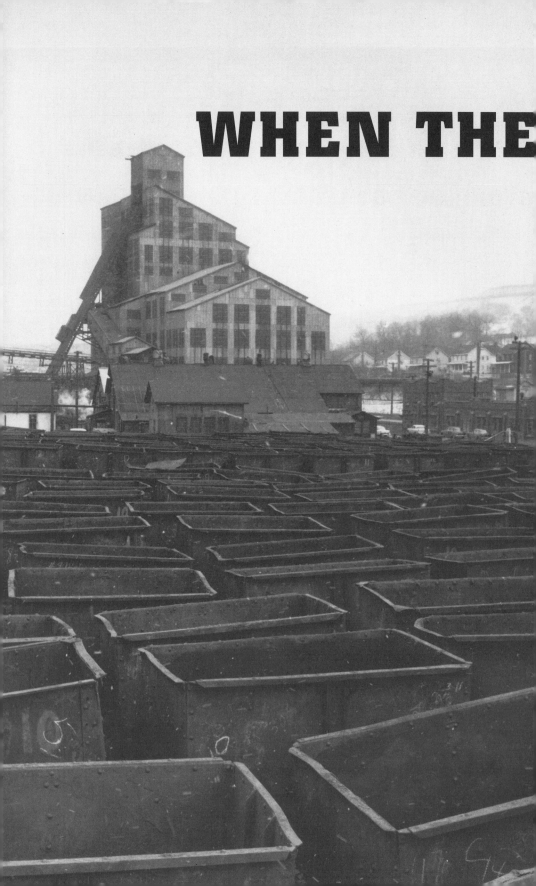

WHEN THE

MINES CLOSED

STORIES OF STRUGGLES IN HARD TIMES

THOMAS DUBLIN

PHOTOGRAPHS BY

GEORGE HARVAN

CORNELL UNIVERSITY PRESS ITHACA AND LONDON

First published 1998 by Cornell University Press.
First printing, Cornell Paperbacks, 1998.

Printed in the United States of America.

Cornell University Press strives to utilize environmentally responsible suppliers and
materials to the fullest extent possible in the publishing of its books. Such materials
include vegetable-based, low-VOC inks and acid-free papers that are also either
recycled, totally chlorine-free, or partly composed of nonwood fibers.

Library of Congress Cataloging-in-Publication Data

Dublin, Thomas, 1946–
 When the mines closed : stories of struggles in hard times / Thomas Dublin ; photographs by
 George Harvan.
 p. cm.
Includes index.
ISBN 0-8014-3462-9 (cloth : alk. paper). — ISBN 0-8014-8467-7 (pbk. : alk. paper)
 1. Mine closures—Pennsylvania. 2. Mine closures—New Jersey. 3. Coal miners—
Pennsylvania—Interviews. 4. Coal miners—New Jersey—Interviews. 5. Anthracite coal
industry—Pennsylvania—History—Sources. 6. Anthracite coal industry—New Jersey—
History—Sources. I. Title.
HD5708.55.U62P42 1998
338.2'724'09748—dc21 98-14330

Cloth printing 10 9 8 7 6 5 4 3 2 1
Paperback printing 10 9 8 7 6 5 4 3 2 1

Frontispiece: Empty coal cars and No. 8 breaker in Coaldale, 1956.

Contents

Illustrations

Acknowledgments

This book rests first and foremost on the generosity of those people of the Panther Valley who told their life stories to complete strangers who, after a phone call, appeared on their doorsteps, tape recorder in hand. Migrants from the anthracite region who settled in the Fairless Hills, Pennsylvania, area and in northern New Jersey were equally generous with their stories. Without the openness of those interviewed, ninety in all, this collection of narratives would not have been possible.

Grant support from a variety of sources was crucial for the laborious work of interviewing, transcribing, and indexing that this project entailed. Funding from the Pennsylvania Historical and Museum Commission launched me into my first interviews. A grant from the Ford Foundation made the interviewing and transcription possible. The National Endowment for the Humanities suported the broader study of which the oral history forms an important part. The State University of New York at Binghamton lent critical financial and logistical support at numerous points along the way. The New Jersey Historical Commission funded the transcription of interviews of northern New Jersey migrants from the anthracite region. The National Humanities Center provided me with a congenial place to work and stimulating colleagues for the semester during which I began editing these narratives. I gratefully acknowledge these sources of support. The use I have made of the interviews, however, the way I have turned some of them into narratives, and the interpretations I offer are my sole responsibility.

Mary Ann Landis and Walter Licht conducted interviews that have been significant additions to the project. Melissa Doak, Laura Free, and Linda

Janke transcribed the interviews with intelligence as well as diligence. Melissa Doak indexed most of the interviews, with support from Linda Janke.

As I undertook oral history research for the first time, I benefited greatly from the support and encouragement of Ronald Grele. Michael Frisch has been equally generous in his thoughtful criticism of my initial efforts to explore the stories of my informants. I have learned a great deal by traveling in oral history circles in recent years and have gained enormous respect for the perspectives this approach offers.

In the process of turning interviews into narratives and producing this collection, I have had wonderful support at every turn. Cathy Davidson read and offered perceptive critiques of my first editorial efforts. Mercedes Vilanova cast her experienced, critical eye over an early stage of the work. For helpful comments and criticism of the final manuscript, I am very grateful to Victoria Brown, Cathy Davidson, Alan Derickson, George Harvan, Walter Licht, Grey Osterud, Kathryn Kish Sklar, Ken Wolensky, and Robert Wolensky. For technical assistance in producing the map of the anthracite region that opens the book, my thanks to Mary Dillon, David Skyrca, and Van Dosmanis.

I have presented several papers drawing on this oral history work and have benefited from comments and criticism in those forums. My thanks to colleagues at SUNY-Binghamton, the University of North Carolina, the Berkshire Conference, and the Oral History Association for the opportunities to present this work in supportive settings.

I am especially grateful for the encouragement and professional support of numerous individuals at Cornell University Press. Peter Agree has been committed to making this publication project work from the start. Grey Osterud and Carol Betsch have made dramatic improvements with their editorial suggestions, and Dick Rosenbaum has designed a work that gracefully joins words and images. My thanks to all for their part in telling the stories of men and women in hard times.

T. D.

Brackney, Pennsylvania

WHEN THE MINES CLOSED

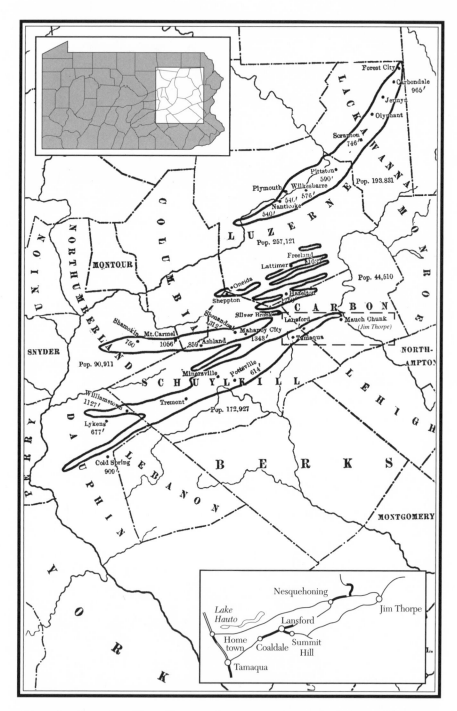

The anthracite region of Pennsylvania, with inset maps showing the location of the region and identifying towns in the Panther Valley. Circled portions of map show locations of major coal deposits. Adapted from Peter Roberts, *Anthracite Coal Communities* (New York: Macmillan, 1904), p. 2.

Introduction

The anthracite region of northeastern Pennsylvania stretches northeast from Tower City to Carbondale covering five hundred square miles in a triangular five-county area. Including both tiny, rural clusters of homes, known as patch towns, and such substantial urban centers as Wilkes-Barre and Scranton, the region depended almost entirely on the mining of anthracite coal for a century and a half after the development of commercial mining operations in the 1820s. Ninety-five percent of the nation's supply of anthracite coal lay below this land. At its peak during World War I, the mining and preparation of coal employed 175,000 men and directly supported a population of about 1 million. That same industry in 1992 employed 1,400 workers, supporting an overall population of perhaps 5,000.[1] Between those two points in time lies a story of industrial decline, its human consequences, and the ways working people in the region responded to and shaped that history.

Remarkable as it may seem, this story of the region's economic decline has never been told. Historians have focused their considerable powers almost exclusively on the period of anthracite mining's tremendous growth, between 1820 and 1920.[2] Virtually all book-length studies examine the

[1] "Production of Anthracite . . . 1913–1932," typescript table in NRA Anthracite Code materials, RG 9, Box 6065, National Archives; Bureau of Census, *1992 Census of Mineral Industries: Coal Mining* (Washington, D.C.: U.S. Department of Commerce, 1995), p. 12A-5.
[2] See, for example, Grace Palladino, *Another Civil War: Labor, Capital, and the State in the Anthracite Regions of Pennsylvania, 1840–68* (Urbana: University of Illinois Press, 1990); Perry K. Blatz, *Democratic Miners: Work and Labor Relations in the Anthracite Coal Industry, 1875–1925* (Albany: State University of New York Press, 1994); Craig Phelan,

region and the industry before it reached its peak in 1917; analyses of the impact of the Depression or World War II, or the fate of the region since the onset of mining's irreversible decline in the 1950s, are rare.[3] This book is intended to fill that void, by telling the story of anthracite's decline in the words and photographs of men and women who lived through it.

When I began research in the anthracite region in 1991, I did not anticipate doing oral history. As an American historian whose previous investigations had focused on working women in nineteenth-century New England, I had always relied exclusively on written sources. Business and census records, letters, diaries, memoirs, and contemporary newspapers had been my stock in trade. In the first two years of my work in the anthracite region I found these kinds of sources in abundance, including a massive collection of twenty-five thousand index cards dating from 1917 to 1954, which comprised the employment records of the Lehigh Navigation Coal Company, a firm with a dozen mines and breakers in the Panther Valley in the southern half of the region.[*] Local newspapers, union and trade association publications, censuses and government reports, and scattered published memoirs rounded out the primary sources.

These materials were all valuable, but they left me dissatisfied. They spoke to broader economic forces at work in the region, governmental efforts to address the regional economic crisis, and the perspectives of management and union leaders, but these sources did not permit me to reconstruct how relatively ordinary residents in the region experienced economic decline. Since much of my primary material focused on the operations of the Lehigh Navigation Coal Company in the Panther Valley, I decided in the spring of 1993 to go there and speak with area residents,

Divided Loyalties: The Public and Private Life of Labor Leader John Mitchell (Albany: State University of New York Press, 1994). Even the best overview offers only token coverage of the region after the 1902 strike: see Donald L. Miller and Richard E. Sharpless, *Kingdom of Coal: Work, Enterprise, and Ethnic Communities in the Mine Fields* (Philadelphia: University of Pennsylvania Press, 1985).

[3] Useful exceptions are John Bodnar, *Anthracite People: Families, Unions, and Work, 1900–1940* (Harrisburg: Pennsylvania Historical and Museum Commission, 1983); Dan Rose, *Energy Transition and the Local Community: A Theory of Society Applied to Hazleton, Pennsylvania* (Philadelphia: University of Pennsylvania Press, 1981); W. Julian Parton, *The Death of a Great Company: Reflections on the Decline and Fall of the Lehigh Coal and Navigation Company* (Easton, Pa.: Center for Canal History and Technology, 1986).

[*] The Lehigh Navigation Coal Company (also known as LNC) was the coal mining subsidiary of the Lehigh Coal & Navigation Company (LC & N), a coal-producing and -transporting conglomerate. The LC & N also owned forests, reservoirs, and several lodges, and owned and operated canals and railroads in the anthracite region. Residents of the Panther Valley used the two names and corresponding acronyms interchangeably, and in their narratives I have maintained this usage.

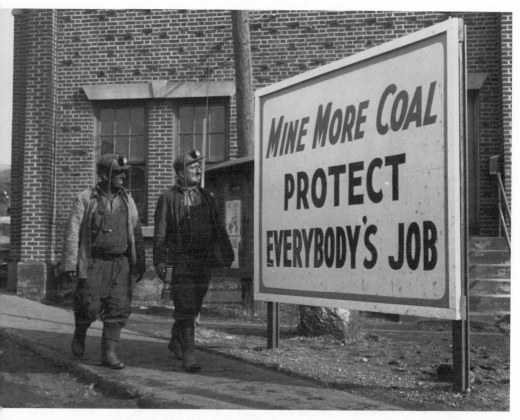

Miners outside the office building, heading from Coaldale No. 8 mine to the wash shanty, passing the coal company sign, 1952.

interview perhaps half a dozen people, and supplement the written sources with the recollections of former miners.

That casual decision opened up a world I had hardly imagined. The residents of what had seemed to me an impoverished backwater quickly took on identities of their own. There was Mike Sabron of Summit Hill, a miner who rejected job opportunities at a General Motors plant in Linden, New Jersey, preferring to make a go of things in the declining mines on familiar home terrain. There was Tom Strohl, who presented me with a 1954 union seniority list when I interviewed him and his wife, Ella, in Nesquehoning. I met Irene Gangaware of Lansford at a banquet in August 1993 to honor the "Last of the Panther Valley Miners" and commemorate those who had recently passed away; Irene complained, with her characteristic acid wit, that they might also have remembered the miners' wives and widows, who were an integral part of this story.

These initial encounters became the basis for new relationships and new

knowledge. I became determined to interview a good number of men and women from the Panther Valley and bring their perspectives into the study. This decision led to almost ninety interviews with people who lived through the region's economic decline. Those interviews are the raw material from which the dozen narratives contained in this book emerged.

The interviews showed that men and women from declining mine communities were active agents in the broader story. They were not simply objects acted upon by larger social and economic forces, but human beings with values and beliefs who made choices under difficult circumstances. The interviews permitted me to view the broader process of deindustrialization in a way that approached the perspective advocated by the late Herbert Gutman, a social historian who made signal contributions to African American and labor history. Gutman took as his starting point the words of French philosopher Jean-Paul Sartre: "The essential . . . is not what life has done to people, but what people do with what life has done to them." Gutman explained how this philosophical abstraction influenced his approach: he was interested in how working people "interpreted and then dealt with changing patterns of economic, social, and political dependence and inequality."[4] Within this framework, working people not only are affected by larger social forces but also interpret the world around them and act on the basis of their knowledge.

Oral interviews offer precisely this vantage point. They permit us to understand how working people viewed, responded to, and shaped the process of deindustrialization in the postwar decades. We see in these narratives men and women shaping their own lives in circumstances not of their own making or choosing, but still making choices and shaping their lives nonetheless.

These narratives reinforce the broader patterns evident in government reports, censuses, and company records. They tell of mines closing, of the garment industry entering the region, of weekly commuting to better-paying jobs near Philadelphia and New York City, and of permanent migration from the region. But, more important than the "facts" they contain, these accounts reveal the ways residents perceived these developments and how their individual choices helped to shape these broader patterns. They tell a story that has heretofore been hidden behind the more visible evidence of growing affluence in the United States in the 1950s and 1960s.

[4] Quoted in *Power and Culture: Essays on the American Working Class* (New York: Pantheon, 1987), p. 326 (my translation).

Oral history is valuable in still other ways, for it operates simultaneously on multiple levels. At one level it permits the recovery of information about industrial decline as experienced by ordinary individuals. The interviews took place in the 1990s, however, and interviewees were asked to recall attitudes and events dating back forty or, in some cases, seventy or eighty years. Both the historian's intervention and the passage of time mean that the accounts unearthed in this way are the products of complex processes. As contemporary practitioners of oral history make clear, historical memory reflects the operation of the present and the more recent past upon people's recall and reconstruction of the distant past. Intervening events affect both the narrator and the interviewer and shape the resulting recollections.[5]

In reconstructing the lives of working-class men and women who experienced economic decline and in exploring their subsequent understandings of those experiences, this oral history speaks to issues of continuing relevance. Coal miners were only the first of a series of blue-collar workers in the years after World War II who had to cope with the decline of the industry that provided their livelihoods. Miners experienced decline in the fifties and sixties; more recently, steelworkers and autoworkers have faced similar challenges. "Deindustrialization" and "downsizing" are terms that were not used in the era of anthracite's decline, but they are common enough in newspapers and magazines today.[6] By examining the responses of anthracite miners and members of mining families forty years ago, we gain insights that are useful in thinking about parallel developments unfolding in our own times. These stories, while rooted in a particular time and place, lay bare broader economic and social processes that continue to work themselves out today in different places. They are "history," yes, but they speak to contemporary issues as well.

Before delving into these narratives, we do well to place them in historical context. Just as the decline of the anthracite region raises larger issues of deindustrialization in the United States today, the growth of anthracite coal mining reflected and contributed to the industrialization of the United

[5] Nuanced treatments of these issues are common in the literature of oral history. Useful discussions can be found in Michael Frisch, *A Shared Authority: Essays on the Craft and Meaning of Oral and Public History* (Albany: State University of New York Press, 1990), chap. 1; Ronald J. Grele, *Envelopes of Sound: The Art of Oral History*, 2d ed. (New York: Praeger, 1991), p. xvi; Alessandro Portelli, *The Death of Luigi Trastulli and Other Stories: Form and Meaning in Oral History* (Albany: State University of New York Press, 1991), pp. ix–x, also chap. 1.
[6] See, for instance, a series of articles that appeared in the *New York Times*, March 3–9, 1996, reprinted as *The Downsizing of America* (New York: Times Books, 1996).

States in the nineteenth century. A brief overview of the region's past will help us make sense of our narrators' accounts of their own lives.

It took substantial monetary investment and intense labor to bring hard coal out of the ground. Coal warmed people's homes for generations, and it heated boilers that powered steam engines, which not only pulled trains but also drove machinery in myriads of factories. As forests were depleted, anthracite coal became the fuel of choice. Anthracite burns much more completely with far less ash and airborne pollutants than bituminous coal, which gave anthracite a decided advantage for many years. The rapid expansion of manufacturing and the rise of the bureaucratic corporation that occurred in nineteenth-century America were fueled by anthracite coal.[7]

The emergence of coal had other economic consequences. Moving coal from rural mines to urban residences and workplaces presented major problems in transport, and this region was the site of singular innovations in canal and railroad transportation. Coal also allowed for a new means of producing great quantities of high-quality iron and steel for the rails, machines, and building beams that thrust this nation into the economic forefront. Finally, as anthracite coal grew in economic importance, a cartel of less than a dozen firms came to control its production and transportation, raising the specter of monopoly and moving the federal government to initiate antitrust action.[8]

Mining, processing, and transporting coal required the work of hundreds of thousands of laboring people. To the anthracite region came successive waves of immigrants, first from England, Wales, Ireland, and Germany, and then, in the late nineteenth century, from southern and eastern Europe. The interactions among these groups at the workplace and within communities speak to the broader significance of immigration in the building of American society.[9]

The story of American immigration is writ large in the region, as is a chronicle of tensions and changing relations between labor and capital. The industrial conflicts of the area are legion and legendary. From the Molly Maguires to the Knights of Labor to the United Mine Workers of America

[7] Alfred D. Chandler Jr., "Anthracite Coal and the Beginnings of the Industrial Revolution in the United States," *Business History Review* 46 (Summer 1972), 141–81.

[8] Miller and Sharpless, *Kingdom of Coal*, chaps. 2 and 3; Craig L. Bartholomew and Lance E. Metz, *The Anthracite Iron Industry of the Lehigh Valley* (Easton, Pa.: Center for Canal History and Technology, 1988); Elliot Jones, *The Anthracite Coal Combination of the United States* (Cambridge: Harvard University Press, 1914); Scott Nearing, *Anthracite: An Instance of Natural Resource Monopoly* (Philadelphia: John C. Winston, 1915).

[9] For a comprehensive examination of one of the anthracite region's ethnic groups, see William D. Jones, *Wales in America: Scranton and the Welsh, 1860–1920* (Scranton: University of Scranton Press, 1993).

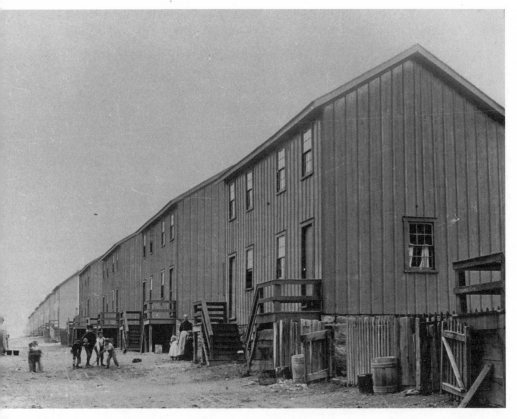

Company homes, north side of West Front Street, Lansford, 1902.

(UMWA), organized labor has played a pivotal role in the industrial evolution of the region. Over time, the UMWA came to accept its role as a junior partner of management, but miners continued their tradition of fierce struggle, increasingly against their union as well as against their corporate employers.[10] Beginning in the Depression decade, rank-and-file mineworkers began to press the UMWA to challenge management's authority. Nowhere have the inadequacies of bureaucratic unionism to meet the challenges posed by the transformation of industrial capitalism in the United States been more apparent than in Pennsylvania's anthracite region.[11]

[10] The best overview of developments in the region is Harold W. Aurand, *From the Molly Maguires to the United Mine Workers: The Social Ecology of an Industrial Union* (Philadelphia: Temple University Press, 1971). For a particularly rich treatment of ethnic participation in the 1902 anthracite strike, see Victor Greene, *The Slavic Community on Strike: Immigrant Labor in Pennsylvania* (Notre Dame, Ind.: University of Notre Dame Press, 1968).
[11] Michael Kozura, "We Stood Our Ground: Anthracite Miners and the Expropriation of Corporate Property, 1930–1941," in Staughton Lynd, ed., *"We Are All Leaders": The Alternative Unionism of the Early 1930s* (Urbana: University of Illinois Press, 1996), 199–237;

The dramatic conflicts that occurred in anthracite mining between the Civil War and the first decade of the twentieth century precipitated the intervention of the state and federal governments. Initially, the periodic deployment of state militia and federal troops strengthened the hand of capital. In the 1902 anthracite strike, however, the intervention of President Theodore Roosevelt forced corporate employers to deal with the UMWA and ushered in a new era in labor-management relations. At the same time, with the growth of mine regulation and inspection, Pennsylvania pioneered in the passage of labor legislation that shaped relations between capital and the state in the twentieth century.[12]

After World War I, well before the Depression, anthracite mining began its steep decline. Major strikes disrupted normal sales channels, and competition from alternative fuels began to cut into demand for anthracite coal. The onset of the Depression exacerbated the region's problems by curtailing industrial production and consumer demand. Miners responded to the crisis by calling on anthracite firms to spread work across all of their operations and limit their reliance on highly mechanized strip mining. When mines suspended operations, unemployed miners in the southern third of the region sank shallow mines on company lands and mined and sold "bootleg" coal to support their families.[13]

The market for anthracite coal rebounded with the entry of the United States into World War II, and with millions of men serving in the armed forces, unemployment in the region declined dramatically. Demand for coal was so strong that the federal government offered mineworkers draft deferments to stabilize the labor force, and miners went on a six-day week. Although miners' wages did not keep up with inflation, families in mining communities had far more steady incomes during the war than they had enjoyed previously.[14]

J. R. Sperry, "Rebellion within the Ranks: Pennsylvania Anthracite, John L. Lewis, and the Coal Strikes of 1943," *Pennsylvania History* 40 (1973), 293–312; Bodnar, *Anthracite People*, intro.

[12] Alexander Trachtenberg, *The History of Legislation for the Protection of Miners in Pennsylvania, 1824–1915* (New York: International Publishers, 1942); Robert J. Cornell, *The Anthracite Coal Strike of 1902* (Washington, D.C.: Catholic University, 1957); Phelan, *Divided Loyalties*, chap. 5.

[13] Thomas Dublin, "The Equalization of Work: An Alternative Vision of Industrial Capitalism in the Anthracite Region of Pennsylvania in the 1930s," *Canal History and Technology Proceedings* 13 (1994), 81–98; Kozura, "We Stood Our Ground."

[14] Sperry, "Rebellion within the Ranks"; Sean MacLeod Quimby, "Shattering the Mirror: American Coal Miners' Struggle with Identity during the 1943 Coal Strike" (Honors Thesis, University of Delaware, 1995).

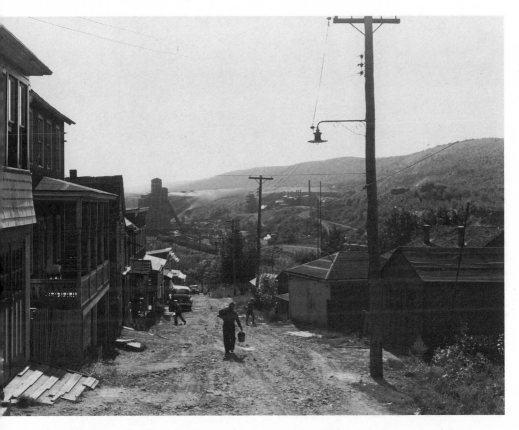

Unemployed miner walking up West Snyder Avenue in Lansford, 1940, view west toward the Coaldale breaker. Courtesy of the Library of Congress.

Optimism prevailed in the region as the nation began reconversion to a peacetime economy. At the Lehigh Navigation Coal Company, the average annual earnings of miners exceeded $3,000 in 1946. Almost five thousand men worked for the company, and another nine hundred worked for contractors hired by the company. Although there were no jobs for youngsters coming of age, former miners who had served in the armed forces were guaranteed re-employment.[15] Residents of the Panther Valley, and in the anthracite region more generally, had some basis for believing that the industry was sound.

But prosperity was short-lived. Coal production held steady for three years, but in 1949 the bottom fell out of the market. In one year, coal sales declined by nearly a quarter, from 59 to less than 45 million tons. By 1953 that figure had fallen again by a third, to slightly more than 30 million tons. The handwriting was on the wall. Despite the overall prosperity of the

[15] Parton, *Death of a Great Company*, p. 69.

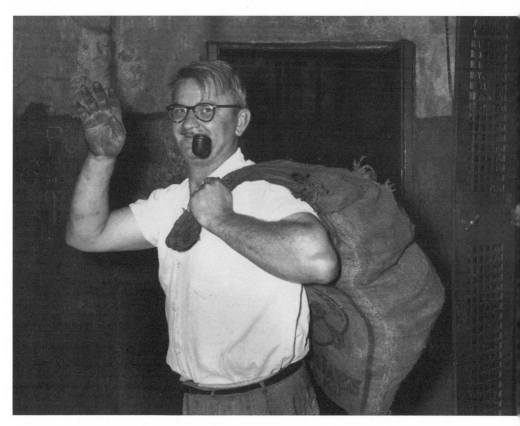

Miner packing up his gear when the mines closed, Coaldale No. 8, 1954.

American economy in these years, anthracite was losing out to alternative fuels—to bituminous coal for industrial purposes, and to fuel oil, natural gas, and electricity for home heating. By the early 1950s, outmigration from the region, already evident at the war's end among young people, had become a flood. In the Wilkes-Barre–Hazleton area, for instance, the population declined more than 8 percent between 1950 and 1957. Despite population losses and despite efforts to attract new business into the area, unemployment soared. Mines began to operate two or three days a week, so much greater was productive capacity than demand. Increasingly firms closed mines and breakers and consolidated production in fewer facilities. Official unemployment reached 17 and 18 percent in 1958 in major anthracite districts.[16] For many of the region's residents, the present was painful and the future bleak.

[16] Jacob J. Kaufman and Helmut J. Golatz, *Chronic Unemployment in Pennsylvania* (University Park: Pennsylvania State University, 1960), pp. 14, 46.

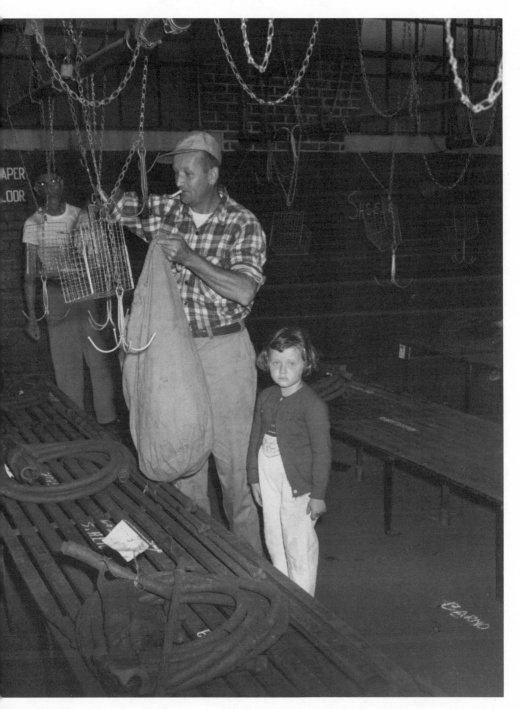

Andrew Marren and his daughter, Andrea, in the wash shanty of Coaldale No. 8, 1954 closing of the mines.

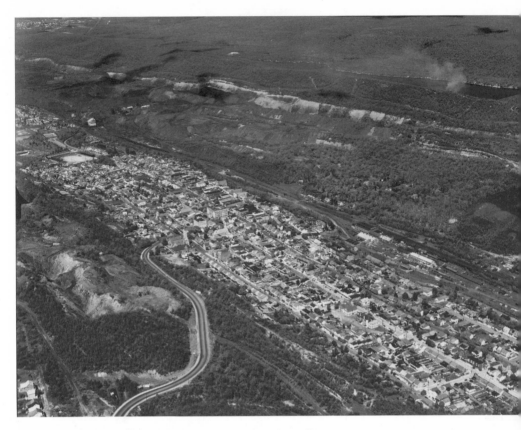

Aerial view of Lansford, the center of the Panther Valley, ca. 1965.

Contemporary government reports and newspaper stories outlined the region's economic decline in the post-World War II period. These years were marked by a steady decline in mining employment, significant migration out of the region, and growing local, state, and federal efforts to revitalize the regional economy by improving infrastructure and recruiting new businesses. The mine closings were accompanied by the rise of the garment industry, which offered low-wage employment to women in the region. The garment boom, however, was short-lived, and a profile of the region today reveals a population decidedly older and poorer than residents of other parts of the state or the nation as a whole.[17] Although a number of cities—Scranton, Wilkes-Barre, and Hazleton in particular—have had

[17] David Glassberg, "Review Essay: Sense of History in Pennsylvania: Work, Craft, Ethnicity, and Place," *Pennsylvania History* 60 (1993), 520.

notable success in recruiting new businesses and bringing in new jobs, other communities in the region survive today on a combination of Social Security benefits and Black-Lung compensation payments. Economic decline has exacted a toll on people who remained in the area.

The broad patterns of anthracite's steady rise followed by its precipitous decline are particularly evident in the group of towns that comprise the Panther Valley. The Panther Valley cuts a narrow swath for twelve miles southwest of Jim Thorpe (formerly Mauch Chunk), nestled between Nesquehoning and Locust Mountains to the north and Pisgah and Sharp Mountains on the south. It begins in the hills above the Lehigh River and ends where a gap in the surrounding mountains has been cut by the Little Schuylkill River. Averaging just two miles in width, the Panther Valley is drained by Nesquehoning Creek in the east and Panther Creek in the west. At the height of land between Lansford and Nesquehoning lies the divide between the Lehigh and Schuylkill River watersheds. Below the earth, on either side of that divide, lie rich veins of anthracite coal. The history of the Panther Valley has been shaped by the rise and decline of anthracite coal mining over the past two centuries. A shared geology and history link the towns of Nesquehoning, Lansford, Summit Hill, Coaldale, and Tamaqua.

The discovery of anthracite coal in 1791 on the slopes of Sharp Mountain near the present-day town of Summit Hill set the stage for development in the valley. After several false starts, Philadelphia capitalists secured ownership of some ten thousand acres of coal lands and exclusive rights to improve navigation on the Lehigh River. The Lehigh Coal & Navigation Company, which was incorporated in 1822, controlled the development of the Panther Valley for the next 150 years. A gravity railroad— subsequently known as the Switchback Railroad—was constructed to bring coal from the mines in Summit Hill to Mauch Chunk on the Lehigh River. Canal development permitted the company to reach the growing Philadelphia market, and by 1850 coal shipments on the Lehigh Canal exceeded a million tons annually. Railroad development after the Civil War permitted further expansion of mining operations in the valley. At its peak in 1917, the Lehigh Coal & Navigation Company employed a work force of 7,500 and marketed fully 4 million tons of coal a year. Mines crisscrossed the valley, with shafts and tunnels in Nesquehoning, Lansford, Coaldale, and Tamaqua offering access to underground workings, some as deep as 1,200 feet below the surface. Strip-mining persisted as a significant component of production, with surface operations in Summit Hill, Coaldale,

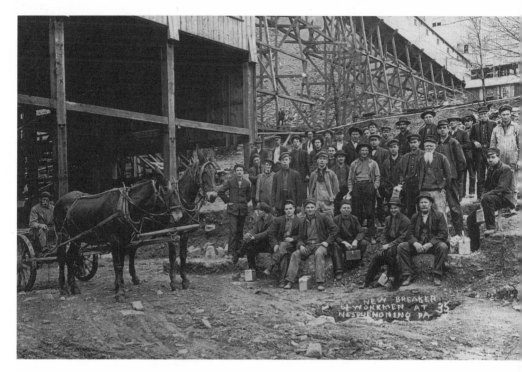

Outside workers at Nesquehoning breaker, 1935.

Nesquehoning, and Tamaqua. Modern breakers and washeries permit-
ted the separation of coal from rock impurities, the sorting of coal by size,
and the transfer of coal to railroad cars and trucks for wider distribution
across the Middle Atlantic and New England states.

The dramatic growth of mining in the Panther Valley attracted a steady
flow of immigrants. In the nineteenth century, the native-born, and En-
glish, Welsh, and Irish immigrants predominated in the company's mines;
by World War I, increasing numbers of central and eastern European
immigrants found their way to the valley. By 1920, almost 36 percent of
the company's employees hailed from central and eastern Europe, another
6 percent came from southern Europe, principally Italy, and 4 percent
came from the British Isles. In succeeding decades, American-born chil-
dren of immigrants from central, eastern, and southern Europe came to
predominate in the company's work force, while descendants of earlier im-
migrants from the British Isles were increasingly concentrated in manage-
ment and supervisory positions at the company.

Immigrants established numerous ethnic institutions. Ethnic churches, fraternal organizations, and businesses were common throughout the valley. An English Congregational Church, Saint John's Greek Catholic Church, Saint Joseph's Roman Catholic Church, Saint Michael's (Slovak) Catholic Church, Saint Nicholas, Saints Peter and Paul, Saint Mary's (Russian Orthodox), and Our Lady of Mount Carmel are just some of the churches that immigrants built and supported in the Panther Valley. Branches of ethnic fraternal organizations provided insurance and social activities for immigrants and their descendants, and ethnic businesses typically permitted miners and their families to "buy on the book," providing crucial credit during economic downturns or strikes. Dense networks of family and ethnic co-religionists provided mining families a sense of belonging and a measure of security in difficult economic times.

As immigrants came to predominate in the mining labor force, kinship networks played a vital role in the region. Operating through chain migration, kin networks first brought immigrants into the anthracite region; they then helped newcomers find jobs in mines and factories. Low wages and unsteady work required that several family members labor to help provide even a modest standard of living. The instability of mining employment made additional sources of income essential to household subsistence; employers, in turn, took advantage of the pool of available and immobile female labor by establishing first silk mills and later garment factories offering low-wage employment to women. An immigrant family economy emerged between 1900 and 1940 in which fathers and sons worked in the mines and daughters worked in silk mills and garment factories. The interconnections of ethnic work and family lives underlay the collective, familial nature of responses to the closing of the mines after World War II.[18]

Class joined ethnicity as a central unifying principle in the anthracite region. Miners in the Panther Valley had traditions of labor organizing and protest dating back to the Civil War. In the 1870s twenty men alleged to be members of an Irish secret society, the Molly Maguires, were tried, con-

[18] For an exploration of the importance of kin networks and family economies for immigrants generally, see John Bodnar, *The Transplanted: A History of Immigrants in Urban America* (Bloomington: Indiana University Press, 1985), especially chap. 2. For a more recent, nuanced view of the working-class family economy which offers a sensitive reading of the operation of gender, see Susan Porter Benson, "Living on the Margin: Working-Class Marriages and Family Survival Strategies in the United States, 1919–1941," in Victoria de Grazia, ed., with Ellen Furlough, *The Sex of Things: Gender and Consumption in Historical Perspective* (Berkeley: University of California Press, 1996), pp. 212–43.

Miner calling "Domo!" (Slovak for "Home!") to signal the start of a strike, early 1950s.

victed, and hanged for the murders of a number of overbearing mine foremen and owners. Whether the convicted men actually committed the murders remains a subject of some debate in the anthracite region today—especially given that the prosecution was paid for and organized by the area's dominant anthracite coal company—but there is no doubt that Irish mineworkers in this era were responding to what they viewed as autocratic and oppressive control on the part of mineowners and managers.[19]

Working-class response to overweening corporate power took on a more public, collective character at the turn of the century, with the emergence of the United Mine Workers of America. Successful strikes in 1897 and 1900 gave the newly formed union a strong foothold in the anthracite region. Miners in the Panther Valley showed their commitment to the union

[19] Wayne G. Broehl, *The Molly Maguires* (Cambridge: Harvard University Press, 1964). For many anthracite-region residents, the convictions and hangings of the Molly Maguires remain a vivid example of class and ethnic injustice. The memory of these events is a living one, with recent re-enactments and a symposium drawing large audiences and considerable press coverage. See *Valley Gazette*, December 1994, p. 21; February 1996, p. 13; August 1996, p. 7; September 1996, pp. 25–27; November 1996, pp. 18, 19, 21, 22, and 24.

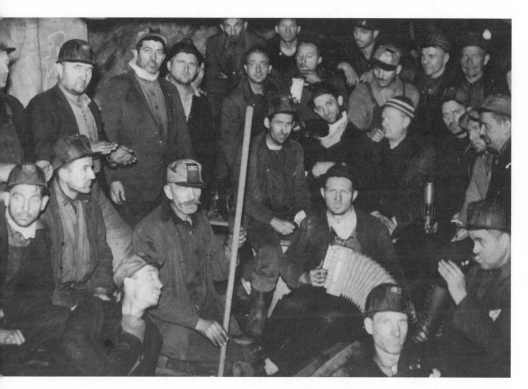

Sitdown strikers relaxing 1,250 feet underground, Coaldale No. 8, October 1937.

during the course of a five-month strike between May and October of 1902. Striking Panther Valley miners harassed strikebreakers and denied them sleep by "serenading" them for much of the night. Episodic violence broke out, as strikers attacked Coal & Iron Police escorting strikebreakers to work. The state militia set up camp at Manila Grove in Coaldale, in a vain effort to keep the mines open. With near unanimity, 140,000 anthracite miners went out across the region, and by October coal stocks in eastern cities were getting dangerously low. In response, Theodore Roosevelt intervened, pressuring the coal operators to accept binding arbitration by a presidential commission. The union, while it did not secure formal recognition, gained a 10-percent wage hike, the reduction of working hours from ten to nine hours daily, and the establishment of a permanent commission to arbitrate future grievances.[20]

In an area dominated by mining, like the Panther Valley, labor protest

[20] Robert H. Wiebe, "The Anthracite Strike of 1902: A Record of Confusion," *Mississippi Valley Historical Review* 48 (1961), 229–51; Miller and Sharpless, *Kingdom of Coal*, chap. 8.

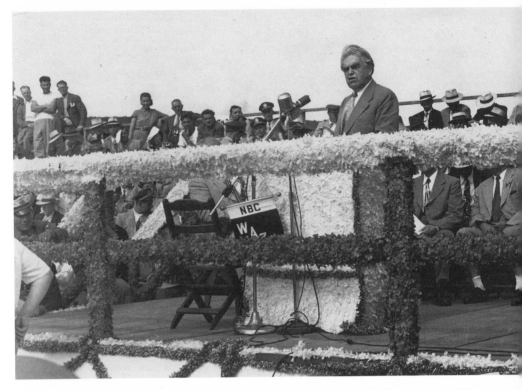

John L. Lewis speaking to a mass meeting commemorating the fiftieth anniversary of the founding of the Coaldale UMWA local, 1952.

easily became a communitywide affair. In August 1933, for instance, a crowd of ten thousand protesters converged on LNC headquarters in Lansford demanding an equalization of working time at all the collieries of the company. With reduced demand for coal during the Depression, company officials suspended work at higher-cost mines and concentrated production in a few of their operations. The result was relatively good employment for perhaps half the company's employees and inadequate public relief for the remainder. Panther Valley miners, with strong community support, demanded that the burdens of the Depression be shared evenly. No resolution of the movement's demands was reached at first, as workers returned to the mines at the urging of Governor Gifford Pinchot. Renewed work stoppages the next winter, however, led LNC to adopt an equalization-of-work provision across its collieries, and in 1936 the regionwide UMWA contract with coal operators included a similar equalization provi-

sion. In its widespread community support of workers' demands, the Panther Valley set the pattern for the rest of the anthracite region during the Depression decade.[21]

The strength of ethnic and working-class traditions shaped work and community life in Pennsylvania's anthracite region over the course of the twentieth century, but these traditions were unable to stem anthracite's ultimate decline. They did, however, set the terms on which miners and members of mining families dealt with the final closing of the mines in the postwar period.

The influence of these broader developments is visible in the narratives of individual men and women who lived through economic decline. The narratives give voice to the experiences of men and women who were native-born children and grandchildren of southern and eastern European immigrants. Their fathers were almost invariably miners. The men worked in and around the mines until they closed; women typically worked in area garment factories. Even years after retirement and decades after the passing of the immigrant generation, the traditions of class and ethnic solidarity remain strong among members of former mining families. Families also continue to draw on patriarchal traditions dating back to the period when male employment in mining dominated the region, but these traditions have been transformed in a changing setting.

Twelve narratives, based on interviews with six men and seven women, comprise the core of this book. They are drawn from the larger body of about ninety interviews conducted between 1993 and 1996. Almost seventy of the interviewees resided in the Panther Valley towns of Lansford, Coaldale, Summit Hill, and Nesquehoning. The vast majority were born in the Panther Valley and resided there all of their lives, except for brief periods of military service. Another twenty-three of those interviewed were permanent migrants from the anthracite region, residing primarily in Fairless Hills and Levittown, just northeast of Philadelphia, and in northern New Jersey. Most were in their seventies and eighties when interviewed and had experienced the closing of the mines when they were in their thirties or forties; two were in their forties and had been children at the time of the closings.

I had several considerations in mind as I chose the narrators for inclusion here. Some are, quite simply, wonderful storytellers. At the same time,

[21] For a fuller exploration of these events, see Dublin, "Equalization of Work."

their accounts are representative of the broader life patterns evident in the interviews as a whole. In addition, I chose narratives that reflected important occupational differences. Among the men, I included three underground miners, one outside mineworker, one dragline operator on strip mines, and one younger person who never worked in the mines. Garment workers predominated among women narrators, but the patterns of paid labor among the women differed quite markedly. Migration was another dimension I kept in mind in selecting narratives. Three of the thirteen narrators migrated outside the region—two permanently—and offered quite distinct perspectives on the region's economic crisis. Finally, and most important, the narratives worked together. Six of the narrators are in two families, and the interplay of husband and wife and of parents, daughter, and son-in-law enriches our understanding of people's lives. I edited about twenty narratives, and only then did I narrow my choices to the ones that appear here.

The interviews from which these narratives derive were typically an hour to an hour and a half in length, conducted most commonly in the homes of those interviewed. I conducted most of the interviews; Mary Ann Landis did a third, focusing on women who had worked in the Panther Valley's garment industry; Walter Licht did another six interviews with anthracite outmigrants who had settled in the Fairless Hills–Levittown area. In the interviews we sought to elicit life stories with a focus on the impact of the closing of the mines and the responses of our interviewees to the accompanying dramatic reshaping of life in the anthracite region.

The interview transcripts range in length from 20 to 180 pages and have the meandering quality of conversation. Interviewees read the initial drafts of their transcripts, helped to clear up obscure points, and revised their initial responses where they wished. The final transcripts are no longer absolutely faithful to the original interviews, but they do offer the perspectives and accounts that the respondents want to share with the broader public.[22]

To make room for more voices to be included in this collection and to provide more focused accounts, I have removed the questions and edited

[22] At the completion of this project, the original tapes, the edited interview transcripts, and indexes of the transcripts will be deposited in public repositories. Of the 88 interviews completed, participants in eight requested anonymity and one withdrew from the project. The anonymous interviews have been transcribed but with names changed to protect the privacy of interviewees and their families.

the interview responses into first-person narratives. In constructing the narratives, I have taken considerable liberty with the internal order of each interview and have deleted repetitious and tangential responses, but unless noted with square brackets, all words are the narrators' own. The narrators vetted my editing to make sure that I captured their original meaning. Occasionally I provide footnotes to explain terms and processes that might be obscure to readers, but I have tried to minimize interruptions to the narratives and have consciously refrained from inserting myself into the stories told here.

As this description suggests, I have had a strong hand in shaping the narratives. I conducted nine of the twelve interviews and worked closely with the interviewer in the other three cases. My research interests as a social historian influenced the questions posed and the responses received. I continued to work with and to learn more about my respondents through the editing process. Once, when looking over photographs with Tom and Ella Strohl, I expressed surprise at seeing so many pictures taken on hunting trips with his buddies. When I commented that I hadn't realized how important hunting had been in Tommy's life, he responded good-naturedly, "Well, you never asked." On other occasions, I commented on some aspect of a person's decisions, offering my understanding of why he or she had taken a particular course of action, and my respondent might comment, in turn, "I never thought about it that way, but now that you mention it . . ." There was a clear give and take in the interviews, and I think we all learned about life in the anthracite region in the process. The narratives that follow are very much shared products.[23]

The final element in the broader collaboration that has produced this volume is the contribution of a remarkable photographer, George Harvan, who was born and raised in Lansford. The son of a Slovak-born miner, and a 1938 graduate of Lansford High School, Harvan took up photography seriously while serving in the Pacific during and after World War II. He returned to his hometown in 1947 and has worked as a photographer ever since, sometimes for area newspapers or as a freelancer, but primarily for Bethlehem Steel doing industrial photography. He photographed inside the mines of the Lehigh Coal & Navigation Company in its last years of operation in the early 1950s and in the No. 9 mine, the last underground

[23] Michael Frisch has written thoughtfully about the joint nature of oral history, making exactly this point. See *A Shared Authority*, pp. xx–xxi.

mine in the valley, between 1960 and its closing in 1972. For the past two decades his photos have appeared regularly in *The Valley Gazette*, a monthly local history newspaper devoted to the preservation of the mining history and folklore of the Panther Valley.

As I began my initial oral history interviewing, I met George Harvan and drew on his store of knowledge about people and events in the Panther Valley. I appreciated the visual record of mining in the valley that he had produced over nearly a half century. He seemed to know almost everyone and suggested likely people to interview to fill in important parts of the valley's recent history. Eventually, we agreed to collaborate on this volume, to combine oral history narratives and photographs to tell the story of working people in the Panther Valley and in the anthracite region more generally during a period of industrial decline.

George Harvan has drawn on his range of photographic talents for this volume. He has taken recent portraits of the people whose narratives appear here. In addition, his large stock of photographs offers insights into the work and life of miners in the Panther Valley. Some of these photographs were taken many years ago of the individuals who tell their stories here; others focus on events, places, and people that figure prominently in the narratives. Finally, George has reproduced personal photographs shared by our narrators to complement their stories. Together, the images, like the narratives, tell the human story of anthracite's decline.

At an early stage in the interviewing, I began to sense how profoundly gendered the experience of the mine closing had been. Men worked in the mines; women labored in the homes and garment factories of the valley. I made a conscious effort to interview roughly equal numbers of men and women, and the narratives included here reflect that decision. The first two narratives, those of Mike Sabron and Lillian Verona, provide vivid pictures of growing up in mining families and the distinctly different life paths open to boys and girls coming of age during the decline of mining in the region. Each offers a detailed view of work in the region and insight into the coping strategies that were developed in response to the mine closings. In the following interviews we are given multiple perspectives on the closing of the mines from several members of two families: Tom and Ella Strohl, their daughter Ruth, and son-in-law Ken Ansbach, and Grant and Irene Gangaware. Then, Gabe Ferrence provides an unusual perspective, having worked primarily as a dragline operator on the above-ground strippings of the valley. Anna Meyers worked in garment firms, becoming an

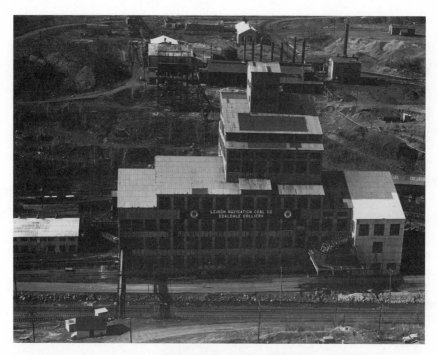

Aerial view of Coaldale No. 8 breaker, Lehigh Navigation Coal, 1952.

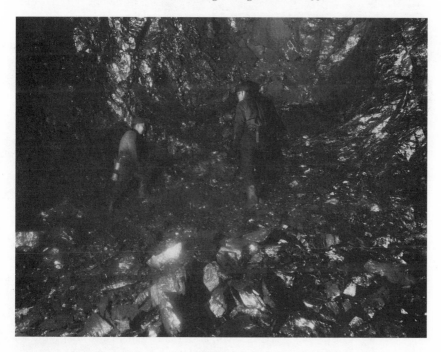

Two miners working at a breast of the Mammoth Vein—forty to fifty feet thick in places—Coaldale No. 8, sixth level, 1950.

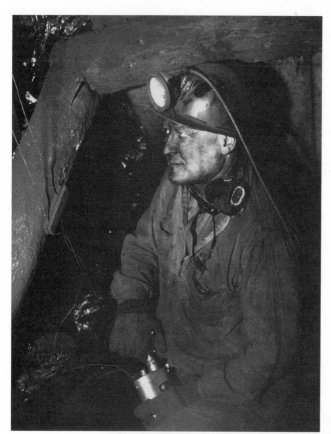

Andrew Julo firing shot in the chute below the workings, Coaldale No. 8, sixth level, 1950.

Fire boss checking for gas at a breast of Mammoth Vein, Coaldale No. 8, ca. 19

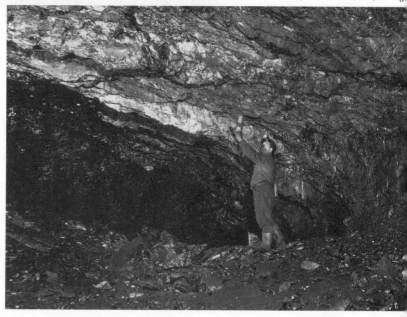

Miners drilling in the
Mammoth Vein, Coaldale
No. 8, ca. 1950.

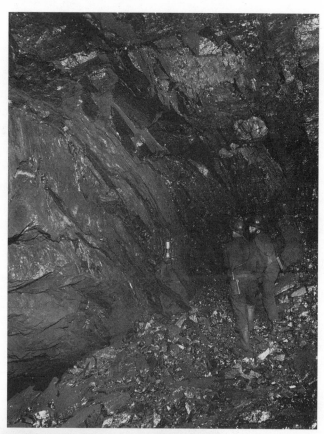

pringdale strippings in Coaldale,
. 1975.

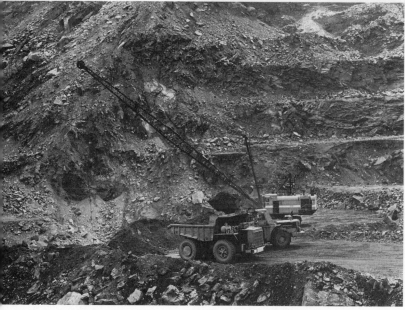

honored twenty-five-year employee of Kiddie Kloes, the major clothing firm in the valley since the 1930s.

The final three narratives document outmigration as a major coping strategy. Theresa Pavlocak and her husband left the Panther Valley when the mines closed and resided in New Jersey for twenty-two years. Gloria Rehill and Ziggie Whitecavage, like many of their neighbors, moved from the anthracite region to Bristol County, northeast of Philadelphia, where they joined the growing work force at U.S. Steel's Fairless Works. Their choices and the lives they made for themselves in suburban Philadelphia allow us a deeper understanding of their fellow "coal crackers" who refused to move and struggled to support themselves and their families without uprooting.

These are distinctly individual stories; nevertheless, several themes emerge when they are read together and in the context of the entire range of interviews they are culled from. Coal and class dominated these people's lives. Ten of the thirteen narrators had fathers or stepfathers who worked in the mines; as children they had picked loose coal from exposed veins or along railroad tracks and brought bags home so that their families would not have to pay to heat their homes. As adults, five of the six men and husbands of four of the seven women worked in the mines as well. One father, one stepfather, and one husband were killed while working in the mines. Even the mines' closing did not free these men and women from their grip: four of the men suffered from black lung at the time of their interviews.

Educational opportunities were clearly limited by family circumstances. Five of thirteen narrators felt compelled to quit high school to go to work to help support themselves and their families. Several were conscious that they might have gone much further in life. Ziggie Whitecavage began work in the mines when he was fifteen; Mike Sabron entered a coal company bagging plant at eighteen. Both recalled the opportunities they had foregone—college in Ziggie's case, perhaps a medical career in Mike's—to contribute instead to their family's immediate needs. Women in mining families experienced similar constraints. Irene Gangaware had expressed a desire to train to be a nurse when she graduated from high school, but her family didn't have the $300 required. A friend had urged Lillian Verona to consider going to nursing school in Atlantic City when she finished high school, but her mother "wouldn't hear of it."[24] Both women found work in local garment factories. Even those children from mining families who

[24] All quotations not otherwise cited come from the narratives in this volume.

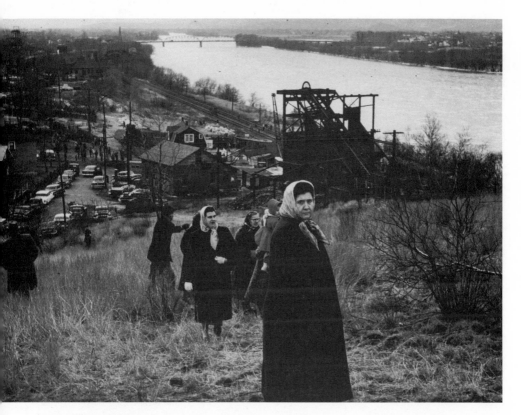

Anxious families of miners during rescue efforts after the Knox Mine Disaster, January 1959, Port Griffith.

completed high school found their opportunities circumscribed by their families' economic needs and constricted expectations.

One of the most striking themes throughout the narratives is ambivalence toward the mines people had depended on for so many years. The older men typically look back fondly on their mining years, a nostalgia shaped, no doubt, by their difficulty finding employment after the mines closed. Mike Sabron expressed a common feeling when he contrasted his work on a GM assembly line in Linden, New Jersey, with his work in the mines: "that assembly line . . . was rough! . . . I didn't like it at all. Nobody liked it." In the mines, men worked at their own pace, commonly set their own hours, were rarely supervised, and enjoyed a camaraderie that carried over into the bars, churches, and fraternal organizations of their hometowns. Work on the auto assembly line, in a lamp factory, a paint pigment factory, or a garment factory—some of the jobs that former miners described in their interviews—compared poorly.

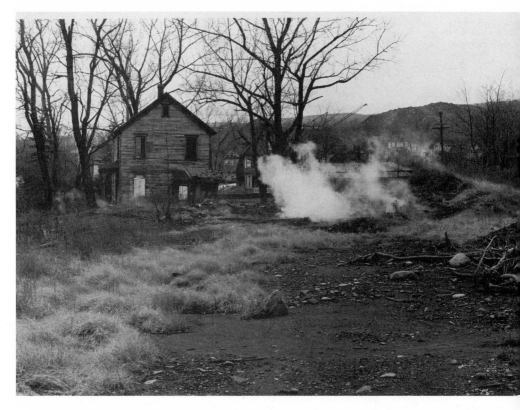

Smoke from underground mine fire seeping through the ground, west end of Carbondale, 1949, with nearby home long since abandoned.

The narratives also reveal sharp generational and gender differences in attitudes toward the closing of the mines. Ken Ansbach, just a kid when the mines closed, had a very different perspective from his elders: "When the mines went down, for me it was a relief, 'cause I knew I wouldn't have to work there like my father." He was afraid of working underground—with good reason, given the number of deaths and serious injuries in the mines—and he knew that if he had started, the money would have kept him there: "For [our dads] it was their way of life. It was a nail in a coffin, really, because you got a good wage at the mines." Ken Ansbach felt lucky to have escaped.

While older former miners remembered their mining days positively and typically acknowledged that they would have kept working had the mines remained open, a fair number had discouraged their sons from following in their footsteps. Irene Gangaware recalled her father's warning

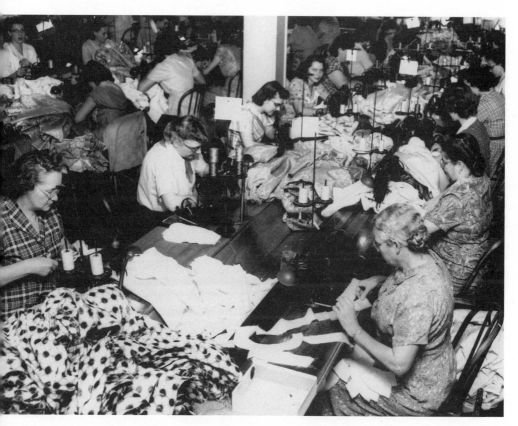

Lansford Sportswear workroom, West Bertsch Street, Lansford, 1956.

her brother never to work in the mines. And although Mike Sabron worked in and around Panther Valley mines for forty years, he indicated that he would not have permitted his son to follow him; he was glad that his son had attended college and moved away. All in all, this last generation of anthracite miners accepted their lot in life and had preferred mining to other jobs, but nonetheless they had steered their sons toward other occupations.

Women were excluded from the mines, but they were as important wage earners as the men in their families. All of the Panther Valley women whose narratives are included here worked in garment factories for significant lengths of time. Most started while their husbands were still working in the mines. Others waited until the mines had closed. Ella Strohl, for instance, began working when an injury on the job forced her husband to give up his janitorial position; she continued to work for fourteen years to supplement his meager pension income. Anna Meyers's perspective was

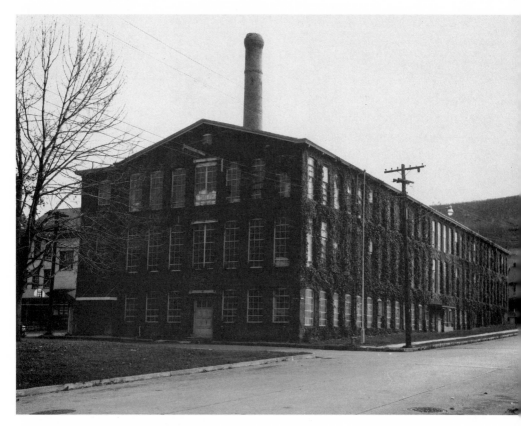

Rosenau Brothers factory, the major garment manufacturer in Lansford, 1950s.

common among women interviewed: "A lot [of] people went to the factories to work after the mines closed down. Well, mostly all the ladies. It was the ladies that kept the valley going."

Men and women rarely worked together in the anthracite region, but they shared a strong commitment to the work ethic. Some men worked two jobs to earn enough to support their families. Wives went out to work so that their wages could supplement the low or irregular earnings of their husbands. During the Depression, children quit school to help support their families. In looking back over their lives, several narrators commented on this commitment to work and self-support. "We never went on relief— never did," recalled Lillian Verona. "Everything I have I got myself . . . the hard way, work and struggle." Her words were echoed by Theresa Pavlocak: "We never got the welfare. We did it the hard way."

Yet, in spite of these protestations, families of a great many of the narrators received crucial assistance from the state in difficult periods. Mike

Sabron's and Lillian Verona's families both received Social Security assistance when their fathers died at relatively young ages. Several narrators or their husbands worked for the Civilian Conservation Corps (CCC) or the Works Progress Administration (WPA) during the Depression. As children, Ella Strohl and her brother had picked up surplus food and brought it home to their family. Later on, she and her husband Tom depended on unemployment compensation for a period, and Grant and Irene Gangaware received assistance from the Veterans' Administration when he was recuperating from an operation for a perforated ulcer. And at the time of their interviews four of the narrators were receiving monthly Black Lung compensation checks.

As a group, the narrators and their families benefited enormously from the social welfare safety net constructed in the United States during the Great Depression. Yet, as Lillian Verona expressed, they viewed themselves as self-made men and women who got things by "work and struggle." Several expressed disdain for newcomers to the area—often Black or Latino—who, to their mind, relied excessively on welfare. Their inability, or unwillingness, to see similarities between their own circumstances and behavior in the 1930s and 1950s and those of poor families in the 1990s is particularly striking.

Men and women shared a strong work ethic, but women in particular exhibited a commitment to caretaking and family networks that tied them to the region. The experiences of a mother and daughter, a generation apart, are revealing in this regard. Ella Strohl left home and moved to New York City after graduating from high school. She took up housework there but gave it up after two months when her mother became ill. She returned to the Panther Valley and cared for her mother until she married in 1944. Her daughter, Ruth Strohl Ansbach, continued to live in her hometown after her marriage. A nine-month stint in Oklahoma while her husband was in the service had been enough to convince her that she needed to be near her family and thus had to stay in the Panther Valley. In both generations, women's ties to family kept them in the region. Just as many men from the anthracite region balked at the demands of fast-paced assembly line work or other distant employment opportunities, women too had their reasons to remain in the region even after its economic base began to erode.

The narratives of Mike Sabron, Ella Strohl, and Ruth Ansbach can help us understand the values that led so many of the valley's residents to resist the pressure to migrate. So, too, do the recollections of narrators who

migrated permanently out of the anthracite region. The differences in the life circumstances of migrants and persisters are instructive as we reflect on the choices residents made in the face of dramatic economic change.

A small family, a parent's death, or a divorce lessened the demands of family solidarity and made it easier for people to migrate once the mines began to close. Ziggie Whitecavage's mother died when he was only two, and after his father remarried, his stepmother arranged for his sister to be placed in an orphanage. Thus, when Ziggie was a teenager, his life was like that of an only child, an unusual circumstance among youngsters coming of age in the anthracite region before World War II. Gloria Rehill had been married and divorced and was not nearly so connected with family networks as other young women of her age were. Like other migrants, Whitecavage and Rehill were less tightly bound by family and ethnic ties than were those who remained in the region in the face of economic crisis.

Nevertheless, migrants drew on family networks when they moved. Ziggie Whitecavage came to work at Fairless Steel at the urging of a brother-in-law and stayed with a sister-in-law on first arriving in the area. Later, he and his wife boarded with her brother for a while before they purchased their own home. Gloria Rehill eventually had several family members living near her, as a sister, a brother, and her parents all followed her down to the outskirts of Philadelphia. After some years her mother and mother-in-law moved in with Gloria and her husband and spent their last years in their household. Thus, migration was not regarded as a way of getting away from family or family connections. Diminished family networks made it easier for people to leave their hometowns, but migrants typically refashioned those networks in their new homes.

While the closing of the mines brought only minimal change to the dimension of family networks in people's lives, in other ways, it had a considerable effect. The narratives afford us insight into relations between men and women in mining families and the division of labor that began to shift as economic circumstances changed. Lillian Verona illuminates the traditional patriarchal structure of her working-class family. Denied milk once as a child, she recalled her mother's comment that her father was "the one that works; he's the one that has to eat." According to a typical pattern of male dominance, her father doled out the money that her mother spent to maintain the family. Although the domestic violence in the Verona household was not typical, her father's control of family members was.

Husbands also maintained control by asserting that it was solely their

responsibility to provide for the family and denying their wives the right to contribute by working outside the home. Lillian Verona recalled her mother's acquiescing to her father's insistence that his wife not take a job: "She said that my father would never allow it. In other words, he was old fashioned and thought the wife should be at home." Similarly, Tom Strohl resisted his wife's efforts to take work at local garment factories even after the mines closed, and his daughter recalled the ensuing conflict. Slowly, the strictures against married women working outside the home began to erode. Ella Strohl eventually did take a job, even in the face of her husband's strenuous opposition, but only after he had suffered a work injury and was no longer able to be the family breadwinner.

Women, however, held onto one responsibility quite consistently before and after the mines closed: being the family's primary consumer and caretaker. Women decided how to spend the income and stretch it to provide for the family in difficult times, a responsibility that could be a heavy burden, especially when a husband was unemployed. In better circumstances, however, a woman could turn her control of the family spending into a source of power in her marriage. Irene Gangaware recalled a confrontation with her husband, Grant, when he was living on the road as a foreman on construction crews. He received a per diem allowance, while his pay went directly to his wife back home. Once, however, he thought he would change matters and have the pay sent to him, a proposal Irene reacted to swiftly: "'The day I don't see your paycheck,'" she told him, "'that's the day you go out the door with the old luggage.' Because I wasn't drinking his money, I wasn't gambling the money. It was our money. We always have our money, we never had 'yours and mine.'"

As Panther Valley wives increasingly went to work in garment factories and men were less likely to be the sole, or even major, providers of family income, domestic roles within the family shifted perceptibly. Lillian Verona and her husband divided the care of their last child; unless he worked the day shift, her husband would watch the baby. Husbands began to do laundry, cook, even pick up their employed wives at the factory at the end of the workday. The distinct separation of male and female roles that had characterized working-class life in the Panther Valley before World War II blurred after the mines closed.

The role of noneconomic factors in people's decisions on how to cope after the mine closings is striking. Ties to family, church, ethnic group, and community were extremely strong in the anthracite region, and older res-

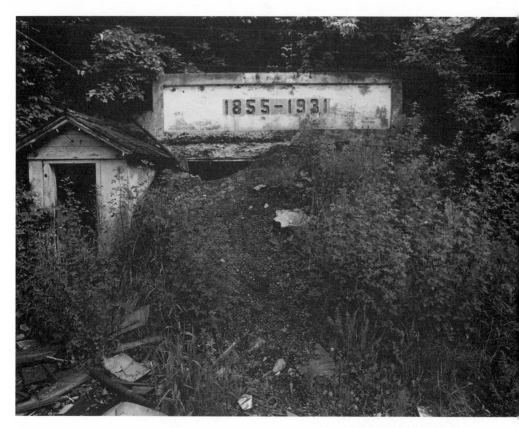

No. 9 mine, Lansford, after the mine closed and its entrance was sealed. The mine operated from 1855 to 1972, making it the longest-operating deep mine in the history of the anthracite region.

idents typically chose to remain, holding out against the pull of economic opportunities that required commuting or migrating some distance. Thus Mike Sabron gave up work on a GM assembly line in Linden, New Jersey, when the Panther Valley mines reopened in late 1954 after a six-month shutdown. Tom Strohl took lower-paying work in the Panther Valley rather than commute to Bethlehem Steel or Mack Truck, two major employers within about an hour's drive. Nursing a sick parent, maintaining a home for temporarily absent parents, or staying close to family and friends of a lifetime were among the motivations to stay.

Even those who migrated often returned to the anthracite region later in their lives. Irene Gangaware's parents moved to Newark, New Jersey, when the mines closed but held onto their Lansford home and retired back

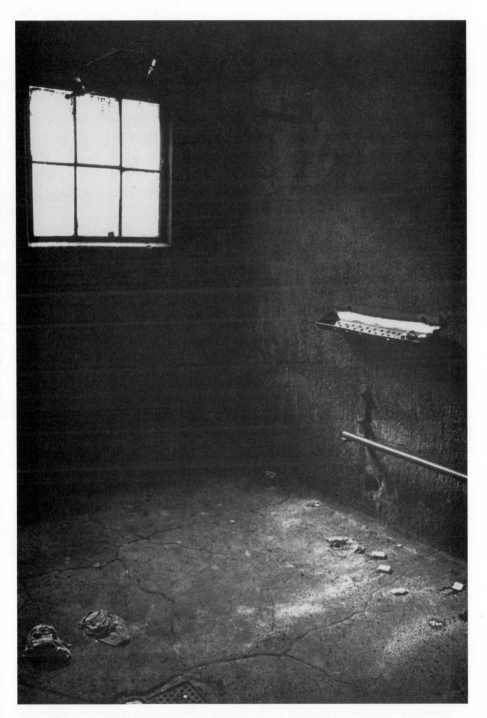

Interior of an abandoned wash shanty, Coaldale No. 8, 1954.

to the Panther Valley. Theresa Pavlocak and her husband lived in New Jersey for twenty-two years, but the death of their son in Vietnam and his burial in Summit Hill took them back to the Panther Valley. Similarly, Gloria Rehill recalled former miners who worked for years at U.S. Steel in Fairless Hills but whose families remained upstate: eventually, "they all went back home." Links to family, church, and community were the basis for this regional loyalty, and these ties remained strong even in the face of economic crisis. By the standards of broader American society, these elderly residents of the Panther Valley, surviving largely on Social Security and Black Lung compensation payments, are impoverished. But in their view their lives are richer where they are, in fact, than they would be in distant communities where they could have earned more money.

These elderly residents prefer to live modestly among friends, family, and familiar institutions than to have a higher standard of living among strangers. Nevertheless, they are ambitious for their children and express considerable pride in the accomplishments of those who have migrated and enjoy a measure of economic success. Mike Sabron is proud of his only son, who graduated from Saint Mary's College and did not follow him into the mines. Ken Ansbach is pleased that he could give his son and his daughter more encouragement to pursue education and careers than his dad had been able to do. Theresa Pavlocak proudly describes how her "girlfriends . . . go all over America because they have four or five children living away from here." She stresses her and her friends' contentment, the comfort they take in the success of their children and grandchildren. Despite the hardships Theresa Pavlocak has faced, she focuses on what she and her neighbors have made for themselves in straitened circumstances—lives richly connected to others they care about—and how they have worked to open up possibilities for their children. She reflects on this broader process and pronounces it good.

George Harvan's photographs, just as much as the narratives, contribute to a fuller understanding of our narrators and their experiences of industrial decline. His images are unusual in the way they express the perspective of a professional photographer and of an insider at the same time. George Harvan was influenced by the documentary traditions of the Farm Security Administration (FSA) during the Depression, but his photographs do not display the distance and searching for despair and distress that can at times characterize the genre. He is, after all, the son of a miner and a lifelong friend and neighbor of the people he has photographed. In telling

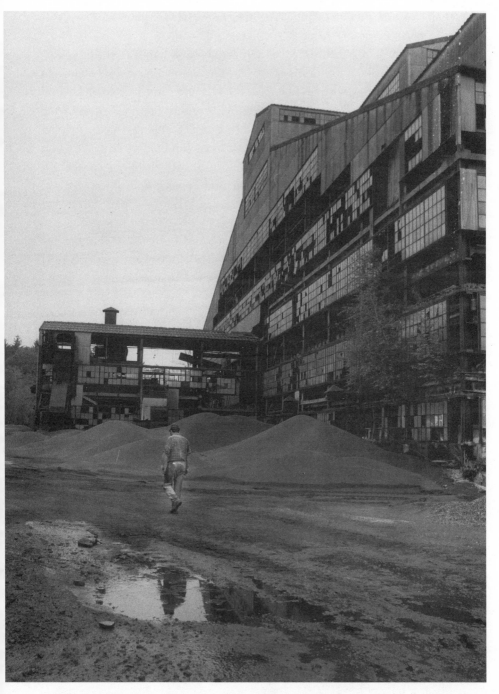

Locust Summit breaker, with lone remaining worker, who continued to operate a bagging plant at the site, 1994.

their stories, he is also telling his own. George Harvan shares more with his subjects than most documentary photographers do.[25]

Harvan's photographs of Mike Sabron, the first narrator in this collection, are representative of his approach. The first picture shows Sabron in his mining clothes, with his helmet and lamp, and reveals a man possessed of quiet strength and self-confidence. Another shot finds Sabron enjoying a beer after work with two of his mining buddies. The men are grimy, but their eyes engage the viewer, and their faces express determination and self-respect. They are also relaxed, comfortable with the photographer's intrusion into their daily lives—evidence of Harvan's insider status. Finally, there is Harvan's photograph of Mike Sabron sitting on top of the last car of coal ever taken from the No. 9 mine in Lansford. It was a drizzly day, and for many of the miners it must have been a sad one, the day that the last underground mine in the Panther Valley was closing down. Yet there is Sabron, waving to the camera with an almost celebratory air, clearly showing his pride in what he and his fellow miners have done in the century-long working life of the mine. George Harvan has an unusual ability to avoid evoking pity and to convey instead the humanity and integrity of this last generation of anthracite miners.

Harvan's photographs are an apt complement to the first-person narratives. The historian Robert Westbrook called the approach of the Progressive reformer Lewis Hine "respectful" and collaborative. He could have been describing Harvan's work when he wrote of Hine's portraiture: "It allows its subjects to participate actively in the production of knowledge others will have of them. His was an ethics . . . that pointed toward working-class self-portraiture . . . [that] not only opened to view the difficult circumstances of their lives but also revealed their strength and solidarity."[26]

Virtually all the underground mines of the Panther Valley, and of the whole anthracite region more generally, are closed today. Strip-mining operations, with their mammoth draglines, loaders, and trucks, employ the vast majority of the region's 1,400 mineworkers. Only a handful of "independent" miners continue to work underground. Where once hundreds of

[25] Lawrence W. Levine points out this sort of problem in the work of Walker Evans; see "The Historian and the Icon: Photography and the History of the American People in the 1930s and 1940s," in Carl Fleischhauer and Beverly W. Brannon, eds., *Documenting America, 1935–1943* (Berkeley: University of California Press, 1988), pp. 15–42.
[26] Robert Westbrook, "Lewis Hine and the Ethics of Progressive Camerawork," *Tikkun* 2 (May/June 1987), 24–29; quot., 27.

wooden, then steel and glass, breakers dotted the region's landscape, processing the raw coal, today perhaps half a dozen decaying ones remain in operation. An era has passed; in another generation there will be no surviving underground miners to share their stories. The narratives and photographs collected here offer us a glimpse into a world now gone—and a chance to reflect on how an understanding of that world can affect how we view our world and lives today.

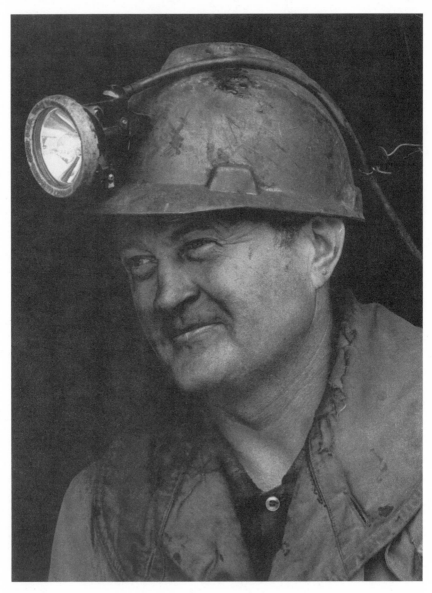

Mike Sabron while employed by Lanscoal and working in No. 9 mine, ca. 1970.

Mike Sabron

Summit Hill June 28–29, 1993

Mike Sabron, known as "Crow" to his mining buddies, was seventy-nine at
the time of this interview. He began working in the bagging plant of the
Lehigh Navigation Coal Company after graduating from high school in
1931. Except for a stint at a Civilian Conservation Corps camp and periods
when the mines were closed in the 1950s, he worked continuously in and
around the mines of the Panther Valley until the last underground mine
closed in June 1972. Mike is one of the founders of the Last of the Panther
Valley Miners, a group that erected a mining monument in downtown
Lansford and holds an annual dinner to commemorate anthracite mining
in the valley. In fact, he designed and helped to build the monument. His
black lung is less severe than that of many of his former mining buddies,
and he remains involved in church and senior citizens activities. His story
speaks to miners' resistance to leaving the region after the mines closed
and the lengths to which they went to make ends meet. Mike's forty-year
career in mining is unusual, but his loyalties to family, church, ethnic com-
munity, and hometown are shared by his friends and neighbors.

◆

My name's Mike Sabron and I was born in Lopez, Pennsylvania [in 1913].
That's up in Sullivan County. My mother's maiden name was Falatovich,
which is a Carpatho-Russian name, and my father's name was Matthew
Sabron. He was a railroader. My mother married him when she was about
sixteen.

Could I tell you a story about before they first married? Well, in those
days, usually it was the parents that married the kids off. My mother was
fifteen when they wanted her to marry one of the boarders because my
grandfather used to like to booze and this guy would buy him the booze
every day so he'd be a good son-in-law. So the wedding [was set], all the
food was there, all the musicians were there—time to go to church and my

mother just refused to go. She just wouldn't go. He was quite a bit older than she was. So then about a year later she married the guy that was the head violinist—my father. She married him.

I wasn't quite four years old when he passed away. I remember him yet. I can still see him. I'm going to be eighty years old. I just close my eyes. I can see him laying there on his recliner with his eyes wide open. He had green eyes. My mother and grandmother come down from what they were doing on the farm, milking cows or whatever, and they start screaming and hollering. Then I realized that he was dead. Even today, I can see him. I can see him right now.

I got to Lansford through my aunt. My aunt lived in Lansford and she met Frank Veron, which was to become my stepfather later on. That wasn't too long, because in those days when they met they just married without love. They married just to be married. About a year later [my mother] married Frank Veron and I kept [the name] Sabron that time. When time come to go to school, my mother come from the farm. What the hell do we know about [school]. You didn't even register or nothing. Just [by] myself [I went] down to the school. I didn't know what the hell to do. I don't know where I went, but I got lost. Somebody brought me home. Then I changed my name from Sabron to Veron and I stayed that way until the time I got married.*

I've been a church member as long as I can remember. I sang in the choir as a boy soprano when I was nine or ten. In our church, we have no organ, it's a cappella. You have a cantor. This is the Saint John's Byzantine Catholic in Lansford. At that time it was known as the Greek Catholic Church. Since then they changed it to Byzantine Catholic. I belong to the choir yet, and I'm eighty years old. I still sing in the Golden Age chorus, but every Sunday I help the cantor out. The three of us sing the mass with the rest of the people. I've been doing it all my life—beautiful choir. I served as officer many, many times—sang solo.

We [sang] European folk songs, other than church songs. We sang our mass. Outside of that one we had an organization, we'd pay our dues, we'd have maybe two outings a year, have good times. They were lots of fun. It was mixed, four-part harmony: alto, soprano, bass, tenor. I'm still interested in it. Over the years it was just great.

My parents were very strict, very strict. [I had first communion] when I

* As Mike Sabron later explained this story, he indicated that it was confusing for others that he used his birth name, Sabron, while his mother and stepfather used Veron. To fit in better in his new hometown, he adopted his stepfather's surname until he got married.

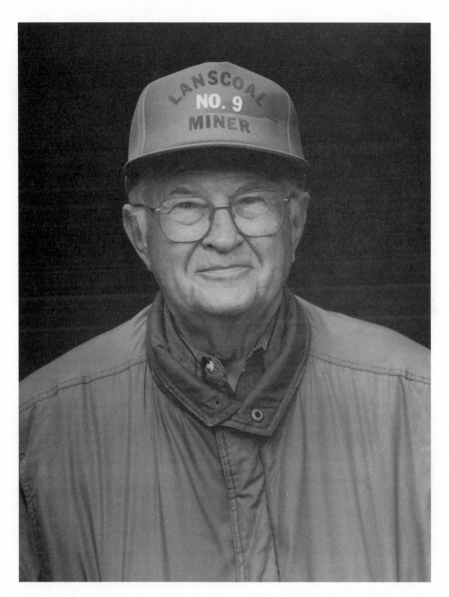

Mike Sabron, fall 1996.

was [in] second grade, must have been seven years old. They prepared us for it. We had instructions, for maybe a month or two.

We were called Greek Catholic. So we had what you called Greek school twice a week. I went six years. It was like first, second, and third grade only: two years in first, two years in second, and two years in third. That's what you call Greek school, but actually it was Russian language. I can speak it

yet—Slovak-Russian. Not the hard Russian, it's that Carpathia-Russian, closer to the Slovak. I can speak Polish, too. I learned it from my grandparents and my parents. In those days, they [came] from Europe, they couldn't speak [English]. I don't think my grandmother ever learned how to speak English.

[I can speak it still.] "Yak she mash." That means, "How you doing? How are you?" And "Dai boze zdrovola." "God give you health." "Hleba" is bread. I learned to read and write it. We got catechism in our own tongue.

[People came from] Austria-Hungary, mostly—Galicia, the Ukraine—there was a lot of Ukrainians around. But there are different parts. Our [family] is from the Carpathian Mountains. But the Ukrainians are in the southern part of Russia, that's where they come from. Their accent is a little bit sharper than ours but we understand each other, practically the same. [Once we both belonged to the same church.] Our church was a big parish. They broke away and went on their own; they're what you call independent. They don't belong to the Pope. That's Saint Nicholas church in Lansford. [When] they broke away from our church, I stuck to my own. All my family broke away, but I stayed with the Holy Church, although I go down to the other one too.

My father's parents stayed in Austria-Hungary. I never knew them. My mother's parents lived in Lansford, up at No. 5.° We had a shanty attached, but they would eat with us and sleep in the shanty. They died [when] I was just a young kid and I can't remember [them well]. My mother was a real good church member, and my sisters and brothers. My sisters still are, but my brothers are a little more lackadaisical.

[When I was young] everybody made booze. We made wine, whiskey, beer and everything. I was practically raised on it—remember getting a load on when I was eight, nine years old. It was always around and if you didn't have it you could buy it for fifteen cents a pint or something like that—cheap.

[We had a lot of organizations when I was growing up.] We had a Sokol, which is a fraternal organization where you pay dues and stuff. That's [a] Greek Catholic organization; it provides insurance. In fact, we still have it. I was an officer for fifty years; I'm still an officer, yet.

We had softball, bowling and basketball. We had state playoffs among our own people. You had the Italian Club, the East End AA [Athletic Association], the Lithuanian Club, the Russian Club, and there was always a

° This was a neighborhood at the East End of Lansford close to the No. 5 mine and breaker.

Sunday School League. We had the Sunday School basketball; each church had their own teams. Each church had their baseball teams—good rivalry. Every town had their own church and then we had the leagues. Later on, after the church leagues broke up, then each town had their own team—good rivalry.

I played for the Greek Catholics and the Methodists. Our church were all good players and I didn't get enough playing time, so I figured, I'm going to go with the Methodists. I wanted to play more, me and my buddy. I was a shortstop and my buddy was an outfielder, Chewie Golditch. So we played, had a lot of fun. Back in 1933 I was valley champion in ping-pong. I weighed about a hundred thirty pounds in high school and I was out for football. I went out for all the sports. I was never a star but I played.

There was a lot of barroom singing. You'd go down past these bars, every bar had a bunch of guys singing away, harmonizing. Oh geez. You had a lot of picnics, picnics galore. Every weekend there was a picnic somewhere around here. Lot of dances: in Sokol Hall, Polish Hall, Greek School Hall, Charlie Williams's barn dancing.

Lansford, up the top of the hill, Kanuch's it was, that was our stop, there. You buy two and you get a free one. Spend some time there. Later on, when I went to Spring Tunnel I used to stop down at Latzie Peltz's—couple of barrooms in Summit Hill.

As soon as you left your work that was the first stop you made, to get a shot and a beer. Then you shoot the shit with the guys: how many cars did you load today and what are you going to do tomorrow? I'd roam around [to all the bars]. Most of [the miners] stopped [at] Kanuch's on top of the No. 9 hill, or Sisko's down lower, but Kanuch's was the big place. There was quite a few bars in town. What with Kanuch's [and] the Lansford Hotel, that'd be ten I guess. Had some good ones in Summit Hill, too: the Twins' Tavern, and Johnny's Gay Bar, and Rod & Gun. The most bars [in a single town in the anthracite region] was a hundred and twenty, in Shenandoah. Imagine having a hundred and twenty bars in one town!

Now you just have mostly the clubs. The Legion, the AmVets, and the Italian Club, they're the big ones. They get over a thousand members in the Italian Club. There's only about a dozen Italians that run it, and the rest are all Slovak, Polak, Russaks and all that. It's the biggest. The Legion has a good business. Sisko on the Friday and Saturday they have good business, but during the week they have nothing at all.

[The bars were busy] till three, four, five in the morning. [You'd play cards] just for a drink, not for money. We had private places to go play

for money—clubs. We had pinochle leagues, shuffleboard leagues, dart leagues—playing from bar to bar.

Women didn't [come to the bars], not too many. Little by little they start sneaking in but way back in the thirties, no. In the forties, I guess, they start coming in and sitting at the bar. But way back, they didn't.

[Wives would] come in after you sometimes. They'd come in, "Where's my husband?" Or they'd call and we'd always say, "Well I'm not here, I just left," or something, you'd make an excuse. Oh, that happened all the time. [A few wives came in and took their husbands home]—not too many, some did. [Then the guys would] tease him—henpecked or something, but you forgot about it. The only way you'd be called henpecked [was] if you didn't know what you wanted to do, if you did what your wife wanted you to do, oh, you're henpecked.

I know I used to spend too much, but I made pretty good money. Some guys spend quite a bit; some guys just so much and that was it.

We used to deal in Bright's—company store. Every payday they'd take a bundle off me. Took it off everybody. Everybody dealt down there, company store. You lived from pay to pay. [You bought all kinds of stuff there,] mostly food—furniture, food, anything at all, you name it. [They had] a market, grocery store, clothes. It was a department store: they had everything. Most of the time everybody bought from Bright's. But years ago they'd give it to you on a book.

My stepfather was a good man. He liked his booze, but he was a good man. He was a shaft carpenter. He worked seven days a week. Ten, twelve hours a day he was working. He made good money and all that. He was killed [in the mines] in 1926 after that six-month strike we had. He was thirty-three years old and he was killed. He was repairing the shaft and some ice broke loose from above and hit him in the head. I was walking home from school and the black ambulance with a red cross went by. I said to my friends as a joke, "That's my father." Later on I found out it was him.

There was five kids then. I was the oldest; I was thirteen and then the youngest was ten months old. I had two brothers and two sisters. When he was killed, my mother went on compensation, which was about fifty-two dollars a month for five kids and herself at that time. There had to be saving[s] there because [my stepfather] made good money. In fact, I remember when he bought a piano; nine hundred dollars he paid for that. That was a lot of money, nine hundred dollars. If he'd have lived, I'd have become a doctor.

I didn't think I was gonna finish school, but my mother said, "you finish school." So all of us finished school. After I come out of school I got a job

Mike Sabron and his mother, Lansford, ca. 1931.

with the [coal] company. I was a bagger down in the shops and worked there 1931 to '33. I went to CCC Camp for a year and a half.° I was supposed to go picking coal then, and instead of picking coal I went to see my buddy off. The guy said, "Anybody want to go as an alternate?" I don't remember if I even knew what the hell alternate meant, but I guess I did. So I put my hand up and went to Wilkes-Barre with a couple guys. Pat failed the physical and I passed it. For two days my mother didn't know where I

° Civilian Conservation Corps, a New Deal program to provide young men with jobs on environmental projects during the 1930s.

was. I can't remember how I contacted her, but [we] went down to Fort Howard, Maryland.

[The CCC] was construction—build roads, reservoirs, trails, and at that time the chestnut trees were dying off. They thought that something from the gooseberry was killing 'em. We used to have what you call gooseberry details. You find it, rip it out of the ground and hang it up to die.

I was out in what you call Cooksburg—"The Valley of the Giants"—the only virgin timber in the state of Pennsylvania. A little bit further there was some soft coal too. I was there for a year and a half. We got paid thirty dollars a month and we'd keep eight and send the rest home. I was a squad leader, got six dollars more. That was the best year and a half of my life.

Well, you are in charge of [a] squad: each one had a squad. We had two hundred and twenty people [in] a company. The guys that took care of us was West Point graduates. That was fun. Played all the sports and belonged to the choir, lot a parties, and prohibition was just repealed then. Everybody had a fifth of Sweepstakes in their locker which was ninety-eight cents—whiskey. Everybody used to drink. We used to go into town and get nickel beer. It was a great time.

[I] came back to Lansford from the CCC Camp in '34. At first I worked construction. We were building the reservoir near the shops, for eight months or so. No other work around, so then I went down to where I worked in the bagging plant and they took me back.

[The miners] got equalization [of work] back in '34. They struck then— at that time I was in the CCC Camp—pull[ed] the whole valley. They stayed out on strike until they got their conditions—equalization. Nobody worked. When [the company] said okay, each colliery [would get the same amount of work], then they went back to work. In other words, I'd work two weeks; then the following two weeks this colliery. At the end of the year we were pretty close, as far as time worked—equal time. That was a big strike. [They stayed out] until every colliery got to work so many days.

I got married in '36. I married the most beautiful girl you want to see. She was Miss Panther Valley in 1934—coal-black hair, beautiful—Edyth Tee. She was an Irish girl, about five-foot-four or -five. And a heart of gold. I called her the saint all the time. Married her and first I lived with my mother down in No. 5. Then we went [and] lived up with her father and brothers and sisters. Because he was a widower, and then nobody'd take care of the kids. [My wife] was the oldest. We went up there for awhile, at Walter Street in Summit Hill. Then we had to get out of that house, somebody up and bought it, we didn't want it because there's no cellar to it . . .

so came looking around all over the place and I bought this [house] for twenty-three hundred bucks [in] 1941. I paid for it in three years and I had three kids at that time. My father-in-law stayed with us too.

Way back, you marry your own kind. Very seldom did you marry out of your own kind. An Irish married an Irish, our kind married our kind, Polish married a Polak. Back in about '36, when I got married, well then that's when you start getting the mixture. [My wife was] Irish. My mother was a widow when I got married. She wanted me to marry my own kind. At first the relations wasn't the best. In fact, I lived down there for a while after I got married, and [my mother and wife] got into an argument. Went back to [my wife's] parents and we'd sleep over on the other side of town.

[We lived] with her father. [Her] mother died in '33. Edyth took care of her family. They had five kids. [When we moved into our own house we had] two of my own. We had Sylvia and Jeannie, two girls. There was four [of us], [and] my wife['s] two sisters and two brothers and her father. We had nine people in all. For a long time we had nine, then eight. Most of the time we had seven at least [in the house] till me and my wife was left in the end.

[The bedrooms were] upstairs. The attic was used and then the three bedrooms upstairs, we had four bedrooms. Nine people lived in four bedrooms. Now that I think of it, how in the hell did we ever live, nine of us here? All the clothes we had, I mean, with four girls you have a bunch of clothes. I don't remember how my wife managed it, to tell you the truth. Most of the clothes were up [in] the attic, the closets are very small in these houses. I know we had to buy cabinets [for] the clothes.

[My wife] more or less went to her church and I went to mine. Every once in a while I'd go down there, she'd come to mine. We never had a problem with religion, never. They had their [service] in Latin; we had ours in our own tongue, Russian. You got used to your own. We sang all the time, they were quiet. Usually they never sang in the Irish church. The priest would say most of the words and everything was silent. Now they sing.

[The children] went to both. They had communion; they were baptized in my church. But when they went to school, they went to public school. They tried Catholic school for a while, and they didn't care for it, so then they went to public school. My third daughter taught Greek school. I don't know how she did it but she taught it. It was in English, more or less.

And catechism, they went to the closest place, that would be here in the Irish Church, Saint Joe's. That's the main reason, convenience. But my wife was a very religious person—a good person. What you were taught when

you was a kid, you just continued. We never argued about religion. People do but we never did.

As my children grew up, they went on their own and most of them are lackadaisical. They don't attend church like I [do]. I hate to miss. To me the most important day of the week is Sunday. My children [were] brought up good and strict, but when they went on their own and had their own families certain things happen. You miss once, twice, three times; then you get off it.

[When I first got married I was working in] the bagging plant. They used to have hoppers which we used [to fill from] gondolas.° At first it was just rough, gondolas coming in and you'd open the gates and the coal would go down to these hoppers. When these hoppers were filled, you had these thirteen-, seventeen-, eighteen-, twenty-five-, and fifty pound bags. You'd open the bag and stick it under this funnel, and you had to leave it and open it and that twenty-five pound of coal would flop into this bag. And oh, the dust! Ah, Jesus! [One] guy would crimp it, hand it over to the guy next to him. Then we had a wire which had eyes on each end. So he'd take that and turn it around and hook these two eyes and pull it and that would twist it. Then you'd dump it down into the conveyor. From the conveyor it would go outside into the boxcars. We used to have about three boxcars set up at that time.

[I earned] thirty-five cents an hour. At first we used to work eight hours a day. We didn't belong to the union. [The first strike I participated in was] the one when I worked in the bagging plant. We had a couple down there. We wanted to belong to the union, and we were getting thirty-five cents an hour, we wanted to get at least 57.8.† That's the first thing we struck for. That was '37, '38.

We got our 57.8 then. We had a couple of strikes, but they wouldn't accept us in the union. I don't know why they wouldn't accept us. Finally [the local for] No. 9 took us in. [Workers in] the shop were in the union, sure, they had No. 7 local. I just can't understand why they didn't want to take us in.

The union was very important—kept the companies down. We got our conditions whenever we fought. I think that there were more strikes in Panther Valley than all the rest of the hard coal industry put together.

° Gondolas were large railroad cars that brought coal from the breaker to the bagging plant.
† This was the lowest wage paid to laborers in the mines.

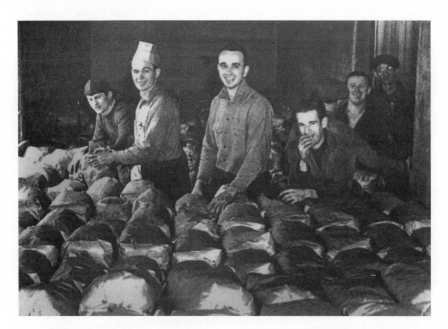

Mike Sabron (*at far left*) and coworkers in LNC bagging plant, ca. 1932.

Every little thing, there was a strike. Oh geez, "Domo! *Domo!*"—must be strike.° Guy coming to wash shanty in the morning, maybe had a grievance the day before. Come to work the next day and he'd take his dinner can and turn it upside-down with the water, floating. Everybody walk up and go home. That was the signal to go home. Guy pick up his dinner can and spill the water out, you get up and go home.

Maybe he had something with the fireboss and they didn't come to agreement, and they just said strike [for] every little thing. They struck for conditions, in other words, and we got 'em, we had good conditions. Lost a lot of days though.

[My] first [pay in the bagging plant was] fourteen-fifty a week, thirty-five cents an hour. I stayed there till 1940. In 1940 I was transferred up to No. 9; Spring Tunnel, that's where I ended up. Once I went down to No. 9 I was there till 1972, that's thirty-two years. There I became a mule driver. I used to tend to the muckers.† The rockmen used to come in and drill a rock tunnel to get up into the coal. They used to drive chutes off these rock tunnels. I tended to the muckers till '47. I made more money than the miners

° Slovak for "Home," as a call for fellow miners to quit work and go home.
† Muckers shoveled dirt and rock loosened as the rockmen tunneled and developed new underground work areas for the miners.

did—bunch of overtime, seven days a week. I'd go down and feed the mule I'd get a shift, later a double shift.

[As a mule driver I worked for the men driving tunnels.] When they blast[ed] this rock, it would come down in a big pile. Some of it would be out further and most of it would stay right close to the face, like a wall there. Maybe they'd put ten cars in there. I'd grab one car with the mule, hook it up, pull it in, unhook the mule, and take the mule and put it to the side, wait till the muckers filled the car. When the car was filled I'd get the mule, hook it up, pull it out the straight—pull the mule to the side. Once I had the first car there, then the other cars just bumped into the rest. Up at Spring Tunnel we had wooden cars, the old ones. All the rest of the collieries at that time had the steel ones.

I would take the mule down, pull the cars out, [and dump the rock] into what was called a counter-chute, which was about a mile away. From the top [level the chute] would go down into the water level. [From there] the [electric] motor took [the rock] out to the rock bank.

Later on I got a job dumping the [coal] cars. You get twenty-one car trips . . . there was two of us there. Twenty-one cars like, behind the switch. You'd throw the switch and uncouple one car, then hook the car to the traces of the mule, and there was a tunnel where the empties went. The car would go down straight, it would dump. I'd go up and get the next car, till twenty-one cars were dumped.

For company men, including mule drivers, quitting time at Spring Tunnel was two o'clock. Maybe I shouldn't tell you this. We used to holler up the pipe after the foreman had left, saying the chute's full, even when it wasn't. That meant the chute was full and you couldn't dump anymore. But maybe there were twenty cars waiting to be dumped, and you couldn't dump anymore, if it was full. Then they'd give us extra pay to wait until the shift loaders came in. We'd wait another fifteen minutes and leave ourselves, but we'd get a whole shift's pay.

Two [guys] was down there, nobody else; [the] fire boss would leave about twelve-thirty. A lot of times when it was full, we'd go home, and my boss always called, "Well, did you dump 'em?" I said, "No." "Well, go back and dump 'em!" So, he'd come and pick us up and take us back to dump 'em, and he'd see that the chute was full. This way I got lots of overtime. One day miners show me their eleven-day pay—hundred and ten dollars. I look at [mine]—two hundred and two dollars, [and] I was a mule driver! All the overtime and the Saturdays and Sundays [meant extra pay].

Weekends you repair the counter-chute where I used to dump the coal, and if there's no repair work to be done, well, there's always some road work to be done—change the rail. We worked there seven days a week. I'd make church ten o'clock Sunday. Sometimes I'd just go down and feed the mule and that was a shift. I made good money.

We worked pretty steady; that's when Hitler invaded. In fact, when the war started, well [in] '39 and '41 the collieries were working good—right before the war and when it started, I got the job as a mule driver—seven days a week and lots of overtime.

After I got through with the dump, I went loading for awhile. The miners used to give us pretty good tips. Especially one guy, he used to wrap it up in brown paper. First time I ever got that—thirty-five bucks I got—that's great, what is this guy crazy? 'Cause we used to take care of his chute.

Well, when the coal comes down the chute . . . chute's full, and then the motorman comes in with these empty cars, and you have two boards—they're called dirt boards. There's one board here with a handle on, and the other board, back here, with a handle on. The guy in the back would more or less check the coal coming down, and the guy in front would let it go into the cars. You load the car, and then you holler, "Next!" and then you pull the next one under. A lot of times, those big rocks, you'd have to blast 'em. You'd have to crack 'em, but if you just had pure coal it was a lot of dust. It was easy going [with coal] but when they'd start loading the rock it was pretty rough loading. You had to move these rocks, you had to jump up and down in the car and up and down in the chute. It was tough, but you were young then. You didn't mind it.°

You just load [the coal] into the cars, and a lot of times maybe one of those got too high, [and the car] wouldn't go [past] the timbers on the way out. So sometimes you have to make room, tumble [the coal] over, [or] sometimes you have to fire [dynamite] on it, [because] it's too big to move. A lot of times you have a lump sticking up too high, especially with rock, [and] you have to make room for it to move it. It was hard.

When you loaded [the coal] it was hitting the car and that dust would fly

° Chutes in the Panther Valley were drilled at an angle, usually 27 degrees, up from a hor-izontal gangway into the veins of coal. The miners typically constructed a wooden frame blocking the chute opening, and installed a pair of dirt boards with which loaders could regulate the flow of coal into awaiting coal cars on tracks below. Because the veins of coal and the chutes to access the coal were at an angle, miners could rely on gravity to feed blasted coal into coal cars. Mike Sabron is discussing here the way he operated these boards when he first worked as a loader.

up and hit you. We worked up at Spring Tunnel, which was more damp. But still you got plenty of dust. Some of the chutes down at the fourth level was dusty as hell.

I went mining down to second level in No. 9 in '47. I worked seven years mining before the mines closed the first time. Mining—go up the chute, lug in timber and everything else. [In] 1954, Tamaqua closed down first, and the whole valley closed down, nobody worked.

[As a miner] you had to do everything. You had [to be] a pipe[man], you had to be a carpenter, you needed to be a master of all trades, in other words. You went with a buddy that had the experience. He had to drill, the chute had about a twenty-seven-degree pitch. You drive up straight and then you drive chutes on the side to go up into the coal.

I got a miner's certificate in 1941, '42, '43, somewhere around there. If you knew the fireboss pretty well he'd give you a chute. I had two buddies that I worked with. The first guy I worked with, Metro Pick—worked with him for thirteen years. He was a good miner; he wasn't a fast miner, but he was a safe miner. I worked with him to '60, a couple of years with the Coaldale Mining. He had black lung and had to quit, and [after that] I worked with a new guy who had never been up a chute before.

During the war we worked a good five days a week at least. From '40 at least up to '50, about ten, eleven years of good work it was. Then the 1950s started, everything started dwindling down. Nobody wanted the coal, [and we] start working less days. That's when I went to the paint racket. I had six guys painting for me as a sideline. Paid 'em a buck and a quarter an hour. If a guy was a little faster I gave him a buck and a half. I had six guys working for me outside and inside in the winter time. Made some good money painting, too.

Even when the colliery was going I'd put a shift in and then we'd tear down [to] Lehighton.° Say you got out of the mines eleven o'clock, twelve o'clock, then we'd go painting till it got dark. And we'd booze from nine till maybe eleven, twelve o'clock. Next day do the same thing again. Remember the doctor telling me, he said, "Mike, you're burning the candle at two ends. You're not going to make it." I'm still here—never know.

The mines closed in 1954. It was a strike. I forget what it was all about. We were splitting time with all the collieries. [There was a big meeting in the] football stadium in Coaldale. John L. Lewis was there. To tell you the truth, I just can't remember. Tamaqua started it all; they weren't getting

° About twelve miles away.

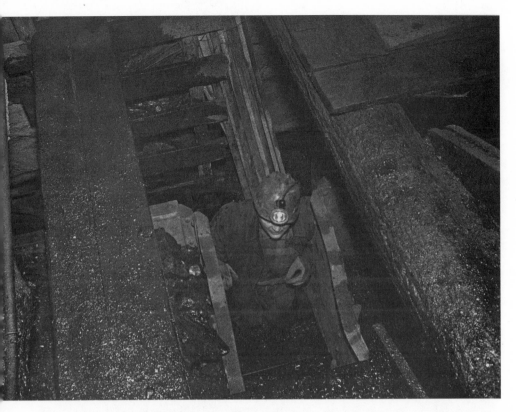

Mike Sabron entering chute, No. 9 mine, ca. 1970.

enough time. [The company was] giving more time to Nesquehoning or Lansford. So they struck on account of that.[*] They wanted just as much time as we were [getting]. Eventually they closed the whole valley down. Tamaqua wouldn't go back and I think we went into strike with 'em. Any colliery went in a strike, everybody else went in a strike, too.

Then [all the mines] closed down in 1954 in March and everybody went to Bethlehem Steel, and they went to Mack [Truck in Allentown] and different places, Fairless Hills and Linden. They didn't want to go away. They'd come home over the weekend and we used to drink a lot.

[*] Miners in the Panther Valley achieved an equalization of working time across all the collieries of the Lehigh Navigation Coal Company in 1934. By 1954 the union contract required the company to work all its mines approximately the same number of days across the year, and if any mine got too far ahead of any others, it had to close until the others caught up. Equalization remained contentious because it limited management's ability to schedule work in the most profitable way.

I went to Linden [in 1954]. They had the Chevy, Oldsmobile, Cadillac—General Motors in Linden, New Jersey. I was there from March till December, [when] I was called back to go to the colliery, which was the happiest day of my life. Got you on that assembly line; oh, that was rough! You see when you work in the mines you have two guys work up a chute. You work the way you wanted to work, but [at GM] you had to move all the time, and I just wasn't used to fast work like that. But we did it. I didn't like it at all. Nobody liked it.

When I was down in Linden, [with] a bunch of guys from the whole valley, we'd get a five minute break and we'd sit there having a smoke. We'd be tired as hell, and then, oh Christ, [we would] wish that we'd go back to the mines again. Although it was so dangerous and everything else. Once you get stuck in them, you like them. You get used to it. You had to, that's all you had.

Linden was packed. Most of 'em were from the coal mines. And then No. 6 was called back, latter part of '54, October. Oh, the guys were so glad to get back to No. 6. Then No. 8 and No. 9 was called back in December of '54.° Nobody else was called, just them, No. 6, and then us. No. 6 closed down after about a year. But No. 8 and 9 worked till 1960 under the name of Coaldale Mining Company.

We worked till February 1960, and the whole valley closed down then. Johnny Zuzu and a couple of the other guys got together and went to the company and asked if we could operate the water level in No. 9. They got it and we worked for about a year before they got it in shape to get any coal. Then we went from 1961 till 1972.

We closed down June twenty-seventh or something like that. We still could probably go in there yet. There was enough coal there to mine, but they wanted us to put new trolley lines in, [and] they wanted to drive a chute out for air. In fact, inspectors were coming in, [and] we were making excuses . . . they did this, they did that . . . we hung for quite a few years that way. Then 1972 come and we were all getting a little older and . . . Black Lung . . . and we closed 'er down in 1972.†

After I become a miner in '47 I was always a miner. But [in the last years] you did everything. If the road was bad, you had to tack it in or you ran mo-

° Sabron refers here to the numbered mines formerly operated by Lehigh Navigation Coal that were leased to other operators between 1954 and 1960.
† The Lanscoal Company operated the No. 9 mine after 1960, the last underground mining operation in the Panther Valley. Unable to meet increasingly stringent safety and environmental regulations, the company closed June 22, 1972.

tor, and you loaded your coal and everything else—that's with Lanscoal. We started out with twenty-one of us [in 1960]; we ended up with ten when the mines closed. We used to haul the coal down to the breaker at Tamaqua.° They used to load the trucks up. First, we used to have to take the cars out of the mines and then where the old No. 8 breaker was we dumped the coal. Then the trucks would come in and we had to scoop it up with a payloader and put it into the trucks [that] would haul it down to the breaker [in Tamaqua].

[Let me describe a typical day at Lanscoal.] The first thing when we get there we get our dynamite and our caps and stuff. Then we'd sit on a motor. Our motorman was always late. The guys would holler, "Come on let's go! Let her go Gallagher, it's raining!" We used to go inside, pick up our empty cars, take 'em inside, and then we'd all sit down and we used to have something to eat. Then after we ate each guy went to his chute, in his mining.

In the morning and after we come out we always had a box of beer there waiting for us. We used to have a lot of parties. Everytime a guy's birthday, he threw a party.

My partner was Paul Petrich—good miner, small guy, but tough as nails. We'd drive [our chute] so far; you couldn't drive too far. We'd drive it, we'd tumble it, and then we'd have to load our own cars.

When I first went mining, in '47, they wanted at least eight cars off you for the first shift. So if your chute was full you'd come in and you look at it, it was full and nine o'clock come and you're going home, your chute was full. [At] Lanscoal we did everything ourselves. But [at] the Coaldale Mining and LNC, we always had loaders and motormen and all that. [It was easier with LNC] because you had more help. Somebody maybe bring the timber up for you, or some plank up the chute as a favor. Maybe twenty pieces of plank up, hand 'em to each other until you get up there. Sheet iron, so the coal will slide easier. You'd have to make the timber, and lug it up. Hard work, believe me.

[Our union local was] 1572. I was the financial secretary of the local— that's for the Lanscoal. I got a salary of about seventy-five dollars a month. I used to bring 'em in here, because I always fed 'em a shot and a beer. [Dues were] five and a quarter [a month]—took off the check.

In the earlier period you used to ballot for mine committeemen and

° This breaker was about four or five miles from the No. 9 mine. In the 1960s it primarily processed strip-mined coal, as Lanscoal was the only underground operation in the valley.

officers. It was a good battle, boy. When you had a grievance, you got the mine committee and you went to the boss, wherever the problem was, and they would try to settle it. If they couldn't settle it, you go to grievance committee and to the district if you couldn't resolve it, never go on strike, but most of the time we went on strike—day or two or three, a week or two weeks, just depends.

We had elections every year. [The issues were] mostly conditions in the mines and as far as a raise in pay or something like that. The United Mine Workers fought that for us, they got our contract, which they still do.

Twice I was hurt [working for Lanscoal]. I had the jackhammer on my shoulder here, and the rock moved and it got me in the side and just ripped my eye open. The jackhammer sliced me. I had it on my shoulder and then when this rock come down the jackhammer went up on my shoulder, hit me in here and busted my eye.

The worst one was when ZuZu and I were driving a chute and another buddy of mine, John Matyka, was running coal up the straight and we were driving. See, this was a straight and we used to have side chutes. Zuzu and I drilled the cut, fired it, cleaned it up, put a set up.° Zuzu said, "Ah, it's a little early yet. Let's drill another cut." So we drilled another cut. I just hooked up the shots—six shots it was—and John Matyka was running the straight.† "Is it okay to fire?" Yeah, it was okay to fire. I just got through hooking up the shots, and I was just getting ready to go over the wing onto the manway, just put my foot . . . and the shots went off. First one went down the chute, it didn't hit me, the next one hit the back of my head and one back here and the other one on the side. I was just lucky that I just went over the side. If I wouldn't, I'd have been killed, that's all. Matyka come running up the chute and I could hear . . . first I could hear his shots go off, then I could hear the next . . . Jesus Christ our cut's going off— thirty sticks of dynamite!

You know what happened? In the morning when we fired the first cut we never broke the [electric] line. That line was open all day coming up to our chute. We didn't break them after the first cut. Both of us forgot. That's the closest I ever came. I used to wonder what would happen if you're there when a cut goes off? Well, I experienced that. Boom boom boom . . . his and our six went off. The whole seven shots went off. I can still hear the first one going off, that was his. When that one went off, I was just over the

° Sabron and his partner would drill holes, load them with dynamite, fire the dynamite, load the coal loosened by the blasts, and prepare to repeat the process.
† John Matyka was another miner, working very close to Mike Sabron and his buddy.

wing, about ten feet from the face. It kicked me over the wing. It hit me back of the head. About a week later I told the doctor, "Boy it hurts me there!" So he examined my back and here was copper wire underneath my skin, that's how it went in.

When the shots went off, well that just hit me. I don't know how I ever escaped that. I told ZuZu, "I'm going. Tell my wife I love her and my kids and all that, I'm finished." This was burning like hell, my back was burning and all that smoke was there, oh Christ.

[They] took me out on the motor. What a sensation that was, wow! I can hear that thirty sticks, six holes, five sticks in each hole . . . boom boom boom! I was just getting ready to go over the side when they went off. That split second [saved me]—[the explosions] actually hit me in the back of the head and the back, threw me into the manway, not down the chute.* [Otherwise] the coal would have covered me up. I'd have been smothered to death.

[As miners we depended on one another and we were close.] We all got together, went out for pizza or something, but mostly the whole shift it would just be your buddy, most of the time. You'd put your shift in and then you'd get about eighteen dollars a day, what you call consideration [wages.] At LNC you'd go home about eleven, twelve o'clock, but if you drove enough, you put a cut up, say you put a set up, you drill the cut, fire it, pull two cars, go home at ten o'clock as long as you did that. At Lanscoal we used to stay there longer. There was no contract mining; you stayed 'til one o'clock.† If you got one car or fifty cars you got paid the same. [At LNC we got paid by the cars] and how much yardage, too: how much sheet iron you put in, how many extra props you put in for safety. They'd pay for that; that was extra.

[We'd] get paid by yardage, how many feet you drove. [The pay was]

* As miners prepared to blast and load the coal, they first opened a chute, a space in which blasted coal accumulated before it was loaded. Parallel to the chute they cut open a space in which they could walk, the manway. Normally miners would exit from the working area via the manway before blasting. Once at a safe distance from the dynamite at the face of the coal, they would use an electric current to set off the charges. In this case, Mike Sabron and his buddy had failed to break the electrical line they had used in the morning, so that their shots were fired before Sabron had gotten out of the work area.
† The distinction Mike Sabron is making here is between "contract" and "company" mining. Contract miners were paid by the tonnage of coal they mined and the amount of timbering they installed in their work area, or sometimes by the length of chute they opened up. Because they were pieceworkers, they were free to leave the mines when they chose. Company miners, in contrast, were paid hourly wages, and had to put in a full workday. Lanscoal miners were all paid as company miners.

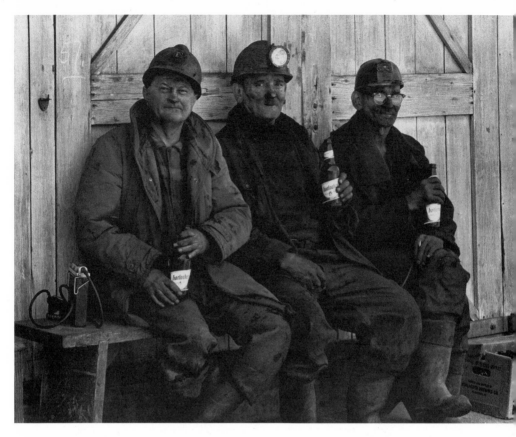

Mike Sabron and two of his Lanscoal buddies after the workday, ca. 1967.

never the same—depend on how much you loaded. Consideration [pay] was about nineteen bucks, [but] we always got a couple dollars more— twenty-one or twenty-two. We always [earned] contract [rates]. Even driving, that's what we got, and running coal. Our vein wasn't the biggest vein there in the water level.

[Other things could affect your pay.] Maybe [the foreman would] give you less cars or something like that. Or say we had five chutes running, maybe he'd give me two [cars] and the other guy five or six—play favoritism. But they were fair and square there, most of the time. [When] they ran the coal, they made sure that the miner got his empties. The motorman was there to pick the cars up. [The fireboss's] first job in the morning was to go in and check for gas. If you had gas, he'd tell you before you got into your chute and you'd have to try to chase the gas out. You'd put a brattice between the manway and the chute, you'd put a burlap up and then get the

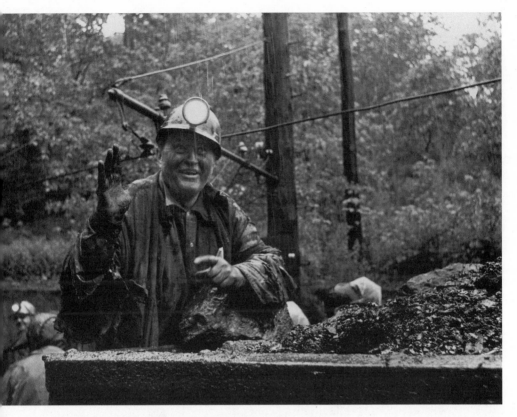

Mike Sabron in last car of coal removed from No. 9 mine, June 1972.

air, and blow the gas out.* We had a pipeline going up with air and then we used to brattice between the manway and the chute. We never had too much gas in there.

Only one guy passed out. That was old workings. That's called black damp [carbon monoxide]. It made him drowsy and he didn't know what he was doing and all that. He come down the chute but he was groggy and he didn't know what the hell was going on. If he stayed there long enough it would have killed him.

In fact, one of the firebosses was killed. He went up into the gas and they found him dead in the chute. He went up with the lamp and then they found him in the chute. Another guy was killed when the gas come down, this was

* A brattice was a divider constructed out of wood and burlap employed to improve circulation in the mine. By installing a brattice, miners attempted to direct the air circulating in the mine to remove either noxious gas (carbon monoxide) or explosive gas (methane) from the working area.

Ambulance passing the Lansford breaker, June 1952. The ambulance is carrying miners overcome by mine gases, as described by Mike Sabron.

No. 6, he was on the motor, he got burnt to heck. Gas come down and burned him, I don't know how.

There was a couple of guys killed other times—gas would go off. I remember one day, 1950 it was, No. 6, there might have been maybe, two or three sets of miners went in to load, they had a lot of coal. They got a ten-foot stick and tacked another ten-foot onto it, then put a bunch of dynamite at the end of the stick.° They shoved it way up there to try to bring the coal down. That went off, and there was gas up there. I think it was about five guys killed that time. They dropped it and then fired and that ripped the chutes apart and everything—filled the gangway up, coal come down.

[The coal] didn't exactly bury them, but they had to walk over a pile [of coal]. When they walked over this pile there was gas there and when they hit this gas they just fell. My neighbor and I picked up [a] buddy of mine and took him to the undertaker. His nose was full of mud when he fell.

Next day was vacation time. The guy that was killed, we just got through playing shuffleboard [with him] over at the bar. "I don't know whether to

° By placing the dynamite on two ten-foot sticks in this way, the miners were intending to blast a location they could not reach by drilling and filling holes with dynamite.

Mike Sabron with David Zebian outside No. 9 Mine Museum, where cleanup is in progress to ready the mine for possible mine tours, fall 1996.

go to work or not," he said. He's supposed to go up to Canada with my father-in-law. He says, "I don't know whether to go there or not, [but] if I don't go work my wife's gonna raise hell." So he went to work. We were playing shuffleboard maybe two hours before that.

They brought him out and put him in the wash shanty. He's laying there with his nostrils full of mud. He always had a smile on his face. My neigh-

bor and I picked him up and put him on a stretcher and put him in the hearse. It was five killed that time. Gangways were full of gas. That's what happened: they put a big stick [of dynamite] up there and then they fired and this ripped the chutes apart. The one guy, they just found pieces of him—knocked him down the chute and just found pieces.°

The next day you just . . . you get used to it. First when you start you think what the hell am I doing here, Jesus Christ? But once you get used to it, you know you had to do it and you did it.

[I had] five [children], one son and four daughters. I wouldn't [let my son go into the mines], but he wouldn't become one anyway. He was a college graduate—graduated [from] Mount Saint Mary's in '66.

[My wife came from] Summit Hill. She didn't go to work until after the kids were pretty well grown up. She worked in a factory for maybe four or five years. She was a presser up in [the] east end [of] Lansford.

Then she was a waitress for Howard Johnson's. She got the biggest tip ever, of anybody ever worked there. Guess who her client was, the one she waited on? Cassius Clay, the boxer. Muhammad Ali, yeah! I don't know how much she got, but she had a real big tip. They were all excited.

[My wife] could do anything. Oh Christ, she was a wonderful cook. And she was clean-crazy—person who just wants everything clean. Work all the time, she was strong too. She wanted a Spanish decor. She just did it all, she was really boss as far as [the house was concerned].

Everything was great. That porch out there, everybody had to have wooden ones. We're the only ones who had the cement. I built a patio in the back; only two of us have a patio in the back. The light out in the front, nobody has a light. It was her influence.

She was something. She died of cancer—gone for nine years now. Two months [after] we found she had cancer, she passed away. She had a bad case of arthritis, her hands were like this, and yet she did her work. See that afghan there? I bet she made about seventy-five of them, for friends and family. She was great.

[If I had it to do over again,] I'd do the same thing. When I think back, I could have stayed in Linden, but I didn't like it. I just loved [it] right here. There's a mixture around here. You name it, we have it—the League of Nations. The street below here was practically all Polish. Here there was mixture. Well, there's about four Polish on this block right now. But this

° These events actually took place in June 1952 and are described in more detail by Jack Yalch in his "Backtalk" column, *The Valley Gazette* (July 1997), p. 36.

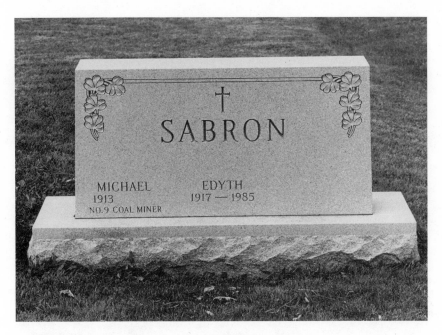

Cemetery marker for Mike Sabron and his wife, Edyth, 1996.

east end was all Polish town. Then on the other end we had a lot of Italians. And the majority of people here in Summit Hill are Irish.

[I have friends from a lifetime here.] Some of them come to the meetings, not to sing in the chorus. One guy, John Scapura, we started together in the bagging plant in 1931, and we also worked in No. 9 and were bowling buddies.

All my kids are good. They're great to me. Almost nine years since my wife passed away, and the kids never fail to call me every week. They come home often. My kids wanted me to go and live with them. No, I want to die here, baby. I worked hard for this.

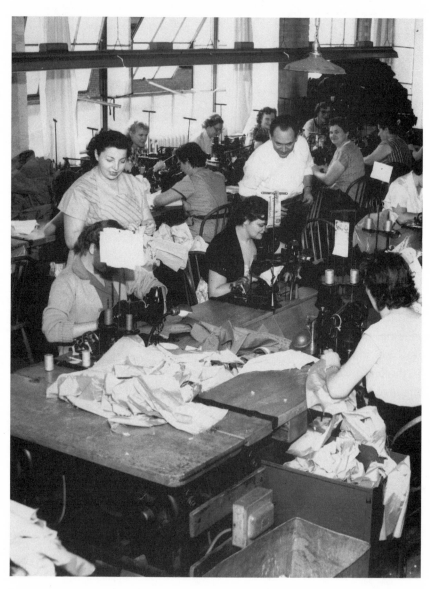

Garment workers at Lansford Sportswear, West Bertsch Street, Lansford.

Lillian Verona

October 5, 1994

The gender divide is a sharp one in the anthracite region. While men faced unemployment or long commutes when the mines closed, women's wage work expanded, as did women's contributions to family income. At age sixty-three, Lillian Verona continues to work in one of the few remaining garment factories in the Panther Valley. The daughter of a miner, she has led a life of hard work, beginning as a seven or eight year old picking coal from the railroad tracks and scrubbing the kitchen of a neighbor who kept a grocery store. She did her first garment work in New York City one summer while in high school, and after graduation began working in a factory in her hometown of Summit Hill.

Lillian Verona had hoped to settle into the life of a homemaker, like her mother, but with the closing of the mines that was not an option. Except for time off when she had children, Lillian has worked steadily. Strikes and her husband's intermittent employment and low wages after the mines closed made her income crucial to the family's standard of living. She has had a hard life and has learned to stand up for herself. Her stories express a measure of bitterness, but she's not one to feel sorry for herself. She demonstrates a quiet determination in the face of obstacles that would have discouraged someone without her will to survive.

✦

I was born in Summit Hill in 1934. My mother's name was Sara Matyka, and she was born in Beaver Meadows, Pennsylvania. My father's name was Samuel Kovaks, and he was born in Hungary. From what I was told, he was fourteen years old when he came over here. He was born in 1892. So, about 1906 I guess, that's when he came [by] himself to get a job. He lived in farmlands. His mother gave him twenty-five dollars to go to the United States; he went on the boat and came over here and got a job in the mines.

Interviewed by Mary Ann Landis. Lillian Verona is a pseudonym. Names in this narrative have been changed to protect the identity of the interviewee.

[He met my mother] in Beaver Meadows, at a picnic. They were married in November 1917, and the first baby was born October 1918. There were ten children in the family and nine are living: one was born in 1918, one was 1920, 1922, 1924, 1925, 1927, 1928, 1931, 1934, and 1937. I think I got them all. The little girl died when she was seven months old in 1929. The first was born in 1918 and the last one was born in '37, so that was a difference of nineteen years from the youngest to the oldest.

I lived where Saint Joseph's church is, on the west end [of Summit Hill]. That was our playground, that cemetery—all tombstones and snakes.

There were Italians, Slovaks, and Irish on our street. My girlfriend's mother was Dutch and her father was Irish. My other girlfriends were Protestant. Growing up, I had friends of all different religions.

I went to Saint John's in Lansford. I had gone to Saint Joe's church, though, occasionally. Because my girlfriend, that was her church, so I would go to church with her once in a while. I got hollered at for that, too, because that's not our church. Our church was Greek Catholic and that was Roman Catholic. At that time, they were under the Pope and we weren't.

We always celebrated Greek Catholic Christmas, January seventh, and I still do. At that time, there was only about two or three, maybe four, in my class [who did that]. There's some bad incidents about me being Greek Catholic with school, because we had to take off January seventh for Christmas. I remember, I was in the third grade, and for the original Christmas vacation, we were told to study our times tables. Then when we came back, the teacher expected us to know them. So that was what I was practicing and rehearsing during Christmas vacation.

I don't know when we went back after the twenty-fifth, but I had to take off for January seventh. The teacher was taking turns. As each student went up to say them, then she would mark who knew them. So my turn didn't come up yet. But anyhow, I had to take off January seventh, and I guess I went back to school on January eighth, and it was my turn to go up and I recited all the times tables—which I thought were perfect—from one to twelve. When I got done, the teacher said something to me, and to this day it's blank. I don't know what she said to me, but I think it was something about my religion. Then she got out a big thick ruler, and kept slapping my hand. My sisters were home from New York at that time, because it was the holidays, and when I went home, I was crying, because I did not know why I got hit. My hand was all black and blue and swollen because of the way she hit me with that big thick ruler. My sisters went up and talked to the superintendent about the teacher in question. To this day, I don't

Lillian Verona and her kindergarten class.

know why she did that to me. I think it had something to do with me taking off January seventh. In other words, why can't you be like everybody else and have one Christmas?

[At school] I was in all the class plays. I could tell you a good story about a play. I had the lead in a play. The name of the play was "Melissa." I was Melissa, in eighth grade. The only thing that I had to wear [was] a white blouse, a Kelly green sweater, and a yellow wool skirt, and one plaid dress. This is what I wore all year long. The play was in March. I told my mother, "I'm in the play. Please give me money so that I can have a different dress, because I'm sure everybody's tired of seeing me having the same thing on every day." She wouldn't give me the money. Then we wrote to my sister, that I'm in a play, would she send dresses? My sister sent dresses, and I thought they were ugly. I wouldn't wear them. I'm still begging my mother to give me money for a dress. She wouldn't give it to me. Well, she knew I was in this play, and I told her if I didn't get a new dress, I wouldn't go. Well, at the last minute, she broke down, and she gave me the money on the day of the play. The play was supposed to be one o'clock in the afternoon. I didn't go to school in the morning because I was making my stand. She broke down and gave me money to go buy a dress. Now, it was slushy

out, it was March. There might have been some snow on the ground. I had to walk the back path, through the strippings down to Lansford, about a mile and a half. So, I went down and bought the dress, and when I came home she said, "This is horrible, the ones you have are nicer than this, you shouldn't do this, blah blah. Bring it back—blah, blah, blah, blah." So I went down, and exchanged it for something different. In the meantime, when I came home, my shoes broke, from being in the wet snow and everything, they just separated from the soles. I didn't have any shoes! They were wet and soaking and I thought, I'll put them in the oven and at least dry them out. And when I did it, they went splat! The soles separated from the top part of the shoe. I didn't go to that play, and the teacher sent two boys down before the play began. I remember I ran into the dining room and my mother told them that I was sick.

I never told anyone the real situation that time. They thought that I didn't want to be in the play. But really the thing was, I wanted a dress and ended up not having any shoes.

None of my sisters [finished school]. My four sisters all went to New York at a very early age, fourteen and fifteen. From what my mother told me, they went because there was nine children living in Summit Hill, and that's eleven people living in one house, and times were pretty hard. They thought they would go out and make their own way in life.

When they first went, I think they worked in a nursing home, taking care of old people. Then one sister got married right away, and that was the last she ever worked. She's never worked since.

My other sister went into the same work, but [later] she worked as a waitress. When the war was on my other sisters worked in the defense factories in Long Island. [My] brothers stayed local. It's just the four girls that moved to New York City.

[My dad] worked in No. 9 in Coaldale. He was a contract miner. There was a way to get down there from Summit Hill—you could just go down a path over the mountain. He might have walked once in a while, but I think as a rule, he took the bus.

[My mother never worked outside the home.] She claims my father was against it. But she made and sold bootleg whiskey—a quarter a bottle. She made it right in the kitchen and people came to buy it from her. It was [the] Depression, and my father wasn't working at all. This is when the girls all left because there wasn't any money except what my mother was making. She did that up until she was stopped. They had the crackdown on everybody, and she was told by a judge not to do it anymore, and she didn't.

Lillian Verona with her high school drum majorettes.

I guess the mines picked up then or something, because we never went on relief—never did. I always felt if I had to get anything, I had to get it myself or I wasn't going to get it. I've never been handed anything yet in my life—ever. Everything I have I got myself. In one way or another—the hard way, work and struggle.

Other families were on relief, I know they were, because my girlfriend's family was. Her father died when he was forty-two from tuberculosis. [Later] when my father died, my mother got Social Security for herself, my brother and me. But when [my girlfriend's] father died in 1942, he was much younger, and they were on relief. She actually had a better life than I did—on relief, yes, she did. I would come home and tell my mother, and I said, "Why don't we go on relief, too? Because they're eating down in that house, and we're not."

"No," [my mother] said. "We don't want to lose the house." So I said, "We can't eat the steps." I was hungry, yeah. I think that's one of the reasons I

never bought a house, because I felt that we had a house up there in Summit Hill, and we owned it, but we were always hungry.

My father bought it when it was four years old. His friends helped him with the initial down payment. My parents paid the house off in six years. He was doing okay. But my father was a gambler and a drinker, too. Whenever he worked, he would just give [my mother] so much money and the rest he kept for himself.

I think coal, at that time, was probably a dollar fifty a ton, if it was that much. But they wouldn't even buy coal. We had to pick it. The boys picked it, and I did. I used to go over to where the coal pockets were, where they used to deliver the coal into the coal pockets to sell it to other people, and I used to go up there and pick it from the railroad tracks. We also picked and cracked coal from the coalbanks, alongside many neighbors.

I used to walk on the tracks to pick the coal that dropped from the railroad cars. In the beginning they let them do it, on the outer fringes of the strip mines. They picked coal all summer to make sure there was enough coal for the winter. If it ran out in January or February, well, that's when I was sent down to the coal breaker. When the railroad car would go over the tracks and would stop, a lot of coal would fall out from the bottom. That's what I would pick up and bring home. My neighbor weighed the bucket of coal I carried and it weighed thirty pounds. I sometimes sold a bucket of coal that I picked to a neighbor and gave the money to my mother. [I was] about eight.

I had my first job when I was six years old. I used to go to the store for the neighbors. When I was seven, I used to go down to this person that had the grocery store and I used to scrub their kitchen and clean their cellar.

I always said to my mother, why didn't she go to work? I would have went to work, with the conditions that we had in our house. She said that my father would never allow it. In other words, he was old fashioned and thought the wife should be at home. But then I thought to myself, what kind of parents were they that would let me, seven years old, go and work in somebody's house? That was hard work for a seven year old. I remember this lady put a lot of ammonia in the water when I scrubbed, and the fumes used to knock me over. I was really tiny.

To me it was fun, though, when I would do it, because my mother wouldn't let me do this at the house. She wouldn't let me sweep or do this or that, but down there at this lady's house, who was a cripple, she would let me do anything—stay to house clean, run the sweeper, do this and that, where I wasn't allowed to do that at my own home.

[I got paid]—oh, this is the best part—a stale candy bar. That was what I earned. Sometimes, I did not get anything. Maybe they were short of items to give.

That first job—well, that was a candy bar. The other one, where I used to go to the store for the lady, sometimes they would give me about two or three cents. I know that I gave the money to [my mother], whatever I got. If it was two cents, three cents, or a nickel, I gave it to her. I know she used to play the numbers. But yet, she wouldn't give me money for milk in school. When I was in kindergarten I was wondering why everybody had milk at lunch break. They had it in these little tiny glass bottles and they looked so cute, and I thought, "Why does everybody have one and not me?" How old was I? Five? I didn't know that your parents had to pay for it in order to get milk. I never got it. I did not realize how poor we were then, in 1939.

[When I was young we] had a little garden. One summer, that was all we ate, what was growing in that garden. I ate a lot of green apples and plums from a neighbor's trees. During the summer we couldn't even wait until they got ripe; we'd start eating them. I want to tell you something. I'm not sickly. I never had any great problems. That's something! I never took vitamins; I was deprived of drinking milk. I know even when we had milk in the house, it was like alcohol. Don't touch it. I even said to my mother, "Why can't I drink this milk?" "Because that's for your father. That's for your father. He's the one that works; he's the one that has to eat." We were pretty poor. But there were families in Summit Hill that were friends of mine whose fathers did the same thing that my father did and they had a good life. Maybe their fathers didn't drink and their mothers controlled more of the money.

My father used to beat my mother, too. When I got older I thought he shouldn't be allowed to do this. I would come home and tell [my mother] what she should do. Then one time she had him arrested. He was a hunter, and he was getting ready to go hunting and he had his gun on the kitchen wall, ready to go when he left. He did terrorize her. That's how he kept her in line, he terrorized her, or hit her, whatever would work. One time, when I was about twelve years old, he did threaten her—pointed the gun at her. He wanted to either kill her or scare her. In the meantime, my two brothers were out of the service already, she called to them, and they beat him up. When they beat him up, I scrubbed up the blood from the floor. She had him arrested for the first time in his life. And that's when it stopped.

I told her that this is not the way to live. When he would come home

drunk, we would all have to run down to the cellar. A lot of times in the winter, he would come in, we'd leave, and go to neighbors' houses. He didn't actually do anything at that time, but this was so he wouldn't do anything.

I wasn't afraid; he never hit me or anything. I feared him, but I wasn't afraid that he would ever hurt me or anything. He never threatened me, but I always had that common sense, keep your distance and watch what you say and do. I think he was proud of me, because I was very good in school. I used to read to him. I don't know what my mother and his problems were, but they didn't get along. I tried to talk to him, because I didn't want him to be a bad guy. I thought with a little bit of persuasion and knowledge, maybe he would change, which I think he did. After my mother had him arrested, he was a broken man.

He stopped doing that in '46. I was already twelve years old. From that point on, on payday, he would come home with a bag of candy, all the time, a quarter bag of candy for the family to share.

At age fourteen, I told him that I would like to take accordion lessons. He told me that if I could find somebody to give me lessons, he would do it. I went to this neighbor who played an accordion, and he said no, he couldn't give lessons. I said to my father that I don't know anybody that could teach me. He then bought an accordion for himself, a concertina. He didn't know how to play it either, but he would play with it. He was making music, but he never had lessons. But, wasn't that funny? I got to him about the better qualities of life. He enjoyed playing it. He made us laugh when he played it. He played it at home before my date and I left for the school prom.

My sisters would come home from the city Christmas or Easter. He was always there, too. He liked them to visit home, yet he was glad they were gone. He was relieved when they left, but he was glad to see them when they came home. They sent home money, and one sister kept me in clothes when I was in school, because my mother could not. I actually used to write to all my sisters. My mother couldn't write, so she would tell me what to say, and as early as seven years old, I was writing letters to them.

I know one time, when I gave [my mother] money, I wanted a penny for something. I found a penny in the house, and I was going up to the candy store to buy a penny's worth of candy. I said, "Mom, I've got a penny, I'm going up for candy." Well, she came tearing after me, "Give me that penny back, give me that penny back." I'm down on the street and our house was higher up, and she was terrorizing me from the porch above, "Give me that penny back!" Well, I got the penny, and I threw it up to the porch above. I

hit our front window, and it shattered! [Laughs.] It was a big window on the front porch. It just hit a certain way, and I saw it go crack! She never hit me or anything. Because I felt I was going to get killed! Isn't that unusual? I'm here to tell you about it. I don't ever remember her hitting me for that or slapping me, and she did hit me at different times, but not for that. I guess she felt she would have killed me, so she didn't do it. But you know, to have that glass fixed must have cost more than a penny.

It was rough. Like I said, my girlfriend's father died and they were on relief and they really had it better than we did. I ate down there a lot. In fact, her mother said she raised me and I think she did. They were very good to me, but then I worked down there, too. I also kept her daughter company. We were friends, and at the same time, if she had to clean house or do dishes, I would help. I think I went down there every night and did the dishes.

I would do it, just like a thing to do. All my sisters were gone, and my brothers were in the service or weren't around, and I went down there for company. I got beaten lots of times for doing that. I'm not supposed to go there because their father died from TB and I'm going to bring the germs home.

[My friend] actually went to Catholic school. But we always maintained being friends, even though she, in eighth grade, went to Saint Anne's in Lansford. I was in Summit Hill, so actually our interests changed at that time, because she was in a different school. She's the one that's a nurse now. She was a supervisor in a nursing home. Now she does something with Blue Cross and Blue Shield in the hospital. She's a nurse in administration.

She wanted me to go away to nursing school in Atlantic City at that time. None of my sisters or anybody in our family went to higher education, so how was I to know there was even something better to be done? So naturally, when my girlfriend gave me an idea that you can get something, and this is how you go about doing it, I was very interested. She told me this is how it's supposed to be done. My mother wouldn't hear of it, to go away for further education.

My mother wanted me to stay in New York to work. When I was down there when I was fifteen years old, my mother said, "Why don't you just quit school and get a job down there?" And I said, "No, I want to finish school first." She said, "All the other girls did it, why don't you?" She wanted me to quit and go to work. And I wouldn't do it. Was I smart? I stuck to my ideals. Yes, she did want me to quit school and she made it very hard for me.

I graduated in '52. I started out to take the academic course, but I knew

there was no chance I was ever going to go to college. I was into school about two weeks and I wanted to change to the commercial course. The superintendent wouldn't let me, because I was a good student. I told him that there's no way I was going to further my education after high school, and that to take algebra and trigonometry and French wouldn't have ever benefited me. I told him that I would rather go on to commercial. He didn't want to let me do it. I said, "If you don't let me do it, I'm going to quit." I felt that would just be a waste of my time to take an academic course where I would never go any further.

I took the commercial course: bookkeeping, typing, shorthand, office practice, office skills. We got a pretty well-rounded education at Summit Hill. Like I said, we did have algebra and languages. I had enough courses if I had wanted to go to college, for I think at that time you had to have two language courses. I didn't take French, but I had Latin. It was nice. And I came out sixth in my class, out of sixty.

I did work in New York City when I was fifteen. I used to go down there every summer to visit my sisters. I spent some time down there, either the whole summer or two weeks, whatever. When I was fifteen years old—I would have been sixteen on August twenty-seventh—they said, "Come down, get a job." I couldn't get a job in the city because you had to be sixteen years old and you had to get working papers. So I went to a factory on 38th Street, the garment district, and I worked there—for two weeks.

They put me upstairs in one big room all by myself. It was very terrifying. It was a room that was maybe six or eight times bigger than this one. Like this big room, with all material stacked in giant bins, and this one sewing machine, which I was practicing on. I was up there for about two or three days, and then they brought me downstairs.

[Downstairs] I was sewing production. I was working on a pleating machine. The material went around there, and you just worked on big bolts of material called pleating. You put the stitch on the outer edge of that thing, and you just kept this big bolt of material, and put another piece in and did it again. It might be about six feet long. They would cut that for a pattern, then, to make a skirt, and then the pleats would already be sewn in it.

There were a lot of men [there]. In fact there were only two ladies there, and I think there were twelve men downstairs in the sewing room. Well, they had a contraption where they would put material into a steam oven, to put press in these pleats before we sewed them. Nobody talked to you.

I think they were Jewish. The two ladies, I think were Spanish, and the men, to me, appeared to be Jewish. The men were sewing, and they were very good. I never sewed before that and was amazed at their skill.

I had to quit because I had no money to go on the bus to get there and no money to eat lunch while I was there. Before I quit, I walked from 92nd Street down to 38th Street for four days, back and forth. [But] that's how I got the job in Summit Hill [after graduation], because the boss asked me, did I ever work in a factory or sew before? All I had to do was tell him I worked on 38th Street.

I went right to work in a factory, Summit Hill Manufacturing. They made sportswear: women's blouses, jackets, skirts, pants, bathing suits. I quit there a couple of times and I went to different jobs, not for long, though. I had an office job for two weeks, which was less money than I was making in the factory, and I went back to the factory.

I quit there again, to go to the Atlas [Powder Works]. I was working on blasting caps, testing them. They were already done, and I would put them in a machine and then press a button and watch this light go back and forth, to see if it was good. If it wasn't good, it would blow up in the box. [Laughs.] I quit there, because it was steady second shift, and I just couldn't see going to work on that shift. Two and a half weeks I worked there. [Then] I went back to the [garment] factory again and I stayed there.

[My father] died [of black lung] in 1951 and I graduated in '52. He died in Hamburg Sanitarium, and he had been in the sanitarium already a year before he died. He actually had been sick from about 1947, [and] the last he worked was 1949. He used to spit up black dirt and everything. He'd cough and big chunks of black stuff came out of his lungs. He became thin and looked worn out.

I lived with my mother until I got married. She got Social Security for me until I went to work [at] eighteen, and then she got Social Security for my brother and herself, up until he was eighteen. After that, I don't know what income she had—very little, except what she had from my father['s] savings, and what she saved from whatever he got from the mines. She started to get Social Security in 1962, when she turned sixty-two.

I got married in '55 and then my husband and I stayed up there in Summit Hill. [I met my husband at] a nightspot, the Twins Tavern in Summit Hill. He had just got discharged from the service, the night I met him. It was the Korean War, but he was stationed in Wiesbaden, Germany. He was discharged that day when I met him. He was out celebrating.

[We lived with my mother] 'til 1957, for two years. [Then we moved down to Jim Thorpe.] [My husband] was going to school, to take up brick-laying, after he got out of the service. Then we had to get married and he took a job up at the aluminum plant in Jim Thorpe. That's where he worked until they shut down in 1965, and he took a job where he's working now, in Lehighton.

I went back to work when the baby was six weeks old. [My mother helped out watching the baby] for a while, but not long. My brother was in financial trouble and she decided that she wanted to watch his kids instead. She had been watching our child. I'd go to work at seven and come home at twelve. I would feed the baby and everything, before I even went to work, so the baby would sleep almost until I would come home. Then my husband was home at different times, because he worked the swing shift. But one time that I came home, she was supposed to have the baby be-cause my husband was sleeping. Maybe he was midnight shift, he came in at seven o'clock in the morning. The baby was crying in the bassinet, and she's nowhere around. My mother was home always. I couldn't imagine where she was. She had left the baby and went to watch my brother's kids. She never even told me she was going or anything. That was the last she ever watched her, because then I worked it out at the factory. My husband would watch the baby, and if he was day shift and I couldn't go in, I just didn't go in that week. That's how we did it.

[Since then] nobody has ever watched my kids, except me and my hus-band—nobody ever. All my children did good in school. The first one made National Honor Society. I never neglected them; I went to bed late a lot of nights. My husband would take off from work and watch them, or stay with them when necessary. It was togetherness and cooperation on our part to raise our family.

I thought when I moved down here, I would never work again. [Laughs.] That's what I got married for, so I wouldn't have to work any more. I wanted to be like my mother, just stay home all the time. We moved down to here one October, and the next month my husband got laid off at his fac-tory. I think he was collecting twenty-six dollars a week unemployment. I had my money saved, and in January I took out the last forty-five dollars. This was in 1958, and I said to him, "This is it. I'm finding a job." I did find a job. The week I started work was in the end of February. My husband didn't want me to go to work.

He thought this was nice, to get twenty-six dollars a week unemploy-ment. [Laughs.] When I went to work, he got recalled back. I worked it out

with the factory. If he worked second shift, I would go in seven to twelve. When he was day shift, I wouldn't go in at all. I think I'm the first one that ever did that, in any factory. They allowed me not to come in when I could not. That was unheard of, but everybody does it now. I think I was the only one that ever did it up there at that time.

I only had one [child when I moved here] in '57 and I had my son in '59. And that was the end of my working career again. I stayed home 'til '61, and I was working part time 'til I got pregnant again in '64, and then stopped working and went back to work in '65. The young one was only one year old. This was when the aluminum plant shut down. My husband got laid off, and he took a job bricklaying, which he worked at until December. They didn't have work for him, because it was winter. Then I went back up to work in Summit Hill. I worked there for about six months. In September of '66, this person I worked for opened up another factory here and asked me would I start in that factory, which I did. I worked there until I got pregnant with the last one. That was '67 and that was the end of my working until 1971, when my husband went on strike. His plant was on strike for six and a half months.

Jill was three and half years old. I went to work in a knitting mill. [My husband] was on strike on Monday; I'm already working on Wednesday, not thinking it was going to be six and a half months long! He was watching the children. It was from that point on that I continued working. I never stopped working again. After the strike, I quit the knitting mill to take a job at a local store, in the deli. I didn't like working on my feet so much. That didn't go over so big with me, because my feet were swollen and everything. I only worked there, I think, three weeks.

Next I worked at a local sportswear factory. The unemployment office made me go up there in February, and I was only working up there two weeks when my mother fell, in Summit Hill. I asked for time off there, because I was running up to Summit Hill to take care of her. She broke her arm. In June I went back there to work. I walked up there every day because my husband used the car. I thought this was pretty rough. Then I tried to get a job at a closer factory, so I don't have that far to walk. They hired me, and that's where I worked for seventeen years. That was a blouse factory here in town.

After that factory shut down, I went to another, where I'm presently working. We sew mostly on denim, but we work on other materials also. When we had pants my steady job was sewing besom pockets, three hundred pair, six hundred pockets on a good day.

For a while there, I wouldn't make any money on production. I was just making my rate, $5.96 an hour. It's not very much money, compared to what I was earning before. I just spoke to somebody about this about a month ago. I cut and notch three times on the pocket curve. I cut the pocket three thousand six hundred times a day. I figured it out. I went in to complain about this price, because I was [only] making about three dollars an hour, with the production. I went into the office, and they got somebody from South Carolina on the speaker phone. Now, I'm averaging about two hundred [pockets] a day when I complained. Then somebody got on the speaker phone from South Carolina and told them that they have a girl who is doing this for ten years, and she is doing a thousand pairs a day, in nine hours.

"Now wait, I'm a good sewer, but I don't think anybody could sew that in a day, in nine hours. I don't care how fast they are, you would not do it. Sewing that and then notching pockets, it's too much handling." The boss said he had a videotape to prove it. I said, "Well, I want to see it. That's the only way I'll believe what you're saying. I can't even imagine anybody sewing that much." Well, they said I'd get to see the video. In the meantime, they upped my price. Well, I don't even do half as much as they claim this girl did, and I'm making money. So a month had passed and I still didn't see the video. And I said to Ann, "Did that video come in yet?" And she said she hates to bother them down there because right now they're having inventory, so she's just going to let it pass until they're not as busy. So I think a couple more weeks passed by, and I said to her again, "Ann, I'd like to see that video." She said, "Well, what does it matter now, you're making money?" I said, "I would just like to see this girl sewing that fast! Just for the knowledge of what she is doing, that she could do that many a day." Well, naturally, I don't think anybody ever did it. I never saw any video.

When I complained about that price, they upped [my] price to 0.1475 and at that rate, I was making $7.75 an hour. A couple of times I made eight. And I figured I better keep it down, because next thing you know, it'll be cut. Now that price, 0.1475, is two times as much as 0.062 [my old piece rate]. [My supervisor] told me I should be satisfied because I'm making money. I said, "I am satisfied."

I got a little bit more productive. I pushed myself harder. When I come home I get more edgy or jumpy, as compared to just sewing for $5.96 an hour, and thinking more or less, if you can't do it, why kill yourself? It was hard.

[I do enjoy working.] It's money. It's a living. The reason I stayed in the factory was because, with the kids and all, and with the way my husband

worked, it would have been really hard for me to work at another job. If it was an office job where I'd come home at five or six o'clock at night, and the kids came home at three from school, that wouldn't work. I always wanted to be home when they came home from school, and made sure they had supper and their needs were met. With another job, I don't think I could have done that.

[For my mother it was different.] My mother was home all the time, doing nothing. [Laughs.] Well, she didn't have to cook, there was nothing to cook, right? And we didn't have clothes, so she didn't have to mend them and she didn't have to wash them. I was washing my own clothes from third grade on. If I didn't do it, it wouldn't be done. Also, when I was in high school, I had jobs all the time. I babysat and did housecleaning for people [and] I did give her the money. But I know with some of the money that I made, say later on when my father died, I would keep that money for myself. That's how I bought my clothes and all for school. That's why I worked when I was fifteen in New York, to get money [for] clothes to go back to school.

[My life has been a lot different than my mother's.] First of all, she never worked and she never drove. She never babysat like I do. Now, my other two daughters, I work and I babysit on weekends, where she didn't have to do that. So, I work and I take care of this house, and I still babysit and have time for other things. I wonder, what the heck did she do with her time? She'd sit at home. That's it. I know we got a television set in 1952. Basically [she did] nothing—just sat there and cleaned the house, I guess, and read the newspaper.

I think she was just happy with her station in life. I mean, she wasn't a go getter. She just liked the life that she had. To her, that was satisfactory. Especially after my father died, she thought she was in heaven. Do you know what I mean? Because she didn't have to worry about aggravation, fighting, arguing about money or this or that. Oh yes, she was relieved at that point.

Although my father was dead, she claims he was bad and this and that. But when he got sick, he was different. And I remember the day he died, too. He always looked forward to May thirtieth, in Summit Hill where they had a parade in town. He was always at that parade and he would meet me in the cemetery at the end of the parade. We would go to the stands where they had food and give me a nickel or ten cents [to] buy something. Then we would walk home together. The day he died was May thirtieth, and that was the first year that he never saw the parade. He was there the year before, but in 1950 he went into Hamburg Sanitarium. He was there a year when he died. I was in the parade that day, because I was a majorette. It

seemed unusual to be at the end of the parade, and he wasn't there. My mother got a call, eight o'clock at night; he died in the sanitarium. He took a lung hemorrhage. That's how he died.

I moved down here in '57, and I think the mines down here were the only mines working at that time. My father's mine shut down in the fifties sometime, the Coaldale mine. But the mine here was still working yet, because when I moved down here, my husband's father was working in the mines. When they shut down, the only thing that changed was that they didn't have the paycheck. I know my husband's parents, they just continued living and tried not to worry.

I don't really think there were that many young people working in the mines when they shut down in 1959 or '60. Really, it affected older men. The young ones never even went into it. My brother worked in the strippings and they shut that down in Summit Hill and then he had to go to Tamaqua, but he didn't have a car and he wouldn't go on the bus, and he stopped working completely.

[It was difficult for us after the mines closed down.] I wasn't really working full time yet. Our income that year might have been twenty-six hundred dollars, for me and my husband together in 1958. We didn't get a new car. We have never had a new car since we were married. When the aluminum plant shut down [in 1965], our car was thirteen years old. I just didn't know where we would go or what we were going to do. It seemed like there wasn't any light at the end of the tunnel for that situation. Because my daughter, Steffie, was one year old when the aluminum plant shut down. She was the third. I didn't know what we were going to do, because there were no other jobs around here to get. [My husband] wasn't much for traveling. We had an old car and I didn't know how we were going to do it. But, he was lucky enough to get a job, and it worked out. It was a better job than he had at the time his plant closed forever.

That was us in 1965. My husband had been working [at the aluminum plant] eleven years. His salary was not that great, so more or less when he was working I could not save money, that if something would happen, we would have something to fall back on. We didn't, because he never got good wages to begin with. It was really devastating. That's another reason we never got a house, because [of] the uncertainty all the time. It really was hard. That's why I went to work right away. He got laid off from one job and I was back working and when he did get another job, I continued working. I figure, "No, I'm not quitting. I'm going to build a nest egg, I'm not going to be stuck again." When something like that happens again, that I wouldn't be prepared for.

I'm not [thinking about retirement]. No. My husband is sixty-two already. He's planning on it maybe next year. But this is the downfall again, because when he retires, his benefits aren't that great. He's not going to get a great pension and he has to pay his own hospitalization, which will cost about $341 a month. That's the reason he's not retired now. That's an awful lot of money to pay a month from what he's going to get. He will get something from Social Security, and about two-hundred-dollar-a-month pension.

It's going to be right back where we were again—struggle. I told the boss the other day, "[I'll retire] when I die." [Laughs.] As far as I can see, I have no plans for retiring. As long as I am able, I think I will work. The only thing that would stop me is if I won the Lotto or my health.

I'm [covered for health insurance] with my husband now. Last year the union [at my work] decided that the costs were too great for them to bear alone, and if I wanted coverage, I had to start paying. So, at that point, I dropped out of it, because I felt that I was getting better coverage with my husband. Besides, it wasn't a good plan. Every time you used it, you had trouble. They didn't pay the doctor, or they say you're not covered. So I dropped it. The pension plan that we get, when you retire, I think it's ninety-four dollars [a month], from the union, if you are sixty-two and working when you retire. [If] you are sixty-five and retire, it's a hundred and fourteen. They give you a little extra money if you work a little longer. And that's it.

[The union hasn't gotten much for us.] What they have gained for us has been there for years. In fact, it's getting worse. Where my husband works, like a lot of places when you retire, they pay your hospitalization up until you're sixty-five, he doesn't have that. When he was laid off, and he had been laid off because one day he quit for one day, he lost all his seniority. So from 1973 to '85, he worked maybe a couple of months out of the year. We had to pay for Blue Cross and Blue Shield about $187 a month, out of his unemployment checks. So, that was rough.

He's been back working steady since '85. I think that is the first time he has worked steady in all the time we have been married—that he's worked nine years straight without a big loss in pay. He took a heart attack last year, too. But he's still working. [When you work off and on] you don't get anywhere. I mean, you're just at a standstill for those times, gaining nothing. You have to take from your savings to maintain your standard of living. So when he was laid off, he got unemployment checks 'til I got done paying his hospitalization and made up for the loss of his pay through our savings. It's just like a revolving door, you go in and out, you don't get anywhere.

[My husband will get a pension, but] it's very little. He's working there

since '69, which is now twenty-four years, and they have made no innovations to that pension plan. In other words, what he started with is still at the same thing. For the record, it's a bum place to work.

Where I work, I don't mind it. I've been in worse places, as compared to where I am now. It's a bigger place, for one thing, as compared to the other—over a hundred and twenty-five people. Up at the other factory, you knew everybody because there were only thirty-five workers there. But down here, you really don't get close to anybody. First of all, you're set up different. I sit all by myself. There's nobody around here in regards to the machine placement. I don't have any coworker here. So I sit there all day and work. Once in a while this girl in the front will say something to me and the girl in the back is busy working, so she doesn't say much. Now, we all know each other, but as far as being real close with everybody, no. You go in, you do your work, and you go home. I'm friends with the ones that I know from this other factory. We got to know each other better with a smaller factory. There's girls down there that I don't even know who they are yet. You see them, and you know they work there, but you don't even know their names.

I would go as far to say as I think there's more people out of the area working there than locally. At one time, it was all local people, very few outside people. Now the majority is from out of the area. It used to be old [people], but they're all retired now. The majority is middle-aged, forty to fifty. I would say that's the average age down there. There's younger ones, but not many at all. The young ones don't stay long. I don't think they like it. They don't like the pay, they don't like the hard work, the difficulty of sewing.

I've sat beside girls, that stayed one hour, two hours; some stayed one, two days. They had big turnover there about two years ago. They were hiring a lot of people; nobody ever stayed. I don't know where they're working. All the people I know are working in the garment factories.

[My children do other kinds of work.] One daughter is an X-ray technician nearby. My other daughter is a legal secretary; she works and lives in Allentown. My son works an hour away. And Steffie, she don't work at all. Her husband has a good job in a business. She looks like my mother, and she acts like my mother! [Laughs.] She said, "Mom, I didn't do too bad for not going to college, did I?" I says, "No, you didn't."

I think she will go to work someday. She has a little three-year-old yet. I think when she gets a little older, she'll go to work. She's pretty smart, if you know what I mean. She has everything. They built a new house.

My daughter Jill went to school on her own. Because my husband was working staggered like he was, she paid her own way through college. She had a job locally with a law firm, and she got a better job somewhere else, which paid more money. When she took that job, she was stagnated. They would give her a raise of twelve cents an hour a year. She was figuring, at that rate maybe by the time she's fifty, she'll get ten dollars an hour. So she decided to go out of the area. She went to live with my daughter, and she was commuting up to here, but she really liked it down there. She found a job down there, and her salary is twice as much as what she was getting locally. At this point she would never come back here to work or live.

Steffie is the same way—the one that's not working and married to the business person and good job guy. Since she's married to him, he works for a big company and he has never been laid off. They're married nine years already. Now, compared to my life, are you kidding?

[My life was] topsy-turvy. I could never plan on anything. I never could get a house. I've always paid rent. I didn't know if his plant was going to be there next year. I didn't know if [my husband] was going to be working. I mean, I really couldn't make that commitment. I could just pick up and go. I didn't go, but I always felt I would have nothing to hold me back. I always wanted to move out of the area, but my husband would never go. He likes it here—barroom on every corner when we first moved here, I mean what more could you ask for? There was a bar right in our backyard. He didn't have far to go. His family was here and his relatives, and his church and his friends. Now half of them are gone. Maybe all of them are gone now. So what we have left is our rent payments. Depressing, isn't it?

[When I think about the future of the Panther Valley,] I imagine it's going to be built up somehow. I know one local businessman did a lot to change the area. In 1965 when the Olin plant shut down, I never visualized that this big company could be there, the conglomerate that's up there now. My daughter said, "Mom, if you want to buy a house, buy it now. Because five or ten years down the road, you won't be able to afford to live here. Because it is going to be industrialized and built up." That's what she said.

Already they built a Wal-Mart in Lehighton; that's going to be a big employer. Since 1965, when my husband lost his job, a lot has changed. In 1965 they had Cerama, they had the shoe factory, now they have Ametek [and] Kovatch which they didn't have before. They have Foodlane. They have Silberline. These are all places that were not here when my husband's plant shut down in 1965. So there is industry coming in. He couldn't get a job in them because he was always too old. First of all, he wasn't qualified

for a better job. When some of these places came in, he was close to fifty. Nobody was going to hire a forty-five- or fifty-year-old person. So, he stagnated where he was. He had no choice.

I don't think [there's much unemployment] right now. But I know in 1981 when my son got done with the college semester, he couldn't get a job and he couldn't go back to college. The following year, he went into the service. [After the service] very few come back. My girlfriend's son just got married. He was in the Air Force, and he just called and told them he married a girl from Chicago and she's in the Air Force; he's not coming back. She's from Chicago and she's still in the service and [when] she gets done they're going to stay and live out that way. He said, "What's here? A few industrial plants, but not much of anything. And the wages are low." If I would tell you what my son-in-law is getting you would not believe me. I mean, I don't know why there's such a disparity between workers. Like why does somebody qualify to get this much and this person who might be working way harder than they are, gets so little? I don't know, I can't understand this. [My son-in-law] makes more than me and my husband together. There's no doubt about it.

But like anything, people need money to live. Industries might come in with low wages, but like anything, you're going to have to pay the higher wages eventually. I don't think they'll ever get up to what AT & T or IBM or bigger places pay, but they're going to have to pay a better wage. It's the same way with our factory down there. If they don't change, if the union doesn't improve conditions for that industry, that's going to be a lost industry, too, because they are not pulling in younger workers. It's not reliable. Right now I'm working steady, but there were times where you don't work steady; it's seasonal. And that's a heck of a way to live.

Imports—well, that's what they claim. I guess it must be true because places are shutting down left and right. I know if you go to a store, it's really hard to find something that's made in U.S.A. That is true. Everything is made overseas: your shoes, pocketbooks, garments, everything.

I'm going to go to the auction now. They have all these various people from overseas having these concession stands! That's an experience in itself. You have all these people with their tents, and they'll sell shirts or socks or underwear or jewelry or food. Place is filled with it. That's where I am going to go now.

The Strohl Family

The next three narratives provide multiple views of the impact of mine closings on the family of Tom and Ella Strohl of Nesquehoning. Tom Strohl's father drove mules in the mines; Ella's father was killed by an explosion while working underground. Tom Strohl had a reputation in his hometown as a great storyteller and a person of strongly held opinions and beliefs, and those qualities come out clearly in his narrative. Ella Strohl was more shy and less of a talker than her husband, but she kept the family going when there wasn't much income after the mines closed, and she found a job when a work accident and black lung made working impossible for Tom. Their perspectives are complemented here by those of their daughter Ruth and her husband, Ken Ansbach. Ruth provides the perspective of a younger generation on her parents' experiences. Ken perceptively compares his own family with Ruth's, offering thoughts on what factors influenced people's responses to change in the years of crisis in the Panther Valley. Tom and Ella Strohl both died in fall 1996, shortly after editing their narratives and providing several of the photographs included in this section.

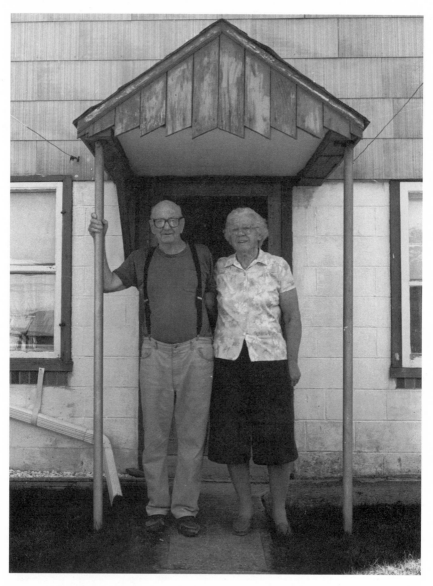

Tom and Ella Strohl in their backyard, 198 Coal Street, 1995.

Tom Strohl

Nesquehoning July 30, 1993

I was born right where our Roman Catholic church is in Nesquehoning back in 1914. We lived there till 1919, [when] I moved over here. I was raised here [at 198 Coal Street]. Then in 1940 I got married and lived up on Railroad Street. Then my father died in '55 and I got the home and moved down here.

Well, my parents was good. My father and I used to hunt together since I was old enough to carry a gun. [We] always hunted together. Up till the day he died, no matter where I went, he went. We were camping one day. He woke me up and he says, "How about taking me home. I'm losing my water, I can't hold it." So we broke camp, clear up at Lackawaxen. We'd come home and he lived a short time after that and he died.

I had one brother and one sister beside myself. My brother, William Alfred Strohl, was a fire boss in the mines. He was a contract miner first; then he advanced to a fire boss. My sister Ethel worked in the silk mill. Now she's up in a home in Hazleton. She's the only one living now beside myself.

Before my father started working in the mines, he used to haul coal for Miller with a team of horses. Then he quit that job and went up to the mine and [worked first as a fireman]. Then he took care of [the mules]. There was six mules in No. 2 shaft, seven mules in No. 3 shaft, and one mule at outside stable. He took care of the three places.

I quit school when I was fourteen years of age. I started to work in the silk mill for twelve cents an hour in 1928. It was the Nesquehoning Silk Mill. Walter Kemerly was the boss. I worked there pretty near two years. Then one day they put us in a hole, digging a well. We were down twenty-eight feet; my buddy was Joe Quashnoc. The boss come over—he used to stutter—leaned over and his pipe fell out of his mouth on my buddy down in the hole. He got mad, and he started arguing with the guy that dropped the pipe on him. There was hot ashes, landed on his back. He come up out of the hole and we got into an argument, and we got fired.

Then I went out on the farm. I worked there till I was sixteen years of

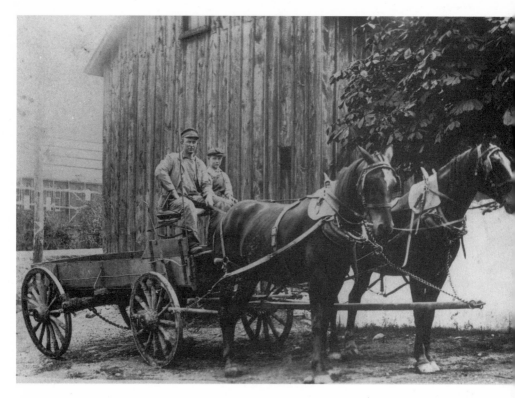

William Strohl, Tom's father, and William A. Strohl, Tom's brother, delivering coal, ca. 1924.

age. I was getting a dollar a day and my board, but at the end of the month you had to take it out in trade. When I got sixteen years of age, I started driving truck. My father bought me a truck [and] I went in business in Nesquehoning—general hauling, anything at all. I hauled there for about two [years]. The fellow from New Columbus, Phillip D'Angelis, went and bought a bunch of trucks and they were all dump trucks. Mine was a flat-body. He was underbidding me no matter what I get. If I'd go for ashes I was getting a dollar a load. He come out at seventy-five cents a load and he put me out of business. Then he come after me and asked if I'd drive truck for him. So I drove truck for him for twenty-five cents an hour. I used to make six trips a day out to Hauto. The first trip we made—this is a funny one. [D'Angelis] says to me, "Tommy, when you get on top of the mountain, and you're going down with your three-ton [truck], you knock it out of gear; you save gas that way." We got out to Stony Crick Mount Hill. He didn't tell me there was a blow-out patch on the front tire. In them days it

Tom Strohl at age eight,
elementary school photo.

was a lot of blow-out patches. I knocked it out of track [and] he fell asleep.
The truck was going eighty miles an hour down that hill and it started to
vibrate. He woke up, he says, "Jesus Christ, Tommy, don't lose your head
now." So when we hit the bottom of the hill, he says, "Tommy, don't do that
no more. Keep it in gear all the time." I had to make six trips a day. I left
there [and] I went to the breaker.

My father's brother was a breaker boss. Now this is facts and I'll back it
up. My uncle didn't like my father's family. Everytime I go up for a job, [he
said there were] no jobs. So one day the fellow that was at the head of the
hiring, he says to me, "Didn't you get a job yet?" I said, "No." "Well," he
said, "I'm going to tell you, you're going to go on the next list. If they hire
tomorrow, you'll be there." Sure enough, the next day I got a job back in
the breaker. He give me the worst job in the breaker, up in the head house.
You couldn't see your hand in front of you. There was thirteen of us hired
that day, and he give me the worst job of the place.

Harry Smith was the guy doing the hiring over in Lansford. He just told me, "You're going to be next. I'm tired of your name coming up and you're always canceled. You'll be next. I'm going to go over your uncle's head." Sure enough I got a job, but then, I got the worst job in the breaker! It was classified as a slate picker but I was watching rollers.

I was working in the head house. That's up at the top where you dump the coal into the breaker. [It was so dusty,] you couldn't see your hand in front of you, whenever the roller was going, crushing the coal. You had a lot of responsibility there. You had to take care of the [conveyor] to haul the coal from the head house down to the lower breaker. If the rock would come down in there and jam, my job was to stop the head house, crawl in the roller and throw that rock out. But you had to make sure that was your bell, because throughout the breaker, everybody's job had a bell. You had to make sure that was your bell that rang to stop that head house because if you get in there and then somebody start the head house, you'd get killed. You get ground up, in other words. So the coal would come down the conveyor line, through the top breaker, from the car. They'd dump it in, it go through the breaker, it would crush it up, then it goes down into the conveyor line and down to the lower breaker. That's where they pick the slate and it'd be sorted. Then from there they'd sell it. It would go down in the rock chute, the coal chutes and [eventually into] the gondolas. They were rolling at that time close to a hundred cars of coal a day.

[Pay] in the head house was forty-three [cents] and three mills an hour. One day I got a fella to take over for me for a couple minutes and I went down [to talk to] Freddy Knolls, the superintendent of all the mines. I seen he was down in the office, and I said, "Mr. Knolls. How about a job in the mines?" First thing he says to me, "You got a job." When he told me that, I said, "Yeah, but right now they're hiring up in the mines. Why not start them out in the breaker like we did and transfer us up there?" He says, "You know, that's a good idea." That's exactly what he told me. The next day I worked, I was up and going to the mines.

Eighteen months I worked in the breaker. When I went up to the mines, we were appointed with a fire boss. He told you what to do. "Go down to-morrow morning to the stable and get your mule, take it inside, into the Skidmore." That was the name of the vein. Well we went down. My father was there. He was showing all the guys that was hired how to harness the mules and different things like that. Then we followed the fire boss in. It

took us 35 minutes to walk from the stable into the mine, where we were going to work. My brother-in-law was ahead of me, driving a mule. He didn't know nothing. He scared the mule. He used to use a club on 'em. I had my mind made up. I'm gonna break that mule without hitting him. The day that I left driving that mule, I could crawl under his belly and I could do anything with that mule. The only thing, he would not lead with anybody around him with a spotlight. He'd get all shook up. One day the boss come in there and he says that the muckers was mucking this car and run off the end of the road. The rail was long on one side, on [the other] it was short and they'd run off the side. So they filled the cart, they called it mucking at that time. The boss, Ken Buck, says to me, "You better go and get a motor, Tommy. You'll never get that car." I put a fish plate under the one wheel that was off the road. I says to him, "Now get behind me with that spotlight on." I whistled at the mule, that mule got down on his belly, and he pulled that car out on the road. You know what the boss told me? He said, "I never in my life saw anything like that. A rock car full of rock, off the track, and the mule pulled it on." From that time on, I could do anything . . . they were friends of mine. They listened to what I would tell them.

I never hit the mule. One day the fire boss [was] doing a load of sills, and the wheels froze. The mule couldn't pull it. I hooked the mule on to pull it in, couldn't. The fire boss took his shovel, he was gonna hit the mule. I got off, and he had authority. I got off, I unhooked the mule. "No," I says, "get the motor and pull it in." I said, "I'm responsible for that mule." From doing them things, I could get along with any of the bosses. I never had a bad record. They'll tell you. I had a good record in the mines.

I was in the stable [for a stretch], and my father showed me how to shoe mules, take care of the harness, and stuff like that. For twenty-nine days I was in the stable, took my father's place. Then a fellow, Gussy Zangle, knocked me out, through the union. There was no hard feelings or nothing; that was the rules of the union. [Otherwise] I might have become a stable boss.

[Then] I was pushing cars for awhile. There's a blaster and a loader. A blaster takes care of the chute, he does the blasting. And the loader, he loads the car, then your job is to fill the corners in that. I was on that, pushing cars. Then I got loading. From loading I went up to blasting—battery starter—and from blasting I went mining.

I worked my way up. During the war [I became a contract miner]. Before that, I'd run motor, I patched on the motor, I break guys [in]. The

boss would say to me, "There's no work today, how about going on the motor and break such and such a guy in." Andy Shutack is one of the guys I broke in on the motor, patching. He was on that motor up until the day he died.

Somebody else would come in and say, "How 'bout teaching him how to load?" I'd go around, I'd help the guy. I'd teach him how to load. That was my job, always.

I got along with the bosses good. But one boss, he was contrary. He's the guy that I almost had fired. He lied and he tried to get me fired. That's the time I was working on a Saturday and I always would make it my duty to ask him, should I wait for the steel trucks. That's the water tank, the steel trucks and the drill. He says to me, "You didn't wait today. So why wait other times?" I said, "Okay." I says, "In other words, I don't have to wait." "No." I was home. The drillers come out and the tanks wasn't in for them. So they went home. I come out to work on Monday [and] I went over to the office. The boss said, "You know, Tommy, I feel like sending you down the hill this morning." I said, "What for?" He says, "Why didn't you put the tanks in?" "Wait a minute," I said. This is the exact words I told him. "I'm damn sure, if the fire boss don't know what to do, I'm only a mule driver, I don't know what to do." He said, "What do you mean by that?" I said, "I always made it a habit, when I work on a Saturday I say, 'Should I wait for the tanks?' The exact words the fire boss said, 'You didn't wait for them other times, there's no use of you waiting today.' So I went home." So the fire boss turned around and said I refused to take the tanks in. He told the big wheel, [who] said [to me], "Will you stand up to that in front of the fire boss?" "Absolutely. I'm telling you the truth. I have a witness." So, that was all right. Then he said, "You go into work, and we'll be in around ten o'clock to see you." He come in, him and George Jenkins, and Ken Buck. They were sitting on a bench there, [and] they send a guy in to tell me to come out. I went out, and who was sitting beside them but Carl Ronemus and the fire boss; they were sitting there. This fire boss was right there clearing his side of the story but he was making an ass out of me. I says to him, "Well, if that's the way you're . . . Do you want me to go in the head?" I said, "I'll get the muckers out and they'll vouch for me." John Grover was the fire boss's name, and Carl Ronemus, they says, "Get on the motor, we'll chase the mule ahead." And I says, "The rockman was on the motor with him." George Jenkins says, "What! Don't tell me that!" "Yup." He says, "Tommy, you go into work. I'll take care of this." I could hear them hollerin' for about a hundred and fifty yards, that's how loud they was. Fireboss almost got

fired for lying. That guy never had any use for me, because I told the truth and I actually cleared my job, but I damn near had him fired. From then on, I never had no trouble in the mine.

Driving mule, when I went [into] the mine, [paid] $4.64 a day. That was eight-hour shift. Then they cut it down to seven hours and I was getting the same thing. We thought that was a big pay.

Then [as a] loader I got more. From there I went up to blasting. Then from blasting I went mining. [As a miner] if you couldn't make contract, then you were [paid] consideration. About 1950 it was fifteen dollars a day. Then we had a rate; we were getting two dollars and thirty cents for mining a car of coal. That was split down the middle for two fellows. So then there was some different things [added] on to it. If we load ten cars a day, we were making about twenty-two dollars a day. But if you got the cars, you could load more if you wanted to. But most of the guys wanted to get home early. Sometimes you could get out of the mines at ten, eight o'clock in the morning, at which time you'd have made twenty-two dollars. Maybe the next day you'd be there till two o'clock, trying to get twenty cars because there's a lot of rock and big lumps of coal would come in.

Used to call it peanuts. If it was fresh coal, it was peanuts. You could load forty cars a day. When the colliery shut down, we were loading forty cars a day. That was two sets of miners. There was two chutes, one coming in on this side of us. We were loading forty cars a day. We could have loaded eighty cars, but we couldn't get the cars. We were making good money, then. But one day, a day and a half before they shut down they says to us, "Put all your tools down on the shoe spout and don't bring any more in. We're gonna close down the day after tomorrow."

[When I first worked as a contract miner,] my buddy [was] Hens Billig. We drove breast.* When you're driving breast they're twenty-four-foot across. You take the coal out from rock to rock. You have to drill that every day. Then you put a length of manway on. You put two props and plank it up, so the coal stays in there. It's like a pocket, in other words. We drove two breasts and two chutes, I drove with him. Then finally he wouldn't work, he couldn't do the work anymore, that's when I got rid of him. I got Bandy Stavecki, from Lansford. He was a good buddy. That winter the chute was finished and we went to drive a breast up when he seen what you had to face

* "Breast" here refers to the working coal face, the wide area at the vein of coal where miners drill holes and place dynamite charges to loosen coal from the vein to be transported above ground in coal cars. The vein typically runs between successive rock strata, hence Tom Strohl's reference to taking out coal "from rock to rock."

every day. He went to Indiana for a month. He quit. He was that scared. I was on the mine committee at the time. He asked his wife to ask me if he could get his job back. Well, in the meantime, when he went to Indiana I got Andy Kashlak for a buddy. He was on the mine committee with me. I told [Bandy,] "I'll get you your job back, but not with me." So he got his job back, and he went with a fellow from New Columbus. Bandy Stavecki was the best buddy I ever had. We made good money.

When you cut, you go up so far with [the] manway. Then you have to cut this coal out in between. Now whenever you cut out the first time, [there are] big lumps of coal laying in there what you dynamited and stuff like that. [Bandy] seen that, you have to go in there to drill. He got scared. He never said nothing; he just simply took off and went to Indiana. He'll tell you that, 'til today. He's living yet.

[You stand on the loose coal to work at the breast.] That's where you would stand to drill. When you're going up you take the coal out from rock to rock. Then you put props in there and plank it off. In other words, you make it like a bucket. The coal's in here and you're working in the manway over here. You put a length of chute of about six feet a day. You could drill out. But you'd have to go in there and cut that coal back from rock. The coal in here is about twenty-some [feet across.] I was in coal where it was eight foot [wide], and I was in it where it was twenty-four foot. You had to take that all out and keep on drilling that. Down at the bottom there's a battery. Then you go to ask how many cars you want out. When you fire you can pretty near bet you get eight to ten cars a day out of that battery, but you don't get paid by car. When you [are] driving breast you get paid by yardage. Now when you're driving chute, you get paid by car. Now, in between the breasts is sixty feet. Well, whenever this breast is finished, it's all big rocks come in, then you go inside, you go up a chute in between it and you drive towards the breast. Then you drill that out. You go up when you drive up and then back. Up for eight jumps. In other words, what they call a jump is from rock to rock, bottom rock to top rock you go. Your pitch should be thirty-five degrees or your chute won't run. You'll have trouble with your chute. When you get pretty near [the level above you], you go and you drill it full of holes and have a battery there. Then you run that coal till rocks come in. Then you drop down and keep on doing that until you get down to the bottom. You want to get the whole vein. Your breast is robbed. There's all rock in it. You want to get this coal in between.

[You drill with] compressed air, jackhammer. That's a good job if you have a good jackhammer. Now we went and bought a jackhammer, oh, and

I could take that around with one arm and [in] ten minutes I could drill a whole cut, it was that fast. But the job didn't last long; have to enjoy it. But that's the story about mining.

[I joined the UMWA] the day I started in the breaker. I was paying a dollar dues then. You had to join the union. Soon as anybody got a job then they were in the union. You didn't have to sign up for it, they took it out of your pay.

Before I started work, back in 1926 was the first strike I remember. I remember that [because] they took the mules out of here and they took [them] over in the Conyngham Valley. I might be wrong on that, but they used to, when they took the mules out of mines, then my father was laid off, too. They took the mules over there in the pasture, because the whole valley went on strike. All the mules was up there. Then when the colliery was ready to go back, they'd bring the mules back and each colliery got their own mules. That's the first strike I remember. Of course, I was only about twelve years old.

Then in 1932 there was a strike. I don't remember too much of it because I was working out on the farm and driving truck. That didn't faze me because I wasn't interested.

[My first strike] was called the Damian Strike. That was about 1940. He broke the union up here. He got rid of the books. He thought he was God, that nobody else could ever run the union. He wouldn't give anybody a check. Before he turned the books over to anybody, he got rid of them. He was the president of the [union]. There was him and Patsy Malaska and Joe Sabol. Some new officers came into the union to oust Damian and the others. Gary Miller was one, and Jack Cadden and Buck Tout and Pat Hartneady. Patty Hartneady was a big wheel; his brother was a big wheel in the union. They took over and the union was broke, no money. In other words, they had to start out from scratch.

That's when the strike was. They used to go around, they were trying to shut all the mines down, so Damian would be sold out of the union. But they couldn't, never did it but then the company beat them out. The company went and hired Sammy Damian as a fire boss, [so he was] out of the union altogether. Oh yeah, there was guns and everything in that one! I don't know exactly how long that lasted. I'd say about six months.

[During that strike] the company asked me, if I would go over and stand in a corner and find out where they're going to picket the next day. I told them, "Oh, no, I have too many friends in this town." I went against it. My brother—he was fire boss at that time—was asking me to go around and

find out. In other words, be like a spy. I turned it down, I wouldn't do it. So for awhile my brother didn't even talk to me because I wouldn't do it. That was the first strike that I was implicated in.

[Later I was elected a mine committeeman.] If a guy had a grievance, he'd come to us. We'd go to the company and make an appointment to meet them, and we'd bring this guy up and either settle it or else, if the company would give us a little rough time, then we'd pull a strike. Then the next day he'd be back to his job again.

There was a guy working in the boiler room, Shorty Grisianna. He come after us. Whenever everybody got a raise, they didn't give him a raise. He come after us and . . . they'd have to go and see the boss first, then they'd come and bring it to us and we won that case for him. He got the same raise we got. That was one grievance. Another grievance we had was Stevie Baker. That thing never got settled. He was a guy that, no matter what he'd get, he was always looking for trouble, looking for something different. There was no strike, but we could never settle it.

He was working in the brattice chute at this time. We went back to work [at this time, and earlier,] when the other company had had it, he had put props on it. Then they shut down. So then we started to work again, [and] he wanted us to get a grievance . . . and make the new company pay him for them props [he put] up [for] the old company. It was impossible, but we went in, we talked to them, but we could never settle that.

I didn't have no trouble during the war [World War II]. I was driving a chute at the time with Hens Billig. [I didn't serve in the armed forces because of a] perforated ear drum. [We] didn't work Sunday but they worked six days a week. You could make good money if you wanted to. You could work overtime, at nights. But, outside of that, most of the men worked their eight hours, seven hours. Because whenever you work seven hours, you don't have much pep left in you when you're in the mines. Now the chute where I worked, when we shut down, the temperature in that chute, they could never test it for heat, it was that hot. It would blow the top off the thermometer. It was so hot, you had to go put dirt when you go to put a shot on, you couldn't lay it on the rock, you were afraid that it would set the damn powder off. It was old gob—gob, they called it. They run into this gob, and that's what made it so hot. Fifty foot, it was that hot, the coal would be steaming.[*]

[*] Gob was a muddy mixture of dirt, coal dust, small rocks, and water, often found in old workings.

[Let me tell you about the United Mine Workers.] Well, they were the boss, they would tell you what to do, you know what I mean. Pete Flyzik, from Coaldale, was the organizer for us. He had his office in Lansford. Before we could go on the case, we'd have to get the rate offa him [to see] whether he'd back us up. In case we'd do something wrong, he'd have to [know what's what.] If he'd say yes, then you'd go-ahead. He'd tell you what to do, how far you'd go.

If we were good, they'd back us a hundred percent. But if you were say, a little bit under a hundred, oh no, they'd back you up but they wouldn't give a damn. You had to get the go-ahead, before you could stick your neck out.

[When the mines closed in the Panther Valley] I went to Washington, to see John L. Lewis with the gang. Lansford, Coaldale, Nesquehoning, we let them gang together, and we went down trying to get him to take the mines over. But he said no, he couldn't do that. When he said no, well that was it. He didn't give a damn because he was the President. He was a big, smart man, John L. Lewis was.

I met him three different times in Washington, with the rest of the committee. We went down one time, it was fifteen of us, Lansford, Coaldale, and Nesquehoning. We went down there and we stayed there overnight. We had a meeting with [Lewis] and he was brilliant. These fifteen guys go down; I seen him in the room. He'd sit there, smoking a cigar, wouldn't say a word. You'd say your piece. [When] everybody got done, he'd get up and tell you what everyone said. He was brilliant. A lot of people run him down, but he was smart.

Well, we went down [to Washington] the first time they were going to close down. This colliery shut down three times. Everytime we went down it was on account of closing down. We got rumors that they were going to close down. When Lewis got sick one time, Tom Kennedy from Hazleton [UMWA national vice president] was there.

[Kennedy] was more for the Valley, for around here. John L. Lewis, he was all over the world, all over the United States. Well, he had more on his head than what Kennedy had. Tom Kennedy, he sat with us one time in Hazleton for two weeks. We were eating hot dogs, every day, [bargaining] on a contract. We got some out of it. We never got what we expected.

I got married in 1940. My first daughter was born in '44 and my second daughter was born '48. We had two children. [My wife Ella is] from Coaldale. I wouldn't leave her go to work, because I said, her job was raising the kids. I wouldn't leave [her] go to work until . . . I don't know, whenever the

Wedding picture of Tom and Ella Strohl, 1944.

colliery shut down the first time. Then I left her to go to work. She wanted to go to work but [I] wouldn't leave her. I said her job's at home.

[When the mines closed first] in 1954, Buster Rehatchek and I, we were doing our jobs. I put a home up in Hauto, without a blueprint. We did a lot of cement work, putting sidewalks in. That's what carried us over until the colliery opened up again. They weren't closed down too long. [Then I got called] back to work.

Buster Rehatchek worked with me. He was my loader, loading in the chute that I was. We both went back to work. It was the same thing. The contract was practically the same. It was like the LNC. [The mines kept operating] around six years. Around 1960, that's when they closed down [for good]. We were loading, there was two hundred and forty-two men working in the Panther Valley [Company]. We were handing out good coal, but when it went to Lansford they started mixing it. Lansford was ninety percent rock. They were mixing it in, and then the yield dropped. Then the mine committee was called in. They told us, "Our yield ain't so great." Well our argument was, you could go down to the bottom of the shaft, every morning you could look at the cars and see the coal in the cars. But go over to Lansford, it was ninety percent rock. They'd mix it in. That cut the yield down, and that's the reason why [they closed down].

[In 1948] they started taking the coal over the mountain.° First thing they had steam engines. Then they started getting diesel to pull them over. That didn't look too good: mining coal and putting [on] diesels to pull the coal over the mountain.

When I first started driving mule in the mines, they would consider, if a miner would give a half a car of coal a day, they could make money on it. At the end, they wanted five cars a day for every miner, which was almost impossible, because today, you're getting coal today, [but] tomorrow you might get rock. You know the rock come down. Well, then you have trouble, you have a hell of time getting a couple cars of coal. There was no consideration and stuff like that with some of the company.

[When the mines closed for good,] we went down to Allentown and we were putting homes up. We were roughing homes up. We'd put everything up, put the roof on, put the black paper on the top, then they'd subcontract the finishing jobs. On the fifth day, that's the longest you would stay, the fifth day you had to be ready to move out and put another home up. We were down off [route] 309. I can't think of the name of the place. The homes were sold for twelve thousand dollars when we moved on to that property. We put up nine homes. The price went up to twenty-eight thousand dollars already. When the homes was put up, at the end, I wouldn't buy one for a dollar. About a week before [hurricane Hazel] we were putting homes up, they told us, one nail in the rafters. Oh, we had to do

° At this time, Lehigh Navigation Coal Company closed down the Nesquehoning breaker and began shipping coal mined in Nesquehoning to the Lansford breaker for processing.

what the boss told us to. We put one nail. We were putting the garage up, hooking a garage onto a home. Hazel come up overnight. When we come in to work, the garage wasn't there, it was down along the turnpike wire, on the fence. Then [the boss] come back and says, "Put two nails in."

Leroy Ziegfried from Fullerton was my boss first, then the next year we got hired by Dan Shuck, we were putting homes up. He'd bid seventy-five dollars to put a double garage up. That's how silly they were. I don't know whether it was dumbness or what it was, but he'd come to us one day, he'd say, "You know fellas," he said, "if you don't put your fingers out I'm going to lose money on this job." He said, "I bid seventy-five dollars on the garage." A double garage! There's just as much cutting on a double garage as there was on a home! We had four days to put a home up and he wanted to put that garage up in a day. Then he sent us over to Shartlesville. We put the first nine homes up at Shartlesville. He was another goofball. He would tell us what to do: "Don't put double studs." He was tight. So we did that, we were doing good, we put the first nine homes up. He told us after we got the ninth home up, "I have a home to put up in Allentown, for a guy." He didn't know the guy was a contractor. He says, "Now you know what to do—single studs." Okay. We went over there, we put the home up. The guy that was having the home built was a retired carpenter. I was at the head of the gang. He come down the cellar this day. He said, "How come you don't have double studs?" He said, "Where the partitions go?" Which they are supposed to, according to law. Well anyhow, I says, "Well, I did what I was told to do." Well, he said, "I'm telling you, I'm paying for this house. I want double studs!" Well, after you have a home up and then you try to put double studs up, you've got a job. So the boss come over to me, he says, "Why didn't you put double studs?" I said, "You're the man that told us. You told us no double studs." I said, "This fellow here asked me who did it." The boss said, "I want double studs underneath the beams, under every joist." It should be double studs, double beams underneath. But see, he was making money on it. He was putting the lumber in, and he was making money on that extra stud.

[Compared to carpentry] I liked the mine work. I'll tell you why. When you work in the mines, everybody pull together. There was times with the miners when I was loading, there was times we had as high as fifty, sixty packs of tobacco, in a box there, we never had to buy no chewing tobacco. The miners would be generous, they'd come in, and then we used to go in, we had electric stoves in the shanties, whenever we'd have a break, we'd

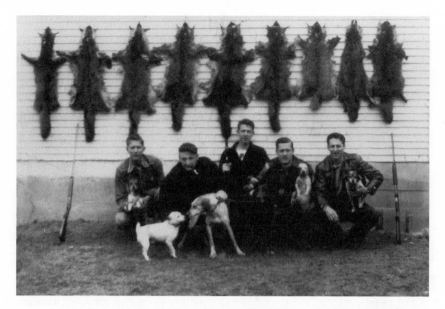

Tom Strohl (*second from left*) with hunting friends and dogs, ca. 1940s. Fox skins hang on the wall behind the group.

make coffee. Boy that smelled in the mines, you know. The miners would come out, bringing coffee, everything in, everybody was pulling together. When you get a job like that, it's a joy; you enjoy your job. Nobody was fighting, and everybody got along good. Now carpenter work was a different story. It all depends on who you got for laborers. Now, this Frank Sisko was one of the carpenters, Andy Kashlak was another one, and Bill Sowers was the other guy, in our gang.

We used to ride down, take turns: you take your car, I take mine. That's the way we were doing it. Then we made an understanding in the summertime. Anytime we could start, they'd leave us start. Then we'd work eight hours and come home. This way, in the summertime, it'd be so damn hot you couldn't stand it, we'd leave at four, five o'clock, get down there on the job and we'd get our eight hours in and come home.

We put homes up in Wallenwapack, Promisedland, and Hazleton, up towards Angela Park there. That's where I put my last home up.

Then I got a job in Silberline.* I was a maintenance man. I was a carpenter. I was a plumber. I did everything. I saved them all kinds of money.

* Silberline was a paint pigment factory that leased the empty machine shop from the closed coal company in the adjoining town of Lansford.

I was on the union committee over there. We didn't want the boss, Walter Ziegenfuss. He was no good. He didn't like nobody in town. Everybody that he worked for, that worked for him, was no good. He was a guy that was always condemning them. I was a carpenter and that used to give me a job of anchoring the mills in for them. The first time we went to put a mill in, they says to me, "Go down, Tommy, and put the anchor bolts in for the mill." I went down there and BBBRRR!!—two and a half inches of concrete. Now how you anchor it in two and a half inches of concrete? I went after John Fitzgerald—he was the boss over there at the time, the contractor that we were fixing it for. I says, "John, you want me to anchor a mill in two and a half inches? . . ." He said, "No!" He said, "There's supposed to be six inches down there." I said, "Come on down." I take the jackhammer, BBBRRR!! I went all over, the most cement there was four inches. Now you try to anchor a four-ton mill in two inches, four inches, it's gonna break out. Finally they give me the job, and then they'd have two laborers come in behind me and they'd dig that cement out and they put anchors [in and pour more cement] so it wouldn't pull out. That's the kind of job I'd do.

I was on the [union] committee over there. That's how I got [to know] Walter Ziegenfuss. Every time I'd see him, him and I'd be in a fight. So one day there was a bucket, two tubs of silver oil. You [know] how oil is when it gets brown. He called me over [and] I was fixing the press that day. He called me over, "Tommy, come here. What's the idea of spitting in here?" I used to chew tobacco. I said, "Walter, if you get that analyzed, and if that's tobacco juice I'll quit the job tomorrow. If it ain't tobacco," I said, "you quit." He wouldn't take me up on it. Then the boss called me in for a meeting. He says, "You settle your own arguments." When I got done telling that boy what I thought of him, he and I were always on the outs. Finally when I quit, he quit. He went to Florida where he could play golf, and I received pension.

Three summers I worked, putting homes up. [After] six years [at Silberline] I quit. After I mixed that there with the coal dust, that's what knocked the daylights out of me, I have no wind at all. [Silberline made] pigments for paint. You work in there, you think it was snowing all the time. I was doing some plumbing [with] a big twenty-four-inch [pipe wrench]. The fellow, Billy Wilden, was holding the ladder for me. Somebody hollered for Billy; Billy left the ladder and went out. I broke the ladder with my nose. I had five ribs broke, and I don't know what the hell all was all wrong with

Tom Strohl wearing oxygen respirator tube, summer 1996.

me. I was laying in the Coaldale Hospital; I looked like a man from outer space. [This was] around '67, '68, something like that.

The funny part of it was, over at Silberline they were giving turkeys out. When I quit, I asked for a lighter job, which you have to do on account of collecting your Social Security. I asked for a lighter job and he didn't have any. So I was walking down the aisle. I said, "Well, I'm going to leave." He said, "Well, I'm gonna tell you, now," Ernie Schiller told me this. He was a boss. He said, "Tommy, you were a good worker, but you were a trouble-maker." He didn't like me because I was on the union and I used to fight for the men.

When I went down to see Doctor Evans down here, he sent for X rays. He told me, "Tommy, if you want [to live] a little while, get out of there." I says to him, "Well, my vacation's coming next month. How about working till my vacation?" He said, "Well, you're on your own till then." As soon as my vacation come, I never went back to work. I retired and I enjoyed my-self for awhile.

[Nesquehoning has changed] lots. When the collieries shut down, this town went to the dogs. Everybody's after that big money. They don't help each other like they used to. One time, if you see a drunken man in the road, you pick him up, take him home. Today, that drunken man will lay in the road. They're not getting paid for it. Everything they want to be paid for. Everybody's out for themselves. That's facts.

Years ago everybody was helping each other. If somebody dies in the family, everybody in town would be sending you stuff. You wouldn't have to buy nothing. Today, only your friends will [help] you. If you don't have no friends then you don't get nothing.

All the young guys moved away; the old guys stayed until they died. It used to be nice and then Kovatch went and bought this whole valley, all the way from Hazleton Road to Hauto. Any property that had no deed on it, he bought it. He went and he swapped some of our best land, from the bot-tom up to the top. In ten years this town's gonna be a mess.

In a way [I wish the mines were still working]. But if the mines was open, everybody would have been dead, you know what I mean, all the young guys. Because that was the only job there was around here at that time. The silk mill, like I said, I worked for twelve cents an hour. Hundred hours, twelve dollars. Well, you couldn't do nothing, you get two dollars and then what do they give you, two dollars. So you keep the rest. What could you do with two dollars?

But still and all, they're killing themselves today. You take a lot of guys

going to Philadelphia, drive to Philadelphia everyday from around here. Well, today everybody graduates school, they go to college. When I was going to school, one out of the whole class would go to college. The rest of them would be working in the factories around here. There was no money for it, but still in all, everybody had good use for each other. Today it's a different story all around.

Ella Strohl in her kitchen, summer 1996.

Ella Strohl

Nesquehoning July 30, 1993

I was born in Coaldale in 1919. My father worked in the Coaldale mines. My mother raised ten children, and we made a couple moves. First we were down Foster Avenue, then we went up to Second Street and Moser Avenue, then we moved to First Street and Coal and then back to Second Street. And that's where we stayed.

In the twenties it was very nice growing up. We did a lot of playing. We had it pretty tough, because my mother raised ten of us. Everything was mostly hand-me-downs. When Christmas came, none of us got a present, couldn't afford it. We witnessed hard times—Depression and everything else—but we survived.

[During the Depression] they were giving food out, different food and milk. I remember my brother and I with a wagon went down to the place in the schoolhouse where they had the food. We got this food and brought it back home. As long as the Depression lasted, that's what we were doing. Once a week, I believe it was, we had to go down and pick the food up like that and that's what we lived on.

I did graduate [high school] in '37 and so did my other brother, the baby of the house. He graduated school, but the rest quit and had to go to work and help out. [The] only [work in town for women was] in the factory, [though] some of them were doing housework, you know. Only those that had money could send their children to college.

[I didn't know] much [about my dad's work] as I was growing up, but I know it was pretty rough. He would always talk about it later on that evening with my mother and sometimes I could pick up the words. It ended up where he was killed in the mines. It was a blast that was supposed to come off . . .

Tom Strohl: [Your dad] went in with his buddy to check the hole that they were supposed to blast and they got caught. When they went in to check it, the blast went off. That's how they were killed.

Ella: I think two brothers went [into the mines], the second to the oldest and then another one. Then you had to register to go to the army so I believe two of my brothers went to the army. They were working the mines and when they come out of the service they didn't go back no more. They'd had enough of it, I guess.

I graduated high school [in] 1937. After that I went to the city to work. I was single yet and my mother was sickly. I was working in New York, doing housework. I got a call [that] my mother was sick so I had to come back. I had quit their housework, I guess I must have worked there for a couple months, anyway. Then I had to come back and tend to my mother. I was doing all that work while my two older sisters were working. They didn't want to quit, because they were helping out.* I stayed with my mother until I got married.

In 1940 I met Tom and we got married in '44. I was married when my mother died. It was really tough, especially when my father was by himself. [Then] my father was killed in '44. Sandra was born in '44. I was carrying Sandra [when] he died. [In] '48 my second child was born, and I still didn't work.

[When the mines closed,] we had it pretty rough. We didn't have no money. We let the rent go, we let the butcher go, but we explained to them what happened and all. Then when they went back to work again, we were six months due on our rent. We went down to talk to [our landlord] and [when Tom] went back to work we were paying her twice a month, thirty-five dollars. One month to catch up and the other month that we owed. So in a couple months we straighten[ed] her out. Then we left the butcher, we did the same thing with the butcher. We paid the butcher about seventy dollars a month when he was working. One was for what we bought for the week and the other one went for what we owed. The butcher says, "I hope they were all like you," in paying the bill, you know. I says, "Well, we're that type." We didn't want bills on our hands. Most of it we got straightened out. But we had no money, until we were retired on the Black Lung and the Social Security that he gets and with my [pension of] thirty-one dollars. So that's how we got ourselves straightened out. We were able to save some money, not too much, but enough to keep going.

When my husband lost his job, I worked for a blouse factory. [T]hat would be in '67, I guess. In 1967, third month, I started to look for work. I

* Ella's sisters were working in New York City at this time, sending money home to help out their family.

did get a job up at Cassie's Sportswear, that big building right up here [on] the corner.

I worked [there] until I got operated on—fourteen years. I was a trimmer. I was cutting strings on blouses, on the buttonholes and around the hems. I was always a trimmer. I never did know how to sew—just odds and ends I could sew. I said I would rather trim. So that's what they gave me, that job, and I was on the roll until they wouldn't hire me back no more.

They had a union, International Ladies' Garment Workers. [In 1967] we were paying [dues of] $4.50 a month.

I liked [the work]. It was something I was always hoping to get if I had to go to work. [I walked to work] all the time, back and forth. I came home for lunch.

[There were no strikes] while I was working. I don't think there was any before that. [There was one interesting incident for me. Once] everybody got a raise, but I didn't get a raise. My buddy next to me had a raise. I knew darn well that I was putting out as much as she was already. So I went over to the boss, I went to see him and tell him about it. You know what he told me? He said, "I thought you were a girl from upstairs on the floor working." You don't make that mistake. I says, "Look, I'm not the one from upstairs. You saw me working downstairs. I'm a trimmer." I says, "I put my work out." He says, "Okay. Next pay you'll see the difference." Next pay I got the raise. If I wouldn't have gone to see him there I would have just stayed there with that same price.

I started out on a dollar a quarter an hour. I guess I went up to pretty near four dollars an hour. [I got a pension] after I was sixty years old. [For the pension, depending on] how many years you work, you got so much money. You know what they gave me [for] working fourteen years? Thirty-one dollars a month—thirty-one dollars and twenty cents, I believe. It's better than nothing.

[Tom's commuting was] all right, it kept us going. He come home. He did some around the house and everything and so we were able to manage, thank God.

[My daughters worked] in factories. My one daughter got married; the other one, she didn't want to go anywhere. She tried nursing, but she didn't make it. So she went to the factory up here, lamp factory. My other daughter graduated. Now she's a boss down here in the factory, Kaijay. She teaches them. New ones are coming in [and] she shows them what they have to do. She did all right—floor boss. One's in Lehighton, and the other one's [a] couple homes up above me.

Obituary of Ella Strohl.

Like Tommy said, as we were growing up, getting older, people change a lot. I think that television has lots to do with it. Before we were sitting on porches or going visiting one another. Now they don't do it. Now we don't even know the people that are in town since Kovatch opened up here. He's getting all those people in here, giving them jobs. Most of them are on relief.

I think it was better then. People knew one another. But today . . . a big change. Well, in a way I'm glad [the mines] closed down because it was so dangerous. Every now and then—everybody was getting either murdered, killed. Later on we saw when they got older, they have the black lung. You have to put up with that now. So, I'm glad in a way they closed.

If it was only for the old people, as they grew up, your younger ones today wouldn't even look at a mine. They wouldn't even think of going down in the mines to work. That's why sooner or later they were going to have to close. Because the younger ones, no way, will they go in the mines. Yet the older people had to go. They had no place else to go to work.

[Women's work today,] in a way it's no hardship for them. Where we went through all that. It seems today they're not satisfied with what they have, or what they get. They're looking for more. I think they have a better life today than before.

Ruth and Ken Ansbach, summer 1996.

Ruth Strohl Ansbach and Ken Ansbach

Nesquehoning September 6, 1993

Ruth: [I was born] in Palmerton, November fourteenth, 1948. [We] were living on Railroad Street [in Nesquehoning], my mom and dad, my older sister, Sandy, [and me].

I remember moving when I was in second grade and my father was still working in the mines. I can remember my mother always saying that the rumors were going around, "They're going to close, they're going to close." My dad was always saying, "No, they'll never shut down, they'll never shut down." It seemed like it was a total shock; it seemed like nobody expected. The other thing that I can remember was my mother would be so worried because there was no money coming in. The unemployment checks—it was thirty, [or] thirty-four weeks that they didn't get any checks. I remember them going to these little stores and asking if they would give them credit, if their credit was okay that they could use it until these checks would come in. Then one day they finally did. They were so happy. They got it all in one lump sum, but they had to go pay all their little bills, to the butcher's and Kunzweiler's up in town.

I can remember going with my mom to Kunzweiler's for things, and we'd go in and she would say to them, "Can I put this on credit?" And they let them. We lived in the apartment building that belonged to the owner[s] of the store, Mr. and Mrs. Kunzweiler. My dad used to do things for them, carpentry work. I can remember them telling, "Oh, your credit's good." They were really nice people, and, by knowing my parents so good, they trusted them.

Ken: I think one difference between today and then was you had all little, family-run businesses in town and you supported them. When things got tough for you, they carried you. Today, most of these places are out of business and you're dealing with corporations. If I would lose my job, I could [not] see going to Lane's or the Acme and asking them if they could carry me for a couple months till I got a check in. I don't think we'd be able to

make it like our parents [did]. I don't think these people would carry us. There was a lot more trust in the Valley.

Ruth: People helped people. The people who have been here a long time are like that. If someone dies in your family, everybody's bringing you food and helping you. If you go down into other areas they don't do that. It's a lot different than it is up in this area, and I think a lot of it's from people being here when times were tough, and you depended on your neighbor for things. Our neighbors help you out or do whatever they can for you.

I can always remember my dad making sure he paid his bills. That was the first thing, anytime the money came in, from his checks, [my parents] made sure they went and paid all their bills off first. That was the big thing. I can remember them telling me, "Always remember to do that, because later on if you ever need help, these stores will help you out or give you credit if you're really stuck." Through all our years now—we're married twenty-five years—[we] pay the bills first, and then you go get or do whatever you want to if you have anything left over.

I remember one year. Up till then, Christmas was always good. I can remember getting a lot of gifts. And when [the coal company] shut down they would be saying, "Now, this Christmas you can't get anything. We just don't have the money." I knew my dad went up to Kunzweiler's, and that year for Christmas we both got a watch, which we didn't expect. But that was all we got, just the watch. We weren't used to that. We were used to getting a lot of gifts and toys and stuff. We were so happy we even got that 'cause up till then they kept telling us we can't get anything for Christmas this year 'cause [there's] no money in the house.

I remember [my dad] looking for a job all over the place, and finally he got one in Allentown as a carpenter. That job was fine until the pay checks bounced. Then a friend and neighbor helped get him a job working in Silberline, when it was just being built. He worked there as a production worker or maintenance.

I remember one time he fell off a ladder at work and had to go to the hospital. It wasn't too long after that he went to the doctor and got his lungs checked. [The doctor] said that if he didn't quit he wouldn't have that many years to go, because of the fumes that they were taking in and besides what he had from the mines. He just came home, and I remember him saying he was gonna retire, he was gonna see if he could get Black Lung [compensation].

Ella Strohl with her baby, Ruth, 1949.

It was another scary time, because all those years my dad would not leave my mother get a job. This was her job to be at home and he wouldn't let her go. I can remember them arguing, [my mom] saying, "I want to get a job," because there was nothing coming in. But he [said], "No way. You're supposed to stay home, this is your job, you stay in the house." It was always her thing to be here and cook and iron, she'd always have his meal

ready for him. My mother used to tell me that it was easy to get a job in the factory. They'd see you in the street and ask if you needed a job. She wanted to work but he wouldn't let her. My sister was out working, so that was pretty good.

[My mother] finally said to him, "I'm getting a job." She went up, got the job, and came back, and she said, "I'm working." I remember it was hunting season. The first day of hunting season was her first day to go to work. You could tell he didn't like it too much, but I think he figured there would be no money coming in until he would get his Black Lung. They were collecting unemployment, but that wasn't enough either. You still had other bills and stuff to pay. I can remember my sister and I saying, "Just go and get the job, don't worry about what he says!" She did it. She said, "I'm not doing it this time. I went through that the last time, worrying about the bills." It was always her that paid the bills. He would just give her the check and she took care of all the financial things. Then she'd always be moaning, "Well, yeah, but it's me that has the headache. You don't worry about it till I say, 'Well, I can't give you this or we can't get that.' Then it's like, 'Well, why can't we get it?'" She was the one who took care of the money. He didn't worry about it. He didn't care where the money went. He figured she'd take care of it.

Way back when, my girlfriends, their parents both worked. So they didn't seem to have it as hard [as we did]. They always had that quarter, or "Give me fifty cents, Mom, so I can go downtown." You know, we'd hang out. [I] remember taking a quarter and we'd buy chips or something, and walk home with something else in your hand. We would always have to ask, "Can I go, can I get jeans, can I get this?" "I don't have it, I don't have it." It wasn't they wouldn't give it; she didn't have it. You'd get an outfit for school, it was maybe just one thing, not a couple. When my sister went to work—she's four years older than me—that helped me out because I'd get all her hand-me-downs. My parents didn't have all that much to give, so I fared out that way.

I can remember all my other friends, they'd be able to go shopping and buy clothes. I'd go with them but I wouldn't get anything, because, their father[s] left after the mines [closed], went down to Allentown and got jobs. My dad wouldn't go right away; he didn't want to leave the area. I don't know what the real reason was, but he didn't want to go until he had to go. I can remember my friends' parents all getting jobs at Mack, or steel was another big one. They all got jobs down there, even though they had to travel. [My dad] used to say it was a waste, the time you go down and the

money on the gas and the car. I don't know if he just didn't want to go out of the area or what.

I don't think my dad has been out of Pennsylvania more than six times in his whole life. We try to get him to go to Canada. He'll find all kinds of excuses not to go. Maybe it's because he's afraid of something new. He always said, "You don't want to do this." But we were getting minds of our own. We wanted to go here or there. Even to go to Allentown, for him, was a big ordeal. He didn't drive to Allentown. It's too big. "What do you want to go down there for? There's stores here," he'd say. "You can get just as good a price here as you could down there." So it was a big treat for me, if my girlfriends would ask me to go to Allentown shopping. I wouldn't have much money but I'd go because Allentown was a big deal for me; I never got there. He didn't take my mother many places out of the area. A lot of it was, they didn't have the money to go, even [to] smaller places. But if we did go it was camping.

This is funny, because [my parents and I] had this discussion yesterday. It almost turned into an argument. I said, "Where did you ever take Mom?" [My dad said,] "We went to . . ." It was out hunting or fishing, hunting or fishing. He didn't even want to visit family in New Jersey. I said to my mom, well, he was afraid to leave the house; he would never leave this area.

[My sister] worked summers with the handicapped. They had schools for them, summer camps. A lady in church asked my sister if she would like to help with their summer schools and she did. My father didn't want us leaving home. He didn't like that. My sister really liked working at the summer camps. My dad felt you had to stay in the area and work. In fact, when my [daughter] Missy was talking about going down to Northampton or getting a job in Allentown, [he said] "You can get a job around here." He did that to me too. If you mentioned school or that we had to go away from home, he found all kinds of excuses why you shouldn't go.

I never remember [my parents] mentioning college or anything to us. I guess it was because they didn't know anything about it either. [My dad] quit school when he was young, to work. They never pushed us to go to college say[ing], "You should go here," or do this or do that, like to further us. It was that old thing, like, "You could get a job around here; there's good jobs out there."

I was surprised when we got into senior year and all of a sudden I'd say, "What are you going to do after school?" One girlfriend went to be a hairdresser, the other two went to business school. Up till that point, I never

heard them talk about it. It was like a shock, [when] they said, "Well, I'm going to Allentown to this business." I never heard them talk about it before. All of a sudden they're going into this school. Maybe I was just not interested, but you never heard your friends [talk about plans].

Ken: [When I graduated, the] only places [hiring were] the Zinc Company or Bethlehem Steel. To get in the Zinc Company, you had to wait for somebody to retire. That's how the turnover was. Most of the people that were working at the Zinc Company when I got out of high school had started in the late twenties and thirties. They were all coming up for retirement age. As, say, five guys would retire, they would hire five men. They had a pretty big waiting list, and when I got out of school, I put my name in down there. Bethlehem Steel took me right away. I started at Bethlehem Steel night shift, and I asked to have the night off to graduate. I was working at Bethlehem Steel a week before I graduated, 'cause we had finished up classes, and then we had four or five days where we didn't have to go back to school. My dad took me down there. He said, "You're not laying around, you're *working*." It wasn't through his pull that I got a job; it was just that Bethlehem Steel was growing so much because of Vietnam going on. I was hired that day. The next day I went down, got my safety shoes, and I was working.

[After about a year] I came home from work, and I remember my mom saying that the Zinc called, and if you're interested in the job you should be down there tomorrow morning at nine o'clock. So I called Bethlehem Steel and I reported off, went down, and took my physical, and they said, "You start Friday." I said, "Well, I'm working down Bethlehem Steel and I'd like to give them at least two weeks notice." They said, "No problem. Finish up down there and you'll start here in two weeks." So that's what I did.

I think our generation was really the last generation to be able to get a decent-paying job with a high school diploma. It's a lot different now. Another thing, I've always held a steady job. I was down Bethlehem Steel when I graduated and then I left after fourteen months for the Zinc Company, because it was paying a little bit better money and I didn't have the travel. I've always worked down there, never been laid off.

Ruth: When I was a senior, my girlfriends had talked to some guys [who] said that this little factory, they'll hire people in the summer for a couple hours. Some of my girlfriends were going away to school and they could work till they went to school. I knew I had to do something because my

father wouldn't have liked it too much if I just sat around the house. So I went over and put my name in. I didn't know how to work a machine except I did sew at home a lot as a hobby. They took my name and I started the following weekend. On a Monday night I went over and it was just till we graduated. It was four hours, from four o'clock till eight.

Once I graduated I started full-time and I hated it. I worked anyway. I was really fast on the machine. My dad was working at Silberline. When he left in the morning I would go and he'd take me over and drop [me] off at my place. When he got out of work, he'd come over and pick me up and take me home.

That went on until it got close to September. It was just a small place, only fifteen employees. There was a couple young people working there. We wanted to get out of work for one day. We told this guy that we wanted to go down to the Tech School, 'cause we were gonna go to school, so we had to go down for interviews, and we were lying all the while! So he calls the school down there and this other kid that was working with us, he gets on and he says, "We had appointments for an interview and our employer wants to know." The lady didn't know what was going on. She just says, "You could come down at nine o'clock," unknowingly. So we all left but we went down to the school, and we were talking to them about classes, and I said about data processing. So I signed up for it.

In September I went to afternoon classes down there. [My dad] kept saying, "What are you going to do? What about the winters? How you gonna drive up there?" He was furious that day I came home. First he didn't like it that I got the schooling because then I was only going to be working half a day, and I finished the other half day down there.

I went [to] school [for a] year. The factory moved from Coaldale over to Tamaqua. So I was running over to Tamaqua, and at dinner time I'd come right home, quick grab a sandwich and go to the Tech School. I was one of the highest ones in the class and [the teacher] got me the job [at] Leader Data Processing in Valmont Park [in Hazleton].*

When I told [my dad] where I got a job he didn't like it. He thought that was terrible that I was going all the way to Hazleton. I can remember him saying, "You're going all the way to Hazleton to work." And I said, "Well, I can't get nothing in Nesquehoning with computers." So that was a big show that time. I just went and did it on my own.

[The pay in data processing was] better than the factory. I knew when I

* A city about fifteen miles north of Nesquehoning.

started down in the factory I didn't want to do that for the rest of my life. I had to do something else. I stayed up there for two years, until we got married and I had my daughter.

When Missy was born [Ken] was in the service in Vietnam. He didn't see her until she was four months old, when he came home. We moved to Oklahoma for nine months, because he was still in the service. I hated it down there, because we weren't by family. I need to be around people that I know and that I could get to in a couple hours at least. Then they decided to send [Ken] back to Germany for his last six months of the service so I came out here and lived with my parents. When he got out of Germany we bought this house and we've been here since.

I didn't work when Missy was little. [Later I tried to return] to data processing. I was a keypunch operator and verifier. I should have stayed with data processing, but I didn't have anyone to watch my daughter. My mom was working and my dad wouldn't watch [Missy] by himself. So I had to quit. If I would have been smart, I could have got a babysitter. That was one big mistake I made.

We were fortunate then; we survived on [Ken's] pay. Now, I don't know how they survive on one pay. I didn't go back to work until my son went to kindergarten half a day. I'd take him to school, and then I'd leave, and go over with my girlfriend and clean for a couple hours. Then I'd come back quick, and pick my son up from kindergarten.

Once Kenny started full-time in school, that's when I started work at the factory. I went in at eight-thirty so I could get the kids off to school before I went down there. Then I'd get home before they got home. If we were busy I'd stay and make my time up. [But most of the time] I'd be home before they came from school. My dad always wanted my mom to be home when we left for school and came from school. I think that's why we always worked it [that way, too].

When I started in Coaldale at the factory, I made hood liners. I worked [there] for about eleven years. Down here I started on single needle, working on jeans, skirts, and jackets. I did that constantly [and] got really good at it. I remember the boss coming up to me one morning—I wasn't there too long—and he said, "I've been watching your progress. Your production seems good. Every day it's going higher." They had quality control down there, and I remember the lady coming over and checking my work, and she said to the boss, "I can't find anything wrong with her work!" So I felt pretty good. Even though it's not a job that you use your brain too much, but you needed common sense, and I had the speed. It made me feel good

because I kept getting better at it. [If] they'd need somebody to do some-thing else, they'd pick me to go over and they'd show me and I'd do it. If somebody didn't come in, they'd say, "Well, let's get Ruth in." They'd put me on that and I kept learning different jobs. Then they put me on a double-needle machine. Every time the opportunity was there, they'd put me on it. A lot of people didn't want to learn new jobs.

I was asked to teach the trainees how to sew. I said I'd like to try it. Well, the boss wouldn't let me get off the machine. He said, "You have all the po-tentials for leadership, but I need you too much on this machine." I've seen three bosses come and go. With the boss we have now, we've been doing a lot of samples—jackets, pants, and shirts. The work is more difficult, work that other factories won't do or can't do. It's all different styles of only a hundred garments of this, two hundred of that, so you're constantly chang-ing. We also have a laundry room, where they bring in work from other fac-tories. They do different types of wash.

When the factory started to do double-needle topstitch on jackets, they needed more supervision and they set up different sections. I was always doing the double needle, so I was asked to supervise the double needle and safety-stitch sections. I supervise twenty-one. When we first started this it was just sample work until the work started coming in. They had the system all set up, [and] they gave me girls that were single-needle opera-tors and every now and then would run a double needle. I had to train them to run the machines. In my safety-stitch section, I had experienced ladies. They almost taught me. On double needle, I actually have to sit down and train them to use the machines. Then it's knowing who to bring in, and how many people you're going to have to do each job, and how fast we'll go through my section to get to the next; you try to keep the pro-duction line going. It's crazy—I have to make charts up, keep track of the style and what operations I have to run through. You always get the unexpected.

They'll say, "You're crazy, why do you want that?" And I say, "Well, I must be crazy, because I'm still not wanting to sit there and sew like I did!" I think it's because I'm running and I'm doing something. Although I hate it sometimes, I'm still doing it. I have a lot to learn, because it's the total fac-tory I'm dealing with now—other operations and other sections I didn't know about. Every day you're learning, but you're learning while you're do-ing it. Somebody didn't actually come to me and show me everything. No-body's there to go over it first; they don't have the time.

Growing up I always heard my dad talk about the union, so I believed in

Ruth Ansbach at the Kaijay factory, Nesquehoning, with a stack of jeans, fall 1996.

a union. When I started there, I was in the union. Now as a supervisor, I'm company. [Still,] I think the ladies are crazy if they get out of the union.° They need job security. I see now, being on both sides, that management

° The main garment union in the Panther Valley has always been the International Ladies' Garment Workers' Union (ILGWU).

could get rid of somebody real quick if they don't like someone [and] there wasn't a union.

One thing I could never understand was that you never got to vote on a union contract. You were never really informed what was happening with negotiations. You were just told everything after it was over.

We have never, ever voted on a contract. We never get to vote on anything. We have a district rep up there and she comes down every now and then and takes things back. [She] tells us a little bit of this or that and shows us, but we don't even [get to] say what we want. I don't think we ever had a meeting down there that they said, "Okay, now, what do you girls want in your contract coming up, or give us ideas, or what's the complaints?" Maybe one time that I remember them ever doing that. We just sit around and wait till they come down with what they're negotiating. It's, "Well, are we getting anything?" That's how ours is run.

Down in our factory when it comes to voting on a new rep, nobody will ever run; they're just glad when somebody says they'll go for it and everybody votes for them. Then everybody's pissed off 'cause they're in and don't prove to be too good. That's how uninvolved we are with the union. It's an attitude like, "Who cares, 'cause we don't even get to vote or say what we want on the contract." If you do say anything, they want this or that, when it comes back, well did they get this or that? "Well, no, they can't do that, because the company can't afford to pay this." Sounds like they're just hanging on for dear life [to] keep these people and get their union dues— [make sure] the place doesn't close down.

Union membership has really gone down because of the closing of the factories. Now the girls have to pay into their Blue Cross and Blue Shield, which they never had to do before. Now our shop rep will go in, [if] there's a moaning that some of the ladies in the other section get better prices. She goes in and the company engineer will be in there and explain why she can't give this price or that price. So that's all. Sometimes she sticks up for them; sometimes she doesn't. [Our] choice in who we put in there wasn't too good. But when you only have one person running, or two, you don't have much of a choice and nobody seems to care.

They're better off being in [the union], because it's job security. At least, if one boss doesn't like you even though you're a good worker they can't get rid of you. But there are some people there that shouldn't even be in the union because they don't put nothing out and I can see where a company gets pissed off. Maybe they're making a dollar something an hour and that's as high as they'll ever go. Some ladies really fool around and

don't do anything. I can see where the company could get discouraged about that.

My daughter just got married and my son's in the service. He's in Kansas. So they're on their own. I guess we've passed some of our [values] on to them because when they were through school in the summers they found jobs so they worked and they always had their own money. I see my son [is a lot like us]. It was a big thing for him, getting out of the [family], and it didn't do him any harm. He's learned a lot. But he says he wants to come back here. He knows what it's like to move away and he says he needs to be by family. I guess it's basically from being around here and having the family around all the time.

We lucked out, but the last couple years [there] was always [a] chance of [Ken's] place closing. The place has reduced from [a] couple thousand to a couple hundred. My factory isn't doing that great either. It's going to get scary when we're ready to retire, because we've seen it happen with these other people. They had so many years in Bundy, and they closed and they lost their retirement by two years, by a year, stuff like that. That's what I think is going to happen with us. [Ken] lucked out up to now. He's always worked, never laid off. We're grateful [that] we had all this while the kids were growing up. It's just us two now. If it happens, we'll deal with it.

[And pensions are pretty poor.] Even the garment industry, ninety-eight dollars, or maybe it's a hundred and ten is the most you can get for retirement. After putting thirty years or twenty years in somewhere. What could you do with a hundred dollars?

Ken: They did away with my pension and paid me off. They gave me three thousand dollars, which I put in an IRA. Now we have a new pension, this new contract we got. It's basically a 401K where they'll contribute.

I keep my fingers crossed. My first objective was to get my kids on their feet, and they are. My boy's in the service. He definitely has a good trade right there, pharmacist specialist. My daughter has a trade in the lab. Hopefully she can continue. I'm just hoping I can get another ten years with the Zinc Company, that I can put a nest egg away that we'll be able to live on, besides Social Security. That's the big thing right now. Seemed like it always came every ten years, well, if I get through this ten years . . . Back in '86, I didn't think I'd be working the following year. Missy was a senior in high school and we wanted her to go to college. Is this place gonna continue? I still got four more years for Kenny, 'cause there is four years dif-

ference between them. You know, am I going to have a job? We've made it through that. Now my wish is that I can get at least another ten years at the Zinc Company to get the money put away for retirement.

Ruth: We always say we saw it harder than [our] kids. They don't know what it's like to [experience what] my mom and dad [went] through or what we went through, when we were kids. I think they're going to suffer more when it gets like that, 'cause I don't think they can handle it.

Even now, if something happens, we always say, "Well, when we were kids we did without, and we can do without now." Everybody's going to be in the same boat, too. I don't know if that generation's going to [make it] 'cause they want everything, real quick. I can remember my mom—she never had new furniture. It wasn't until she start[ed] working that she start[ed] finally getting things new for the house. It was always either hand-me-downs, or things they'd had for a long time. Even when we first got married, we didn't rush into getting everything right away, 'cause my parents never had it. We were patient and we waited. There's things in our house that we haven't had new yet, but it doesn't bother me.

Ken: To me, it's funny. It seems like when [Ruth's] talking about her dad, he never wanted to leave the area. It seems like the people from the area that went in the service and had to go out on their own and do things on their own [were better prepared to adjust to change]. [Ruth's] dad had a busted eardrum so he was never taken into the service. He stayed right here. My dad was in the service, so when the mines went down he didn't mind looking out of the area for a job, 'cause there was nothing here. I think that's the difference between her dad and my dad.

[When] I was growing up, I didn't want to work in the mines. I didn't want to go underground; I was afraid. When the mines went down, for me it was a relief, 'cause I knew I wouldn't have to work there like my father.

But at the same token, my dad didn't have a job anymore. He worked hard. I can remember my dad working for eggs and milk, not even money, when he was helping put the White Birch Golf Course up in Locust Valley. They were just building it at the time. The people [there] were dairy and poultry farmers and they didn't have the money. My dad was up there cutting trees [and] clearing the fairways, and he was getting paid in eggs and milk. My dad picked apples up at Moue's Orchard. It was like a basket that you used to hand in front of you—seven of them were a dollar. That was

very hard work, up and down ladders. You had to pick the apple just right. It had to have the stem on and it had to be pinched off. I can remember how swollen his thumbs would be. I wouldn't want to do that.

For me, the mines went down, it was a blessing, 'cause I didn't want to go underground. If the mines would have stayed up, I would have been working in the mines. For [our dads] it was their way of life. It was a nail in a coffin, really, because you got a good wage at the mines.

None [of] my close friends went to college. One was a contractor; right now he's a car salesman. Another is the area rep for United Mine Workers. Another one works over at Hart Metals, in Tamaqua. Another close friend is a policeman here in town. He never went to school.

I'd say out of all my friends, one basically climbed the ladder of success by going to business school and is now an accountant. But other than that, they're basically unskilled. Some of the other friends that I had—their fathers were doctors or lawyers—they went to college. That type went to college. The regular coal miner's son, the Bethlehem Steel worker's son, they didn't talk about college. They talked about working at the lamp factory, or working for a contractor, something like that.

Everywhere, it was from $1.75 to $1.50 [an hour] when we got out of high school. That was basically your small factories, the lamp factory that was up here, I think they were paying $1.50. I started at Bethlehem Steel for $1.70. I came to the Zinc Company for $1.95. When we graduated, Vietnam was going on. I couldn't go anywhere to get a job, because at that time, President Johnson came down with that bill where they had to protect your rights while you were in the service. When you got home, they had to give you your job back. Not everybody wanted to hire, except the bigger places. I tried to get in the lamp factory, and they didn't want [me]. First thing they asked me was my draft classification. I said, "It's 1A." They didn't even want to talk to you.

Hardly anybody knew what they were gonna do when they got out of school because at that time Vietnam was really starting pretty heavy and just about everybody that got out had that classification of 1A. I was a little better [off] because most of [my friends] already had turned eighteen as we got out of school. I was just turning eighteen. I went in the following year. I was down Bethlehem Steel about fourteen months and at the Zinc Company two months when I got my draft notice. The recruiter called me: "What do you want to get drafted for? Why don't you at least get some education out of the service?" I went over and talked to him and took three

years. At that time, computer missile was really coming in and my training was on the Sergeant Missile; it was all computer activated and stuff like that.

When I went in the service, I was scared of leaving, because I had to go to Wilkes-Barre. I had to catch a bus all by myself. They told me where to be but that's the only help I had. I found my way there. I left from there and went down to South Carolina, but again, there was four or five of us then, so it was all right. I was traveling, and I learned how [to] go different places and meet people and I think that's the big thing the service does for you.

I was over in Germany approximately three months, [when] I come down on [assignment] for Vietnam. They didn't have any missiles in Vietnam with nuclear capability so I ended up as an artillery crewman. From there, since I had the training with radio and computer, I ended up on recon[naissance]. I was a private [and] was promoted very fast in the service. I was only in the service a year and I was a buck sergeant already.

I work[ed] with different people and through getting promoted to a sergeant I was in a leadership role, which I never had in my life before. It taught me how to treat people. Right now it bothers me 'cause I'm just basically a common laborer. I see a lot of people coming in out of college as bosses and they have no leadership role whatsoever. They have book knowledge and everything else, but they don't know how the job runs, and they don't know how to treat people in that respect. There's a lot [of] animosity, you know, that he's coming in, he's just out of school, and he's making a lot more money than me. The thing is the way they try to get you to perform your job. It's like putting food in a dog dish and throwing it at the dog and saying here's your meal, don't bother me.

Where I'm working now, you don't bid on jobs, you're promoted. I have company time, but in the division, I am a junior employee with time. I went in as a second helper and they seen that I had a little bit of gray matter, and they were putting me out on jobs where they already had operators. They were putting me on the job, because they knew this guy couldn't do the job, yet I wasn't being promoted. They would step me up to that operator rate until the job was done, and I was just coming back, at a lesser rate. One guy I was working with—he was the operator and I was his helper—he couldn't set a job up or nothing. I was getting very frustrated because I was setting the job up and everything and he was making the money! It would be basically fieldwork: going out in the plant, running surveys, taking samples, running different machinery that just came in. Once we got it perfected then it would be handed over to regular workers

[who] would work that job. It would be all experimental work and stuff like that.

That's basically the work that I do, and right now I am still not an operator. It's frustrating, because when I finally made assistant operator, another guy was promoted, because he had seniority on me. I can understand because I'm in the union and this is the way the union is. The older man gets promoted. I'm a union official, but sometimes I get very disgusted with the union. It's not what you know, it's who's in front of you, put it that way.

But I'm strong union, I'm very strong union. I'm a shop steward. This is where I got into my leadership role, through the union. I feel that I'm leading these guys that we work with. I'm representing them as a shop steward. I also am an officer with the union—not a high officer—and whatever leadership I can contribute there, I am doing that way, even though I'm not basically doing it on my job.

[Where there's problems] it's not the local, it's our international. We had a strike in 1984, and we were out for about three weeks. [The company was] advertising our jobs in the newspaper. The head of our district was supposed to come in and explain that the company couldn't do this. They just couldn't fire us outright. I got a telephone call from my brother-in-law and he said, "You have to make the meeting tonight. The union rep will be there and he's going to explain what the company can and can't do. What they're doing right now, basically, they can't do, 'cause we're not on strike long enough." I got a phone call about ten minutes later from one of the guys I work with. He said, "Did you hear about the meeting tonight?" I said, "Yeah." And he said, "Michele is gonna come back and he's gonna tell us we gotta accept the contract"—the one we already voted down. I said, "No, he's just gonna come and tell us what protection we have and explain everything about the strike." There was a lot of confusion because it was the first strike in twenty-five years. This was our first experience. He told me a lot of stuff on the phone and I was very mad. Before I hung up I said, "Where'd you get all your information?" He said, "I got it from my other buddy. One of the bosses at work told him and he called me." I went to the meeting that night, and what that guy told me was exactly everything that our district rep told us. I was very frustrated. We were sold down the drain.

They should have been negotiating. They shouldn't have been pushing us back to work. There was a payoff under the table. From then on I have no confidence in the international [or] the district. Once it gets out of the local, I have no confidence whatsoever because whatever the company and

the district negotiate, and whatever is paid under the table, that's what we got to abide by. It's not right, because now I'll tell you my feelings about union dues. I pay car insurance, I pay life insurance, I pay just about every insurance there is, and I also pay work insurance, and that's what it means to be in a union today. You're paying insurance for your job. If the boss don't like you, and you're not in the union, you'll be out that gate quick, because there's nine hundred guys out there that will work that job in a heartbeat. There's a lot of guys that don't have jobs, or are working at low-paid jobs, and believe me, they're gonna come in, for the bene[fit]s and the money. And you're out. Okay, that's why I believe in unions. I don't believe in districts [or the] international. They're way over the working people's heads. They're there for one thing—how much they can fill their pockets. They're not there representing me, they're representing theirselves. Your local union is the one that backs the guys.

We negotiate our contract. We elect people for the bargaining team. They sit down with our district rep. They are the ones that do the negotiating with the company. The district isn't involved, and the international isn't involved unless there's a strike—that's when they come in.

What really makes me mad is I'm paying a percentage of my pay towards union dues, and the percentage that the local gets back itself is unbelievable. I mean, we own our own building down in Palmerton. That local bought it. The international didn't buy it. Our membership was down so low at one time, that we had a "for sale" sign on it. We weren't getting enough money from the international to keep the heat going through the winter. In fact, we have a part-time secretary.

The international and the district send me a United Steel Workers [newspaper] every month. All they do is brag in there about their conferences and everything else, but when it comes down to the small locals, they don't care. The only thing they're worried about is getting their share of dues, so they can have these big conferences in Arizona and Las Vegas. They're not with the working people. Instead of them making eighty, ninety, a hundred thousand dollars a year because he's president or he's recording secretary, they should be making twenty-five thousand a year like I am. That's what they should be making. Maybe they'll get down with the grass-roots people, the people that's paying to have them in there. They're not representing us at all. They really aren't.

I had my chance once to be on a negotiating committee but we always go to Canada in July and that's when our negotiations are going. I was

Ken Ansbach with his dog, fall 1996.

pretty proud because the guys voted for me. That was the contract of '87 and I turned it down because I'm not going to give up my vacation. That was one thing I would like to be involved with, but the people we put in are good people.

I'm a shop steward because when a problem would arise and I would go

to the shop steward who was representing me, I'd always get double talk or, "Yeah, they can do this." Then somewhere down the road I'd find out they can't do this. So I got tired of being represented by people [whose] only reason [for] holding the job was super-seniority. In other words, if the division went down, they'd be the last person going out regardless of how much seniority they had with the company on the job. I didn't take it for that reason. I took it because I got tired of going to people and finding out nothing. So I thought, "If you treat guys right, and you have the answers for them when they need them, with health problems or anything like this, you're doing your job as a chief steward, and you're protecting them." So I ran against the guy and beat him without any problem. I've been a shop steward twelve years. Nobody's ever run against me, and everybody I've represented, I've represented fair. If they definitely had a problem, we always got it straightened out. The people show respect for me and basically that's why I went in as an officer. The union is only as good as the people that's in it. If you have people running the local that really don't care about the workers, the workers aren't gonna care about the union, and you're not gonna have a strong union.

Right now, the officers we have are representing the men. If a problem arises, it gets straightened out. The answers are found out and the men are told. The local is really good. It's the international and the district that make people say, "Well, what's the sense of paying union dues because we never get anything." Yet, you are getting something—you're getting job protection.

Coming back to [what Ruth] was saying about people that are lazy and aren't doing their job, I always get this whenever there's a problem and I have to go into the office. I don't go in [by] myself; I always make sure there's someone with me as my witness. Thirty days it is now when you start as a new man to get in the union. That's thirty days that the bosses have a chance to watch this guy in action and see what he can [or] can't do. They always say, "Well, this isn't enough time." Believe me, when a guy comes and works with me, after a week I know if he's gonna be a good worker, [or] if he's just gonna lay back and just collect his paycheck every two weeks. That's plenty of time to weed workers out that aren't up to their standards. But they always use the excuse, "He's in the union and we can't do nothing about it." That's just a big cop-out. It's because they're not doing their job. If they get out of the office and see what's going on, they'd be able to evaluate the guy. The union takes a bad rap on this.

I've gone a lot further than my father has as far as providing for my kids.

I definitely took a giant step. The thing is, I've always held a job. He had that problem—everything was shutting down. I feel good about that and I know my kids are progressing a lot further than what we did.

[Kids] really have it tough right now. They can't even get jobs when they come out of college. My daughter works as a lab tech, in the Quakertown hospital. The last two years she's been worrying if they're going to close down, or make it into an elderly care place. They're cutting their staff. She's going down further and further where she can't do her tech work. She's doing paperwork, because they won't rehire the ones that quit because [of] all the cutbacks. They're growing up learning that there's nothing you can depend on or have for twenty years.

The [Panther] valley itself, I think it's been the same up to maybe the last ten years, and there's been an influx of people moving in. You don't have your close-knit families. I don't know half the people that live on Coal Street. I'm not blaming the people that are moving in 'cause of the crime and everything else that's going on but it seems like there's a lot more that was never here before. When we first bought this house, we never locked the doors. I wouldn't go anywhere now without locking them. I just see it, by the influx of people that are coming in—not necessarily that they're city people or anything.

I'm not a really religious person, but I do believe you should go to church. I think that's one thing that's wrong with America today. The kids are being brought up and there's no religion whatsoever in the families. It's either the single parent or somebody else is watching the kids, and there's no time for the family to get together and worship. That's one of the big things today, why you got the problems you have. There's just no religion in the family.

This area was highly religious. I can remember everybody went to Sunday school—went to church—when I was a kid. I won't say that today. That's the big change. Now, you don't have the people going to church like you used to.

Ruth: When I [was young] I didn't worry too much about [the mines] closing, because I figured my parents were going to take care of me. But it hurt more than I realized. I wasn't getting nothing for Christmas! I could see them worrying and fighting over the money and that bothered me. I guess it just happened and maybe that's what it was supposed to be, but it did change the valley. When [the mines] closed, people left [and] a lot of the smaller stores closed. People [asked], "Where are you working?" Every-

body, "Oh, my father works in Allentown." So that changed the valley right there.

I hate to see the mines—the coal banks and stuff like that—because of the environment. I guess if they were running, the mines would be a lot different, a lot safer. There would be more jobs around here. Or maybe not—they need less people to work them now, right? Somehow they have them modernized?

I don't know if it would really help us. I think the valley's becoming a retirement valley. Most of the people that moved away are coming back. There's a lot of older people. The banks are loaded on Social Security day. It's a nice place to live because it is quiet. It's not quite as bad as the city.

If it's going to be a retirement place, you don't need that much stuff. You're getting your checks all the time; industry doesn't have to be here. That's what it's probably going to turn out to be. I just think you gotta go places for jobs now anyway, no matter where you choose to live. My daughter's in Allentown. She still has to travel twenty minutes. Now, if she loses that job, she's gonna have to travel maybe to Philly for the job. I think you gotta travel no matter where you go. Kovatch is there. He's the biggest industry in town. But I don't like to see the ground ripped up or anything like that anymore. I think we're beyond that, somehow.

Grant and Irene Gangaware by their home, June 1996.

Grant and Irene Gangaware

Grant and Irene Gangaware lived in the Panther Valley all their lives, and they knew coal. Grant's grandfather was a janitor at the main office of Lehigh Navigation Coal; his father worked as a mule driver in the mines when he was young, but settled into a career as an inspector for the Lehigh & New England Railroad, the coal company subsidiary that transported coal to urban markets. Grant himself worked in the company's forestry department and its coal storage yard. Irene's father worked for LNC from the age of eleven until the mines closed in 1954, beginning as slate picker and finishing up as a contract miner.

When the mines closed, the Gangawares stayed in the Panther Valley. Irene worked in garment factories; Grant worked at a lamp factory and then as a security guard. Finally he landed a construction job that required him to travel all over the country installing floating roofs on oil storage tanks. His wife and family remained in Lansford. Grant served as construction foreman until a heart attack and lung problems forced him to retire at age sixty-three.

I met Irene Gangaware at the August 1993 dinner honoring the Last of the Panther Valley Miners. She had enormous respect for the former miners and the mining traditions of the valley, but she had to complain about the exclusion of the surviving widows of miners from among those honored at the annual dinners. She tended the flowers around the miners' monument in downtown Lansford, but felt that women had contributed to the community's survival in hard times and deserved recognition as well. Her acid wit reminded me that there were women's as well as men's stories to be preserved, and she was the first woman I interviewed for the project. She passed away three years later, after battling cancer.

Grant Gangaware

Lansford May 17, 1994

I was born February the twelfth, 1919, in the five hundred block on East Bertsch Street in Lansford. My dad's name was Emanuel and my mother's name was Ella. My father was born in Lansford and my mother was born in Lynport, Pennsylvania. I'm not positive [about the] background [of my] grandparents. [As I was growing up] our grandmothers were dead. I can remember one grandfather. He was a janitor at the main office in Lansford, but he was a wheelwright by trade. I don't think he ever worked in the mines. My dad worked in the mines during his younger years, as a mule driver, [but] he was a railroader when I was born.

My dad worked for the Lehigh and New England Railroad. He was a car and air inspector, and most of his work was at the Summit Hill stripping, but he also worked at the Lansford yard and at the Hauto yard. They would inspect trips when they come in empty to see that they were in good condition for loading, or after they were loaded before they were shipped out to make sure the cars were in good condition, air hoses in good condition, the journal boxes packed, and so forth. Any safety appliances or equipment that involved the railroad car had to be checked.

We had a large family. I had three brothers and three sisters. I was the oldest of the brothers and I had two sisters older than myself. The brother that would have been oldest drowned when he was two years old in the sewer at the corner of Leisenring and Bertsch. When they were installing the sewer, his ball went into the sewer, and when he moved the board to get over he fell in, and they didn't find him till a few hours later. He was two years old at the time.

There was seven of us and it seemed that Mom had more to do to keep us just in line, the seven of us. We weren't born that far apart, and she was a very good mother, you couldn't have asked for someone better, but I don't think that she really had the time to get involved with church. I'm sorry to this day that it had to be that way.

I attended public school in Lansford until the eleventh grade and I quit against the wishes of my mom and dad. I hated school, and that was one of the reasons that I left. I was the only one in the family that did not gradu-

ate. It was hard in those days. It was during the Depression, and I thought if I could get a job, that I could help out and get the other ones going and get them through school by adding a few more dollars that I earned in the CCC camps.

I went into the CCC camps in the fall of 1935. I stayed in there for a year and came out the fall of 1936. I was in Huntington County, Pennsylvania, small place by the name Haitch, or Paradise Furnace. We done reforestation, road construction, road maintenance, strung telephone lines, and various other jobs that were connected with forestry and outdoor work.

When I finished my first year in the CCC camps, I came back to Lansford, picked coal, cut firewood, but there weren't any jobs available. I stayed around for a year and a half, and instead of becoming a bum I went back into the camps and put two more years in at Lock Haven, Pennsylvania, where I done forestry work, reforestation, fought forest fires, worked on bridge construction, state roads, private roads, some of your dams, [and] a few of the state parks that are out in that locality.

I could have stayed in the CCCs, but that was a dollar a day, so you were making thirty dollars a month. When I first went in you got paid five dollars and twenty-five dollars was sent home. They raised that later on, [so] the man that was in the CCC camps got eight dollars a month, and twenty-two was sent home. Out of that you bought all of your own supplies, soap, tooth powder, toothpaste, cigarettes, whatever toiletry necessaries you needed or wanted. I became a leader when I was in there—assistant leader first [at] thirty-six dollars a month. [As] a leader I got forty-five dollars a month.

I went into [the CCC for the second time] in spring of 1938. I come out in spring of 1940, and I was promised a job with the Lehigh Navigation Coal Company, forestry department. I started with the forestry department in April of 1940 and worked until the latter part of May 1942. At that time I went into the Army Air Force. I took my basic training at Keesler Field, Mississippi, went through aircraft and aircraft engine mechanics school at Keesler Field, and was held back as an instructor in aircraft engines and aircraft mechanics. We taught students coming through the schools. We had all different branches from hydraulics, electrical, propellers. I was in one of the final phases of the school, which went up to fifty-hour inspections that we taught the students.

I had been told that I wouldn't get out of there, but I left Mississippi. [After] two years I went out to California and was reassigned to an airfield in Tonopah, Nevada, where [they offered] final-phase training for crews that were going overseas. From there I was shipped to Salt Lake City,

Utah, and [then] to California in the earlier part of '45, and was shipped overseas to the South Pacific where we unloaded troops at Leyte and Luzon. From the Philippines I was shipped [to] Okinawa [where] we were cut out for invasion of Japan, but the war ended, so instead of invading we just occupied. I spent six months in the occupation of Japan and was discharged from Indiantown Gap, Pennsylvania.

I was discharged February the sixth, 1946, and servicemen were discharged at what they called the 52[-20] club.* They allowed them fifty-two weeks of payment. I don't recall what the payment was anymore. My foreman told me that he didn't want me to be one of those bums that were hanging around and collecting. He said there was work for me and he wanted me out, so I only stayed home a few days and I went back to work with forestry in February, the same month I was discharged. I stayed with forestry until 1951, and there was an opening in the storage yard over at Hauto where they stored excess coal that was mined. Instead of paying demurrage† on a car, it was taken over and dumped on stockpiles. When they got a demand for it, it was reloaded and shipped out. I stayed in the storage yard until we closed down [in] 1960.

When I didn't have work in the storage yard, I worked inside No. 9 mine. I done loading on the fourth level of east side. I done cleaning roadbed, labor work. I worked with the brattice man, closing airways and opening different sections of airways to pull smoke or gas from different sections. I worked with a pipefitter and we'd go through these different passages where there were pipe leaks and we either put clamps on them or changed the pipes that were broken or rotted away. They carried either water or compressed air for drilling in the chutes.

[One time] we were down at No. 9 on the fourth level, and there was smoke hanging in the gangway and gas in the chutes. They wanted to brattice off one section of the airway so it would pull more out of the section where the smoke was hanging. Another lad and I—he was the brattice man, I was his helper—got all the material to the place where we were gonna close this area off, and [then] he said to me, "You be sit here and hammer on the plank." He says, "I gonna go for a walk. Anybody walking in the gangway down below gonna think we be working." I got tired sitting there, the air almost blowing your hat off up in there. So I started nailing plank on, and putting the burlap on to get it closed up, so we [could] get back down out of there. When he come back, he was madder than the devil

* It was $20 a week, so the club was called "52-20."
† Demurrage payments were charged by the railroad when loaded railroad cars of coal remained on the side tracks because there was inadequate demand for coal to ship it out.

at me. He says, "I not gonna work with you no more. You don't know how to work." I says, "Good, I don't want to go with you anymore, neither."

Well, if he was assigned to that job, instead of hurrying up, getting it done, and going back and getting assigned to do another job, he probably figured he'd spend the day on that job, where I'd rather been out of the airway and down in the gangway where it was warmer. There was some stories, some comical ones that went on in different areas.

I've worked loading coal. One time I snuck up in the battery 'cause the chute was empty and there weren't any miners in for the last trip to be loaded. I snuck up and I [crow]barred and when I heard the coal start down through there, I figured I was never gonna come back out with all the noise and the rush and the dust. When I got back down at the bottom, the trip wasn't there, they went out and loaded somewhere else. I had to wait for them to come back for me.[*]

You took a bar and at the battery if there was a big lump of coal that was too big to come through the battery, or there was two or three lumps stuck together there, you take the bar and you'd pry around until you got one started and sometimes when it would start, it would fill the whole chute up.

You used [a] regular crowbar to bar. That had been the first time I done that. It scared the devil out of me. I wasn't supposed to be up there. We weren't supposed to go into the chutes without a safety lamp. We didn't have any safety lamps with us. They usually required a man that was classed as a battery starter to get the coal running out of your battery down into your chute. You had a check down below that would stop your rush of coal, and below the check you had what they called a dirtboard, a board that slipped between two other boards that you had nailed on each side that you raised and lowered to let your coal into the cars.

You had a car in there and you also had to scoop. Sometimes the place was so dusty that you couldn't tell whether the car was full until you heard the coal dropping over and hitting on the drawheads.[†] [Then] you knew the car was full. If you done that too many times, you got the shovel and scooped up the mistake that you made.

I worked with a pipeman, a buddy of mine that used to work in the stor-

[*] Grant Gangaware here is describing the sensation of prying coal loose above the chute, so that it runs down to the blockage at the mouth of the chute. He climbed up into the battery, the area above the chute in which coal collects after the miner has blasted the working face. Although classified as a laborer, he tried out the work of a battery starter, a more skilled and experienced mineworker, and got something of a scare. The battery starter had to have miner's papers, because he used dynamite to break up coal and rock and get the coal moving down the chute.

[†] Drawheads are the couplings on the coal cars.

age yard. Him and I worked together inside at times, changing rail that were broken. We tried to wait until the trip would go in, pull the old rail out and get another in, before the trip would come back out again.

You'd have a broken rail or one with a flange worn off. You'd get that all set up, so many spikes pulled out before the trip would come in, and then when it come out loaded you were supposed to have that rail back in or else make sure you had that trip stopped before it got that far. I done a little bit of everything in there. I never done any actual coal mining though. [To do that] you gotta be tested and all—work a certain length of time, and got mining papers.

The Lehigh Navigation Coal Company, at that time, owned a lot of ground. We used to get up into the Pocono area, where Split Rock Lodge is. That was built by the Lehigh Navigation Coal Company. We done landscaping up in that area, and fought fires far up into the Poconos. We cut our power lines that went to collieries. Every second year we used to try to get over our lines, to keep the brush cut on them, and if there's any trees that were overgrown, where they'd get in danger of damaging the wires, we had to take the trees down. If the lumber was salvageable, or was close enough to the road, it was hauled back into our sawmill to be used at the mines for timber.

We had some places that we would timber out and cut our timber, the nine-foot gangway timber or the seven- and six-foot chute timber. We cut eleven-foot poles and five-foot laggings for either the gangway or the chutes.° But there wasn't too much of that done by the Lehigh Navigation Coal Company. Most of their wood, lumber for the gangways or chutes, was brought in by rail, and they had sawmills that would cut this to the proper lengths.

In the Hauto storage yard we had eight trimmers.† It was built on a pyramid style and it had a scraper line that would take your coal. The coal was dumped into a pit from the gondola and it went onto a scraper line and it was taken up this scraper line and piled.

[These] were metal scraper lines. You had a certain amount of breakage when doing this, but we used to keep pans under our scraper lines so that [the] droppage of coal wouldn't be too far, that it would break too much of our coal. When they would get an excess amount of pea coal we would dump pea coal or chestnut or stove coal, whichever. We even dumped the

° Laggings are lengths of timber used to support the walls or roof.
† Each trimmer was an inverted, V-shaped steel structure above the piles of different sizes of coal in the company's coal storage yard. On one side a scraper line carried coal up to the top of the pile, and steps provided access for maintenance. The other half of the trimmer supported the scraper line.

number four and five buck, which had to be washed out of the car by hoses and used to slop up pretty good, but we finally got it piled. That's the fine coal, more like silt or dust. I guess they called it silt.

If they had an order for loading coal, they had a machine that took care of two piles. It ran on rails and rollers and was driven by cables from an engine house. You had an operator that would turn the wheel one way to move your reloader to the left [or] the right. We could load chestnut coal on one side, or pea coal, or whatever was in the pile next to it. Railroad tracks came up and there was a tower with a chute on, and you had a man up there [who] controlled [the] amount of coal that was put into these cars.

The fellas that I worked with were mostly an older crowd. They had a little bit of broken English with their talking. I was a Protestant, and a few of them were Catholic, and they'd see me eat on a Friday, and one old fella used to say, "Grand, you're gonna go to Hell," he says. "You eat the meat on a Friday." So I figured I'm gonna get squared away with this guy so I watched his dinner can and I saw how his sandwich was wrapped. I had a sandwich made at home, took it to work, put it on top of his dinner can on a Friday morning. He got about three-quarters of the way through the sandwich, and someone must have seen me or knew that I'd done it, and they were laughing, and he couldn't understand why they were laughing. He told them, "Honest to God, I never eat the meat on a Friday." Well, the first thing, he headed for the shanty door and he started spitting things out. He come back and looked at me and he says, "Grand, I know you be do this, I hit you on the head with the hammer."

There was other incidents. We had one lad liked his alcohol a little bit. He'd come in the morning with two neckties on. He used to mostly [do] light work, like pinching cars to get them started into the chute if they were stuck. Some of the fellas used to have to go up these trimmers—we had four trimmers, ninety feet high and four were seventy-five feet high—and in the winter time the steps were icy. I offered one day, told the fella, the older of the lads that was working with us, I said, "You go down that piece with the rest of the men. I'll run up and turn the grease cups down and oil bearings up." He gave me the devil. He thought I was gonna take his job. That was the end of me trying to help him out, take a load off his back or being afraid that he was gonna fall down the steps.

I guess they were born in the Hauto Valley, a lot of them, or probably over in Europe, Czechoslovakia, and came to this country at a young age, and most of the people that they lived around spoke the language, and I guess they never got where they would get away from the language itself. It was interesting—[not] that you had a hard time understanding

them or anything like that—it was just some of the things they said was comical.

That [area] is a housing development at the present time. That would be west of Lake Hauto, approximately two mile. It would be west of where [the] Tonelli Plant is now, between the Ametek building and the old Tonelli battery reclamation plant.

It really didn't matter [whether you worked in the mines or above ground]. We used to have a very good relationship in the Valley with the different people. It seems now that people are more distant than they used to be years ago. You never had to lock your doors. If people wanted to borrow a cup of sugar or a glass of milk, the doors were open. They'd just knock and come in; everything was neighborly at that time in comparison to the life that we have today. You could walk these streets any hour of the night, without any fear of running into a problem.

When I was with forestry we didn't have a union. It didn't come under the production of coal. Forestry work was spring to fall, and then in the winter we'd do various jobs, wherever we were assigned at the collieries. Our wages weren't up to union wages on forestry. We didn't have union backing, but when I went to the storage yard, then I got the union. I belonged to No. 9 local at the storage yard, and that's why when there was work at No. 9, two of us used to go inside the No. 9 mine, and the rest of the men they worked at No. 8 colliery.

I used to go to a [union] meeting once in a while, but I never held office. I wasn't that much involved with them. We paid our union dues. That was always required of you.

[While I was working in the storage yard I met my future wife, Irene Uher.] I met her in 1950 [at] a picnic in the east end of Lansford. The Slovaks used to have a picnic ground up at the east end, Sokol Grove. We used to have picnics up there on Saturdays and Sundays in the summer, weather permitting. I met her up there one night when I was at the picnic and asked her if I could take her home and she told me yes, so I took her home. We started dating after that.

Nineteen-fifty-two is when we got married. I was thirty-two years old at the time, getting to be an old man so I thought it was time to settle down. I never had a problem with her parents [or] my parents. As a matter of fact, my parents were at the wedding reception when we got married. After that, never had a problem as far as their family and our family was concerned. There was no interference with religion or ethnic backgrounds.°

° Grant Gangaware makes these comments because his family was Protestant and Irene

There was a period when things were slack—we were down for a few months [in] 1955—I worked for the Pennsylvania Turnpike as an inspector for the Turnpike Commission. I worked on the fill below Quakertown interchange for about two weeks, watching the contractors [to make sure they were] obeying the law of the turnpike that rock were only supposed to be a certain height or else they had to smash them. Your fill had to be compacted to six inches. Then I was shipped up to a batch plant that was run by Allegheny Asphalt. Our job was to run gradations on material; the sand [and] stone had to come up to certain gradations or it was condemned.

[After the mines closed] there was a lot of people here—buddies that I worked with on forestry—that left. One went to Jersey, to Johns Manville, some went to automotive plants, and some went to Bethlehem Steel. Any place that they could get work they went, [even if] it meant moving out of state. It was really rough around here, I mean, everybody complains today about sometimes one little plant will shut down and there's a big rumpus about it. But when the valley went down with the mines, that meant the whole valley, from Tamaqua, Coaldale, Lansford, Summit Hill, Nesquehoning, and there was people from Jim Thorpe, White Bear, that this was their livelihood. It was just a big blow to the valley.

If you got into Bethlehem Steel or [the] automotive industry, they were all unionized and they had good benefits and their wages were good. The job that I took, I wouldn't say it was a top-notch job, but it was steady. The paychecks came home, I didn't get them on the road, my Missus got them. She took care of the home front.

Dad had already retired from the railroad when the mines shut down. The whole family stayed in Lansford with the exception of a brother that moved to Denver and worked for Continental Airlines. Then he went into a moving business of his own [and] into real estate.

[My youngest brother] worked at No. 6. He was a blaster on the rock chute, where the rock came down, [was] loaded into cars, [and] hauled out to the stripping. If they got rock in there that were too big, he used to do the blasting. [When the mines closed] he went to work with Silberline in Lansford, a paint pigment manufacturing plant. From there he went to the Pennsylvania Turnpike, where he became a foreman until his retirement. The other brother that was next to me, Harold, he was a railroader. He worked on a railroad until the company closed down.

[After] six months [the mines reopened and] we went back to the stor-

Uher's was Catholic. Irene Gangaware also comments on their religious differences at several points in her narrative.

age yard again. What coal was in there had to be loaded, so we used a bull-dozer. I ran a bulldozer to help clean the piles, get them scraped together, push it into the scraper line, got the rest of the coal that was in there cleaned up. After the mines closed completely and my work was done with them [in 1960], I went on unemployment compensation for awhile, then I worked for Carbon-Schuylkill Industrial Commission for a short while, and then started when the lamp factory moved into the Lansford shop yard. We had to train six weeks at no pay. You collected unemployment compensation while you were training, and if you came up to par with those people then they held you; if [you] didn't, they released you. I was held on as a metal man, making the metal parts for lamps, bending the metal, making jigs for the bending metal, and the drilling and the tapping and the sawing. I became a lead man in the metal department. Some of the older fellas had left and gone back to New Jersey and New York where the lamp factory came from originally.

They brought their own people in to get it started, and some of them did stay till the end, but some of them left, and we worked for a dollar and a quarter an hour with this outfit. We had quite a few arguments there. That was a non-union plant at first, and they were trying to put different unions into it. There was a lot of disagreement on which one would come in, so we finally got the International Brotherhood of Electrical Workers to take command of it. We still stayed at the low rate; we were by no means paid electrical workers' wages.

Majestic Lamp Factory folded up in the shop yard and then went back into business in Coaldale. He's still there; it's called Elk Lighting now. Ebenstein was the man's name. [When I worked there it was] in the old Lansford shop yard. It was in the storage building. Previous to our going there it was a shoe factory. Silberline owns those buildings now.

While I was working there I'd been approached by a detective agency, Dan Zeigler. He asked me if I would be interested in working for him, which I thought I could make a few dollars on the side. So I went to work for him. I worked Split Rock Lodge in the Poconos, Big Boulder Ski Area, and Jack Frost Ski Area.

We [also] done security work at Quartite, a lamp factory in Hauto, at Ametek, [and at] Pottsville Wire and Rope. Wherever they wanted a guard, he would send you, or if it was three shifts, you went on different shifts.

At the lamp factory I worked five days a week. I'd come home from work Friday evening, I'd change clothes, and I'd go up to Split Rock and stay up there until early Monday morning and I would leave and come back home

and start working in the lamp factory Monday morning. In other words, I worked a full weekend up there.

I done that job until [Zeigler] took a contract to install aluminum floaters and decks and roofs on oil storage tanks for an aluminum plant in Nesquehoning, Canalco was the name of it. That was a big contract. I went out on the first job [in] Atlanta, Georgia, worked that job and then went to Fort Lauderdale, Florida, and later on I was made a foreman and had a crew of my own. We ran the whole Eastern seaboard from Florida to Maine, as far as Ohio and Kentucky. In 1977 he went out of business and we had another contractor locally, Kovatch from Lansford, that hired me on as a foreman [for the same work]. His work was mostly South and Southwest. I worked Mississippi, Texas, Oklahoma, New Mexico, and Louisiana.

I had some good men. Sometimes you had to [pull] them out of bed in the morning or you couldn't get them out of bed, and you were under contract for a certain length of time to get a job done, and usually the boss was raising the devil if something was taking too long. In other words, I was a babysitter for some of them, but I had some real good men, didn't have any problems.

Once in a while they'd get drunk and get in jail or get in a brawl, and I used to have to bail them out. When you're out of state and get into trouble, you get into more problems than just being local, because you don't know anybody and they don't know you and they're gonna try to put the hammer on you. But otherwise, it worked out. I used to try to eliminate the bad ones. One lad was a great roller skater. And he could do flip-flops on skates, and he'd get on the dance floor one night in Texas and the manager asked him to leave [but] these people didn't want him to leave, they were clapping and egging him on. So the manager called the cops and they locked him up. I went to bail him out the next morning, but they had moved him from that jail down to Houston, and it was raining the morning that I got down there to pick him up, and I paid his fine and he [had] no shoes. I asked him where his shoes were. He says, "On the back of the truck back at the motel." So we walked down the street barefooted. But otherwise, it was like any other construction outfit. You get the good and the bad.

I started with Zeigler in '65 [and] worked till '77. [With] Kovatch I worked from '77 till out on the road I had a heart attack going to one job, and after I recuperated I went back out and I worked with him till '82. After the heart attack, I was having chest pains and I went down to the hospital in Lehighton and the doctor found a spot on my lung, so he sent me to Allentown. They didn't know what it was, so they removed the upper left lobe of my lung.

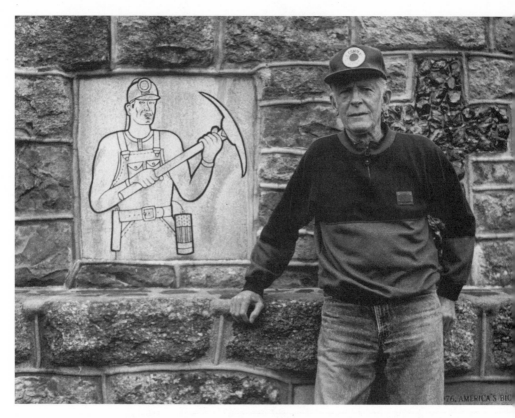

Grant Gangaware in front of the Miners' Memorial, Lansford, 1995.

They was afraid it would go from there to the brain, because they didn't know what it was. But after a test, they found out it was histoplasmosis, which is common in the Southwest. As a matter of fact, in California they call it the San Joaquin fever. It could have been treated instead of being removed. Bird droppings and soil cause the disease; where I contacted it I really don't know.

[On that job] I used to go take the crew up, and sometimes you were gone two weeks on one job and you were back in on the short haul. I worked tank yards in Philadelphia—Arco, Sun Oil—Delaware, New York, New Jersey. Sometimes you were gone a month, but one time I recall I was gone seven and a half months before I got home from [the] Southwest. I was getting pushed from one job into another. Instead of bringing you back, he wanted you out there and keep on going, making a buck. It was seven and a half months I was gone one time, before I got home. So I didn't spend the time raising my children; it was my wife that really done that.

My children were brought up as Catholics. They attended Saint Ann's school in Lansford until the eighth grade. Then they had their choice of

either going to Marian [Catholic] or to Panther Valley and they chose to go to Panther Valley. They were not forced in any way to go. They thought Panther Valley had a better football team than Marian. That's why they wanted to go to Panther Valley.

We've had a good relationship all the way through with [our] daughters. We still have the same relationship today. We haven't had any arguments among each other about doing this or [that]; as long as they were happy I was happy also. Their mother was a little bit more strict than [I] was. [She] used to have the hammer down, always. I think she still tries to do that today. But we all have a good relationship, mother and father and daughters, sons-in-law; we get along good. Grandchildren are all great, no problem.

In the beginning, if I would have gone into it early enough I think I would have been interested in mining rather than laboring. I think there would have been a few more dollars involved than in doing laboring work. Well, it wasn't easy to get work in the early forties. I was only too glad to be able to have a job with forestry. That's why I took the job.

I had crews of my own. I had a fire crew and then had road crews I would take out. You usually had a foreman with you but if there wasn't a foreman there, you were hauled out by a stake body truck. When you come back in you'd have a foreman out to inspect your work, or run by every so often to see that there wasn't any problems.

[At first we earned] about forty-nine cents an hour. It wasn't very high. It was a job! The cost of living at that time wasn't the way it is today, neither. You couldn't begin to take a job now at forty-nine cents an hour and expect to live. 'Cause you could go to the store with a five-dollar bill and come home with a few bags of groceries, where now you come home with a pocketful.

My rate [of pay] increased [at Hauto storage yard] due to the fact that I worked inside No. 9. When you worked in the mines you used to get what they called travel pay. They couldn't pay me travel pay in the storage yard, so what they done, they increased my rate to a carpenter rate to compensate for the travel time that I would have gotten. I was above some of the older men that were in there. They didn't see my paycheck so there was no argument about that. I wasn't hiding it.

I've got the black stuff in there. I was denied [compensation for] black lung or anthrosilicosis for the longest time. When I had the upper lobe of my lung cut out, the pathologist report showed that there was anthrosilicosis, and I was still being denied it until my lawyer wanted a deposition from the doctor that was denying it to me. When he saw the paperwork, he said he didn't know that I had this paperwork. Eventually it came through for me.

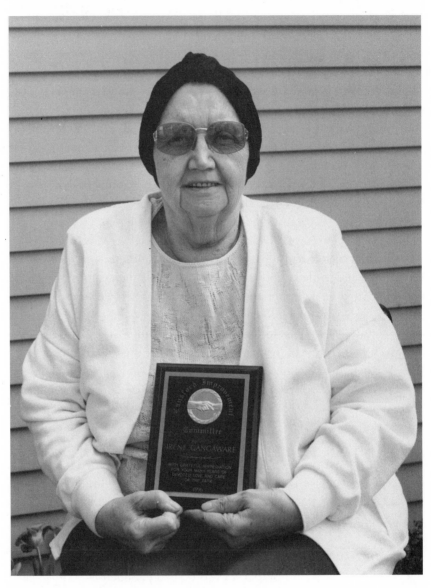

Irene Gangaware while undergoing chemotherapy, with the plaque awarded her for taking care of the Miners' Memorial, June 1996.

Irene Uher Gangaware

Lansford September 5, 1993

I was born in Lansford, December fifteenth, 1928. My father's name was Frank Uher. He was a miner. He worked for the [Lehigh Navigation Coal] company for forty-two years. He started as a slate picker; he said he was eleven. He'd be going to work, picking slate at No. 8 colliery at that time. His lunch bucket was hitting the ground, that's how short he was, 5′6″ or 5′7″. He had to go to work at eleven, so what can you do? Then from there, now I couldn't tell you what year, but as far as I know, my father was a miner in No. 9 mines for years. He worked on the third level.

[As a child I went into the mines] once. I was scared, so I couldn't even tell you about it; I didn't appreciate it. I was scared, because I thought it was illegal.

I can remember my father picking coal. He always picked coal. He'd go on the coal bank at five in the morning, come home with a couple bags, and then go do his shift at work. On a Saturday or when they were off work, he would also pick coal. I'd cry to go pick coal with him, and he'd say, "Okay, okay." So I'd go up the bank with the bucket and there was a pile. One pile coal that was shaped like an egg. The other pile was cracked anthracite coal. Well, I just thought that was how all the coal grew—on piles! I thought you'd just go up and fill your bags or buckets. I was never aware of the fact that my father used to do that for me, so I could fill my bucket and I'd just get out of his way. He'd do that before I even got up there. Oh, God, and that to me was a big treat! [I was] about nine or ten, because I went once or twice a year. I never had to do that [as a regular job]. My father was a very responsible kind of man, and felt his job was his job.

[Growing up] I was alone for eleven years. My mother's maiden name was Mary Gruz. She was born in Czechoslovakia and my father was born in Lansford. They met through relatives and friends, when Mom was in New Jersey. Actually, she came from Czechoslovakia to New Jersey. Then, when I was eleven years old I had a brother. Well, I thought nobody else in this world had a brother or a sister. Then I had a brother! Well, he was the

light of my life. I didn't know till after he died, that he always thought I was like a second mother to him. I loved him. He died in 1986. He was forty-six; he died of a massive heart attack. He left a wife and a son.

I'm Slovak, true-blue Slovak. I belonged to Saint Michael's Catholic Church in Lansford [and] I went to Saint Mike's School for eight years. Then for high school I went to Saint Ann's in Lansford and graduated in 1946.

We were a family that went to church Sundays, holy days, and in Saint Michael's, you went every morning to Mass before school. We lived a good distance from church, and, well, you just had to go. May and October were May Devotions and October Devotions. They had the rosary every night and benediction. You had to go or else you were in trouble; the nun would chew you out. I loved every minute in Catholic school, all the way through. A lot of them say, "Oh, I got hit and all this." I can tell you, a lot of times, I didn't get caught. It's not that I didn't get it! We were devout Catholics, but not every time the church bell rang. We went when we had to go and that was it. Only once I hookied from church, benediction, and my mother was aware of it. I said, "Mom, I want to go to the movies, okay?" She said, "Okay, but don't tell Tata." I used to call my father Tata, daddy in Slovak. She said, "Okay, don't you tell Tata, that I let you go." Well, I had his prayer book, and guess what? I lost it in the movies. My father is dead twenty-three years now, and he never knew I lost his prayer book in the movies! I'll never forget that.

My mother didn't work when I was small. She was the typical housewife. You had dinner at noon; we went back and forth to school. I walked to Saint Mike's in the morning, came home at lunch time. There was no brown-bagging it, because you were right in town even if it took you fifteen, twenty minutes one-way. Mom cooked dinner at noon, 'cause my dad came home from work, he was a contract miner, well, any place from eleven to one, he would be home. He'd always say, "The coal's running." He's there; he was a very hard-working man. He said he's not moving until they can run their chute or whatever it is. I'd go back to school and then come home and then supper was leftovers, more or less. We had the one cooked meal a day. Mom was very efficient as a mother—a kind, kind person.

I lived on West Snyder Avenue. It was a duplex, a part of a double block home. It had the basement kitchen, and of course your bathroom was in the cellar, and at one time, you just had the tin tub, you did not have a bath-tub. You got your bath in front of the open oven. Then when I was in eighth grade, would you believe that I got a gift from my godparents. They bought us a bathtub so that was put in the cellar, a real, honest-to-God bathtub.

I don't remember anything about not having hot water. [Some] people my age—I'm sixty-four right now—will say, "Oh, I remember the Depression." They [must] have the world's greatest memory, because I remember nothing about the Depression. As a child, what would I know? My mom and dad put clothes on my back; they fed me. That's all I needed; you didn't expect much more. Evidently, I had it pretty good. Maybe I had two toys and the other kids that had big families had to share one toy.

I can remember not having [things], which was par for the course. You'd say, "Mom, can I have it?" "No, we don't have the money." Well, I got out of high school and I said, "Mom, I want to go in training." She says, "Oh, no, that's too much money." I wanted to go into nursing. "No, that's too much money." It was three hundred dollars, for three years. I would have gone to Sacred Heart in Allentown. That was the big thing at that time. I didn't say anything to my father; well, he had a fit when he found out. 'Cause Mom said no. So naturally I didn't apply and that was the end of that, but I made sure my two daughters had the opportunity to further their education.

I graduated in 1946 and there was no sitting around. I never had to pay my parents anything, never paid them board. I started working in '46, right away, in the factory. That was Lansford Fashions; they made blouses. I was on the floor there, meaning I was a bundle girl. You gave bundles out and you took the finished work and gave it to the next girl.

[At first] I didn't know the front from the back of the machine. All I was doing was carrying the work to them and away from them. Then I wanted to learn how to operate a machine, and the boss said, "No, I want you on the floor." And I thought, "Baloney!" I knew I wanted to learn how to operate a machine. So I went across the street to Rosenau Brothers. They made all the Cinderella [and] Shirley Temple clothes. I worked there from about '47 till '52.

I was married November fifteenth, 1952. I married Grant—his real name is Granville—in Saint Peter's and Paul's Church, a Catholic church in Lehighton. My husband's Protestant. We got married in Lehighton because at that time Protestants had to take what they call instructions. What they really instructed them was on why a Catholic does certain things. The reason we went to Lehighton was his parents didn't appreciate the fact that he was marrying a Catholic. That's beside the point, but it's factual.

Grant was born and raised in the East End of Lansford, I was down on the West End, in the No. 9 section. It ended up his parents came to the wedding anyway. We had a small affair, and we had two daughters. Claudia was born February twenty-eighth, 1954, and Judee was born April twenty-

third, 1955. Grant had worked for the LNC, over at the storage yard in Hauto, where they stored the coal. I can remember him saying that he had to go up ninety-foot trimmers and when the coal was frozen they would have to dynamite it to make it loose.

I worked till I had Claudia. Then I quit, because my mom and dad, they were still around but older. She was only in her forties, but to me, when you're twenty-something and your parents are forty, they're ancient! So I just didn't feel that she should have to watch Claudia, and me go to work. After we had Judee, my mother said, if you want, go back part-time. Maybe I'd go back two or three mornings. Then that got [to be] too much, because it was two babies, really, that she'd have to tend to. Then my mom and dad moved to New Jersey, because the mines closed down. So there I was, all alone, with two babies. If you haven't got your parents, or brothers and sis-ters—your immediate family—then you're all by yourself. So I didn't work until Judee started kindergarten. Then I went to work part-time, after she went to school. They had full sessions in kindergarten at that time. I thank God, because then I worked till they came home. The thing was, like they were home from eleven to one. I made sure I was home; my children came first. Lansford Manufacturing was just a half a block away.

I was a machine operator for thirty-seven years. At Lansford Manufac-turing we made blouses, good quality blouses. [Lansford factories made] women's clothing and sportswear. Now by sportswear, it's women's skirts and shorts, or children's dresses, women's dresses and women's blouses. We had quite a few factories in town.

Rosenau Brothers, also known as Kiddie Kloes, they were Amalgamated. Then Lansford Manufacturing was ILGWU, the International Ladies' Garment Workers' Union. I stayed with them. I made sure, when our shop closed down there, that no matter where I went later, that it was the ILGWU, because I wanted my twenty years in there when I retired. I just felt, what's due me, I want.

[My pension], it's not from the firm. A great amount, one hundred and four dollars a month after thirty-some years, and you have to be with the union for twenty years. And oh, there's technicalities there too, but I'm getting my hundred and four. I think maximum is one hundred and twenty if you retire at sixty-five.

I remember with my father they'd be on strike. They'd say, "Oh, well, there's a strike." That meant there was a strike, and they just didn't work. I think prior to me working again, at Lansford Manufacturing, they had a strike, so I was never involved in a strike.

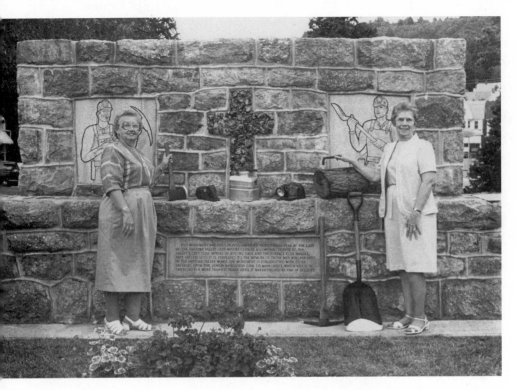

Irene Gangaware (*at left*) and Irene Mariotti, two miners' wives, ca. 1978.

I put most of my years in Lansford Manufacturing. I admired my boss, Pat Damico. He was a good-living man. He was the owner and manager, but he was a businessman. To me he was like a father figure. I knew when he was around nothing could go wrong. I'm definitely afraid of thunderstorms, and if a thunderstorm came, I knew nothing was going to happen in that factory, because Pat was there. If you had a grievance, before you got in the door, you lost your case. But he knew that you were mad about something, and you got it off your chest. You could understand the logic to it; it wasn't anything really bad. Now, we did have a floor lady, she's dead, God rest her soul, so let's just leave it at that! I mean, her and I argued like the dickens, but I felt sorry for the girls that didn't argue with her. [We'd argue] . . . just about, you didn't do this right, you didn't do that, and there are ways of saying it, and be firm, but in a nice way. She tried to belittle you. She'd tell you right to your face [if she didn't like something]. If you were woman enough to argue back with her, she stayed off you. She'd say, "Okay, hey, this is wrong." I'd say, "Okay, fine, I'll change it. I'll fix my repairs." But the poor girls that didn't argue back, they were the ones I felt

sorry for, because they were traumatized, they were a wreck. But I liked working in the factory, I really did.

Truthfully, I don't think the union does a darn thing for you. They're for themselves and that's it, as far I'm concerned. I know girls that have complained to them, and, for instance, there is a former employer of mine, very recent, [not] Pat [Damico]. I worked for a guy and he still owes me, till today, for twelve paid holidays at thirty-five dollars per day. We reported it to everybody you could think of, even the IRS. Nobody did anything about it. I'm talking about, let me see, about '87. So what are you going to do? Say, "Okay, God, you know I'll get it back some other way."

The last place I did work was Aquilla Fashions. That's where I retired from. They were really nice people. I learned a lot up there; I appreciate a challenge. Our boss would say, "Would you like to try this machine?" My theory in life is if one dummy could do it, so could another, especially something like that. I wouldn't hesitate to try on my own level. I loved it, and I learned so much.

I was there at Aquilla Fashions about a week, enough for them to understand I had a lot of experience under my belt. Just in a week I got a forty-five-cent-an-hour raise. They saw what speed I work at and that's where I think the forty-five cents an hour came in. I was very grateful.

Then you work on piecework: how much you produce, that's what you got. [My pay] would vary, six, seven dollars an hour. Sometimes it went higher, sometimes you just made minimum, if the work was lousy, which happened on occasion. Or the job was just tedious. I mean, you'd almost have to see it and see the difference. That's the only way I could explain it, you'd have to know about the garment industry. Some work was just lousy and then they weren't going to raise the prices. They'd bring your earnings down to a minimum to accommodate them.

About three years after Grant and I got married, he lost his job; the mines closed. Then he got a job, when they first started the Northeast extension for the turnpike, he worked on that for six months. Well, our Judee was just six months old when he lost his job. Then a new lamp factory came into town. Now they worked for nothing. You could register for unemployment, and Grant was getting thirty dollars a week, and we had two babies. We were renting a home, [and] at that time it was thirty-five dollars a month rent. When the training period was over, he was getting paid a dollar and a quarter an hour. I swear to God, I thought everybody in this whole wide world got paid fifty dollars a week. I did, I really did.

When the mines did close down, I was traumatized. I just felt it was the end of the world. What do you do now? Not thinking, because all I knew

was mines and sewing factories. Then my parents moved to New Jersey. They closed the mines down one week, and the next week, my father was in New Jersey as a super in an apartment building. His friends in Lansford even said to him—his nickname was Fido—they said, "Fido, why you go to New Jersey? You have a house here in Lansford?" And he said, "Well, I can't eat the house. I've got to work."

It was the first block in Newark, right next door to Hillside, the first block, very nice section at that time. It was called the Weekwake section. He took care of a thirty-five family apartment, I think there were two Gentiles in it. And Mom loved all the people. Well, my mother was a very easygoing person.

When they moved, they said to Grant and myself, "We're moving; you come and live in our house." We lived there for eight and a half years, rent-free. They paid the taxes; we paid all the utilities. When anything had to be in the house—new floors and what have you—they bought the material and Grant did the work. Grant's a hard-working guy. They had owned that a good while. They said rather than have renters in, they could be losing for the fact that somebody might not take care of it, where your children will take care of it.

Another thing, Grant has a bad eye. He tried getting something but he couldn't pass the physical. The day I went to the hospital to have our Judee, that day he went to Johns Manville in New Jersey, to apply for this job, because they had this appointment set up, he and another man.

[So we stayed here.] [First] he worked at Majestic Lamp Factory. He was there for awhile and then he used to work part-time security work for Zeigler Detective Agency. Then Dan Zeigler went into business and he asked Grant would he work for him. They put roofs and decks on these big fuel tanks. I don't know how many hundreds or thousands of gallons go into these fuel tanks.

When he was at Majestic, we had just bought our house. When my dad retired, my mom and dad came back from New Jersey, [and] we moved into our house. We bought the home we're at presently. We bought it in September, and in December, didn't he have a perforated ulcer, with the tension on his job with Majestic.

There I am, getting, for two weeks, maybe I'm getting forty-five dollars 'cause I'm working part-time. He was sick then, no benefits. Then one of the guys, a mechanic at work, said to me, "Was your husband ever in the service?" And I said yes. He said, "Go down to Jim Thorpe (the county seat) to their Veterans' Administration, and see if they can help you." I went down, my father went with me, and we got vouchers, not cash, at that

time. We were allowed a ton of coal per month for three months following the surgery. They allowed you forty-four dollars a month for food, sixteen dollars a month for clothing, and more for dairy, because you had children—for three months! They gave that because that was the recuperation period.

We were driving home, and I'm crying, I was thrilled to death because we're getting this money. Our mortgage at that time was $37.50 a month. We paid thirty-six hundred dollars for our house in 1965. They allowed us thirty-five dollars a month mortgage. So on our way home I'm crying and I said, "Oh, Tat! Do you realize we're going to get this great help." My father, very logical, said, "Just think of the poor SOB's that aren't aware of this program." I said, "I'm going to tell you something. Nobody that I know of will ever be unaware of it, if they need it." So that was that.

Then Grant went with Dan Zeigler putting roofs and decks on fuel tanks. We said that he was going on vacation so that Grant could see if he would like this new job. He liked the work. It was bad for the fact that we were separated, but then bread and butter comes first. So he went down to Georgia, that was his first job. He quit the lamp factory, and then he was fifteen years on the road. Then ZDA° closed down and then he went with Kovatch and did the same work, but Grant was always a foreman, he was a lead man. At that time, he got a dollar more an hour. He was a constant babysitter for these kids, when they're out on the road, you know how it is.

I got his check all the time—full check—for the fact that they were on a per diem. From the money allotted him he had to buy his meals and pay for laundry, also personal items. He never took a penny from his pay because he managed it from his per diem.

[He worked] on the road [until] 1981. He was on his way to a job in Syracuse, when he got his heart attack. He worked after that; well, he felt better, and, no matter what you say, you're not going to hold him down. Then he used to go out to Texas and Oklahoma. That was for Kovatch.

One time he came home from a job and he used to have all kinds of young guys with him. One boy said to me, "Irene, I don't give a damn what Grant says, but I have to tell you he's had some chest pain." This is maybe a year or so after his heart attack. I said, "Well, we're going to the doctor." No, he's not going to no doctor. Well, we went the next day and what they found was a spot on his lung. So what do you think of right away? Cancer! So our doctor said, "Right to Allentown." So we went down to Lehigh Val-

° Zeigler Detective Agency.

ley Hospital in Allentown. Well, they didn't know what it was. They had no idea what it was so they said they're going to operate. It was histoplasmosis, from bird droppings. They removed that part of the lung. The doctor did ask him, "Did you work in the [San] Joaquin Valley or live there?" It was because he was out in the western states, and that's what he got that from.

How did I feel [living alone with my children in those years]? Well, I certainly was mother and father. I didn't mind it for the fact I knew he had to be there and I had to be here. We trusted each other implicitly, so I never thought too much about it. I mean, he was my husband, and that was it. He had to go away. [And the job he got was] definitely much better. Around here, he would just about have to work two jobs. If he worked, let's say, in Majestic, then he would be running up to Split Rock on security work. That means, that Grant was going, going, going. That was all weekend, so he was working seven days a week, really. I thought we were multi-millionaires, when he would get two hundred, two hundred fifty dollars a week. Some jobs [around here] paid good wages but Grant didn't have that kind of job.

He never sent the check; the check came from his boss in Lansford. Never once did we have an argument about who's going to get the check. I remember one time, he said, a long time ago, long before this, he said to me, "You're not going to get my checks anymore. I'll be damned. I'm going to get my checks." I said to him, "The day I don't see your paycheck, that's the day you go out the door with the old luggage." Because I wasn't drinking his money, I wasn't gambling the money. It was our money. We always have our money; we never had "yours" and "mine."

[We were] raising the kids [then]. Then you put your kids through training, so. They got married right out of high school, so they weren't home too long after high school. I'm glad they have what they have today, so it's well worth it. [Other men back then were] commuting, but as far as being away, I felt like I was the only one in town. I couldn't even tell you, aside from the young guys that worked with Grant. They were single and had nothing that would hold them back. But this was his bread and butter, I mean, *our* bread and butter. I worked all through that time too. So, he did his best, God knows.

I was involved with the kids, no matter what. When our girls started school, the girls and I belonged to Saint Michael's. Somehow Grant was under the impression that it was a Slovak parish. He said to me, "I would like for them to go to an English-speaking school." Now we learned a half hour or an hour a week of Slovak in Saint Mike's, that's all. But to everybody else, that's all you did was talk Slovak. If my parents didn't teach me Slovak, I'd

have never learned it in school, trust me. So then we changed over and I belonged to Saint Ann's. They call it the Irish Church, but it's 99 percent Italians, so who cares. I thought, I'm not going to argue about Catholic churches. So then I changed over and our girls went to Saint Ann's grade school. Then they went to Panther Valley High School. Now, I think I would have impressed upon them the fact to go to Marian High School, that they were all nuns there, but they were lay teachers. So we had lay teachers up in Panther Valley, which had a good faculty then. Our kids always did well in school. There's a mother blowing her horn, but what do you expect? Mothers aren't prejudiced, you know. But I think it depends on the child; if they want to study they're going to study no matter what.

[Despite our backgrounds we get along.] Grant's a Protestant; I'm a Catholic. He's a Republican; I'm a Democrat. So we could kill each other every day, if that were the case, but that's it. We never argue religion; we discuss religion. For how much I know about politics, you can put under your fingernail; so we don't argue politics.

Now I can say I'm glad the mines did close, because I can remember my father telling my brother, "Don't you *ever* go in the mines. You make darn sure you study and get out of here—get out of here!" Looking back, truthfully, I believe I would have played every political game I could to get my husband a job with the state. You better believe it.

[My daughters] are registered nurses. Claudia was the oldest, graduating in '72. Then Judee graduated in '73. She graduated at the beginning of June, got married at the end of June, went into training in August of '73. By that time her husband was in college, beginning his junior year. She went to Saint Luke's in Bethlehem, into nursing. I must tell you, my mother just thought, you know the old-timers, the Catholic thing. Mom didn't know till the day she died that Saint Luke's was not a Catholic nursing school. It was non-denominational. But she felt all the time, well, that was good, Judee went to Saint Luke's. Then my son-in-law Jack Garrett graduated from East Stroudsburg [University and] got his master's in history at Bowling Green University in Ohio. He didn't have to pay for his education after his B.S. They moved to Ohio and he went to Bowling Green University, and since Judee was a nurse, there's no problem getting jobs. They had two children in Ohio. Heather was born in '77; then John was born in '79. Then Jack finished his doctorate when he came back to Wescosville, Pennsylvania. They had Jimmy in '83. He raised the three children while she worked at Lehigh Valley Hospital Center [as] a burn unit nurse. Jack felt badly because he was home and she went to work. I

Grant Gangaware laying a flower on Irene's coffin, August 1996.

said, "Jack, you are raising these children, and working on your doctorate. How much more can anybody expect?" They worked together.

After Judee was a nurse for a few years, Claudia said, "Mom, I didn't want to tell you, but would you go for the transcripts of my marks, up to school?" I said, "What for?" She says, "I'd love to get into training." I said, "Oh my God." And you know, she's older, you know how it is. There were four seats left [at the] Jewish Hospital School of Nursing in Cincinnati, Ohio. Wasn't she fortunate enough to get one of those seats! I think there were like twenty applicants. "Oh gee, our Judee's keeping a family." She said, "Heavens, I can do that!" So the both of them, they're always in a specialized hospital unit. So I can't complain about the kids. Like I said, Claudia has one son who is going to be twenty-two, and Judee has three children. Heather will be sixteen next week, John will be fourteen in November, and Jimmy will be ten in October—the light of our lives.

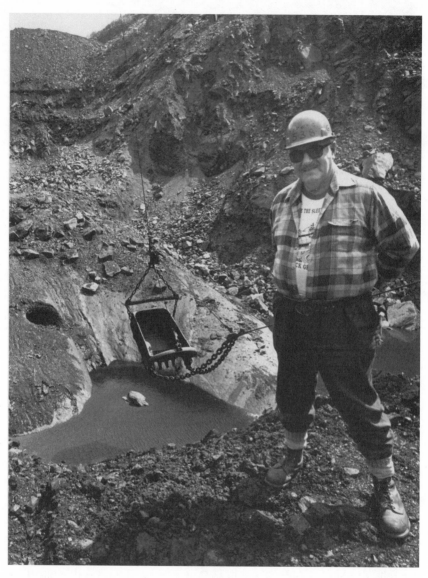

Gabe Ferrence in front of a dragline shovel at the Springdale strippings, ca. 1978.

Gabe Ferrence

Summit Hill June 20, 1994

Strip-mining has replaced underground mining throughout the anthracite region since the mid-1950s, and Gabe Ferrence is uniquely qualified to speak to this aspect of mining life. He lives just outside the Panther Valley on land his immigrant father bought in 1906. He graduated from high school in 1934, and after brief stints at lumbering and with the New Deal's Works Progress Administration, he began working on the coal strippings of the Panther Valley and surrounding towns. His father had worked as a steam fireman, miner, and hoist operator for Lehigh Navigation Coal. After a period of time as a loader and then an oiler, Ferrence became a dragline operator, and he describes with evident pleasure the skill with which he made that mammoth machine do his bidding. He retired in 1991 at age seventy-five, after more than half a century in strip-mining.

I interviewed Gabe on his property, where he has an extensive collection of old mining equipment, including a diesel shovel. He has become quite an authority on the mining history of the Panther Valley and is a frequent contributor to *The Valley Gazette*, a monthly that details the area's history and lore. He supplemented our interview with several written installments discussing strip-mining processes, the history of the Panther Valley, and the closing of the Lehigh Navigation Company mines. In his narrative he recounts his own experiences and draws on stories his father told him. This unusual combination of mining experience and enthusiasm for local history makes his narrative particularly rich.

✦

This is called Bloomingdale Valley, [and] I was born on this small farm back in 1915. My father had two or three cows and one horse. It was all hard work; we didn't have modern farm machinery like they have nowadays.

My father's name was John Ferrence. He came to this country from Humeno, Slovakia, in 1887, a young man. He landed in the town of New Philadelphia, about twenty miles west of here, and he worked for a dollar

a day for some coal company out there. After he worked here about a year then he sent for his wife. She was over in Europe and she came here, and she had a baby and the baby died. There's a baby buried in New Philadelphia cemetery somewhere from my father's first wife.

He couldn't read or write but he understood steam power. Later on he got a job in Panther Valley here, as a steam fireman for Lehigh Coal & Navigation Company, and he also knew how to operate the steam hoists. My father worked for the coal company for forty-nine years, and he only got a pension of twenty dollars a month for one year, then they stopped it. At that time there was no union pension.

And some of the men didn't like it that my father worked during a strike, but the coal company asked him in to work and my father did. The coal company was good to the men. The men, if they ran short of food or something like that happened, the coal company would help them. The Old Company [nickname for the LNC company], some of their officials were good-hearted men. Sometimes other miners used to call my father a scab because he worked during a strike. But, what the hell, if they wouldn't have worked during the strike period, when the strike would be over, how could they get in the mine to work when it would be flooded?* See what I mean? So my father worked during the strike period—he and the crews kept working round the clock, three eight-hour shifts—to keep the fires going, steam power to keep the mines dewatered.

While he was a steam fireman at this boilerhouse where they made the steam, the mines flooded one time.† There was a lot of rain and the steam pumps weren't fast enough to keep the water out of the mines. So the mines started flooding. Two different times my father saved twenty-four mine mules from drowning. He went down in the mines and let the mules loose. Everybody else was afraid to go down there. My father told this story many times. He went down there, the mules were trying to break loose from their chains to get out because they didn't want to die down there, they didn't want to drown. This happened in the Nesquehoning mines.

* Drainage water always accumulated in mines, whether or not they were in operation. During a strike, if pumps did not operate, the mines would become flooded and then at the conclusion of the strike, the mines could not be reopened immediately. For this reason, mine operators tried to keep boilermen and pumpmen working during strikes to keep the mines ready to reopen upon the strike's settlement.
† Anthracite mines typically depended on a great deal of steam power: to run lifts that took miners down to the workings and coal up to the mine's surface, to hoist coal to the top of the breakers for processing, to run pumps to drain the mines, to heat breakers and other buildings around the mines. John Ferrence worked for a stretch as a fireman in Nesquehoning.

One time it was eleven mules; the next time, thirteen. He went down there and the mules were so glad to see somebody to rescue them. He let them loose and the mules knew how to get out of that mine. It was a timbered slope where they could climb out. They went to the mule stables down in Nesquehoning. You didn't have to lead them out; they knew how to get out. So that happened to my father.

My father lived in Nesquehoning for ten years before he bought this place in 1906. In Nesquehoning he and his first wife—which wasn't my mother, my mother was his second wife—had seventeen boarders in a small house. They slept on straw-tick mattresses on the floor and his wife cooked and washed clothes for those miners, washed their clothes on a washboard. You didn't even know whose wash was in there.

My father knew how to make outdoor ovens to bake bread—stone ovens. I think there's one in New Columbus yet. My father knew how to build them. And so, my father's first wife, Mary, used to bake bread. Imagine the work that poor woman did! If she's not in heaven there's something wrong!

So they saved—they had seventeen hundred dollars in gold in the Mauch Chunk bank—by having all them boarders and my father had good pay. The firemen had good pay, you know. They worked steady all the time. Seventeen hundred dollars in gold—that's the money they used to buy this place.

We had our own vegetables here: raised potatoes and cabbage, had a lot of apples and planted corn. I found an ox shoe here when I plowed this field up one time, about fifteen years ago. That shoe was lost by the Dreisbachs who were the pioneers of this farm. I still have the deed.

I learned Slovakian first [before I learned English. Both my parents came from Slovakia]. My mother came from Cerrove-Leskove, near Bratislava. They didn't know each other over there. I kept talking Slovakian to my mother till she passed away in '59. I used to come down here every day to my mother's, because when I got married I lived in Summit Hill. She had a wood-burning stove, and coal, and I always saw that she had enough coal and wood in the house, and that she had a decent, comfortable living.

My father spoke sort of broken English, like the oldtimers did when they came from Europe. Did you ever hear some of the language that was spoken in [the mines]? I wish I would have had a tape recorder while I was working. I worked with a man right in Nesquehoning here. He was my oiler and he used to tell me some of the words—broken English. When he first got a job in the mines, he was a gate tender in the mine, keeping the

gate open and closed to control the ventilation in the mine tunnel. So the miner would say, "Hey, Billy, don't forget closen the gaitch." He didn't say, "gate." He told me a lot of stories about the broken English talk of the miners—part English and part Slovakian words for some of the things around the mines.

Right here, there was a wagon road went up the mountain. It's still here and it used to have a sign there, "Pozor!" That means "Notice!" That was in Slovakian because they knew there was Slovakian people in through this valley. They were warning you; they didn't want you to go up here to pick coal.

[My father] couldn't read or write. My mother used to be able to speak English. She couldn't write English, but she wrote and spoke Slovakian. When she'd write me a note for the store, it would be in Slovakian. I understood it, and sometimes I'd give the note to the storekeeper. I'd say, "What's this?" "I dunno!" I did that just for the hell of it.

Some of the first strippings [above-ground strip mines] were up here, top of the mountain, and my father saw where some of the veins were. We used to pick coal, not only us, but a bunch of the neighbors here. We used to go up there and pick coal. We'd haul it down with a horse and wagon.

As a boy, picking coal—hard work, boy! We had to carry it up out of a stripping hole, pick a path up along the side of the hill, and carry it up, and we'd hide the coal in bags in the woods, covered with brush. We'd accumulate about twenty bags, about a ton or more, and we'd go up with a horse and wagon, haul it down.

My brother and I got caught up there one day. We were picking coal and saw these two hunters coming. We're down there, picking coal, putting it in bags and right in a solid vein. Here was coal and iron police of the Lehigh Navigation Company—Harry Chester and Jack Williams, oh, them two bastards. But they were doing their job. So they came down and they had shotguns. We thought they were hunters, you know. It was hunting season. They were hunting us! They asked us, "Any birds around here?" Ha, we were the "birds" they were looking for.

My father had to pay a fifty-dollar fine for picking coal on company land. Stolen coal, they called it. They weren't even paying taxes on that land. Yeah, we got caught. They used to take it off his check, so much a pay, and they had written, "Stolen coal." It was awful. Back in the 1920s, you know, Depression days. I was only twelve years old or so.

We all helped. All us kids worked on the farm. Picking weeds and potato bugs, and then helped the harvest, picked corn, take the corn off the cob

for the chickens. We always had chickens and ducks. I milked cows from when I was twelve years old. That's why I have big strong hands. I always had two, three cows, and the horse to care for. And my father always kept a couple pigs.

I went to Nesquehoning High School and graduated in 1934. I was the only one in our family that graduated from high school because there was no jobs anyway for young people around here. My older brother was working on the farm here, and my older sister and my [three] younger sisters. So I was the only one that was allowed to finish high school.

I [also] had a half-brother named Andrew and he was a cook at Camp Lee, Virginia, during World War I, and four half-sisters, Anna, Mary, Susan, and Maria.*

[After graduating] I got a job cutting timber for Eckman Lumber Company. We made about twenty cents an hour. It was hard work. East of Lehighton, that area out where Bethlehem water dams are now, by Wild Creek Reservoir. I worked there for a while; then I got a job at WPA because there was no work around here. We worked on the highways here; we put them stone gutters in.

I married an Irish girl in '38, Rose Campbell from Summit Hill. I started work on the stripping right after that, when I was, let's see, about twenty-four years old. I spent practically fifty years on strip-mining jobs, mostly operating big giant draglines that dug rock and coal. I dug millions of tons of rock and coal, through the years.

[I worked first] for a stripping contractor, Fauzio Brothers. They were strip-mining on Lehigh Navigation Coal Company land. I was loading mine cars from a big chute. The trucks would dump the coal into this big long chute that held maybe fifty ton of coal or more. Down under the chute there was a railroad. Steam engines would bring the mine cars up from Nesquehoning mine and we'd load them up. We had a platform and a gravity run there. We'd pull a rope and the brake would release and we'd leave one car down at a time. We used to get sixteen cars in a trip. We had to close the gates first before we could load the mine cars. I had a buddy, one on each side, we'd close the gates. It was rods and levers there. I done that for a couple years.

Then I got a job oiling on a power shovel. I greased the machine, lubricated the machine, checked the oil in the engines and water, oil, water,

* Gabe Ferrence's father had ten children by his first wife, five of whom died as infants. Gabe was the third child of his father's second wife, four of whose ten children also died young.

Gabe Ferrence beside a shovel he has collected on his farm, 1995.

gear cases and stuff. Winter time would be something. Machinery always interested me—like my father the same way. I learned to operate the power shovels. I got on with some good operators. We weren't allowed to run the machines because the contractor didn't want any breakdowns, because some of the fellas were rough with the machines. But I always was gentle. I always listened to the operator, how to work the machine without doing any damage. I learned to operate the machine—diesel engines. They had three-cubic-yard buckets and eighty-five-foot booms on them. I was known as one of the smoothest operators that they had.

I broke in quite a few fellas to run draglines. When I first started working on a shovel, they didn't want you to run the machines, because the con-

tractors were small and they couldn't afford any breakdowns. Some of the young fellas were too rough and they would break the machine and then it cost a lot of money to repair it. But I got with some operators that left me run and I was one of the first ones to learn to run. Some of the older men didn't like it because I could run the machine and they couldn't, but they were with men that wouldn't leave them on the seat. I took advantage of the operators left me run the rig and they took advantage of me, also. They'd leave me run but they'd get a break. I was only getting oiler's pay but I was glad to get the experience.

I learned a lot from them. There was a little short Italian fella from Tresckow, also an operator named Jack Fauzio helped to break me in on a Lima dragline shovel. He was a cousin of the Fauzio brothers and a great guy to work with. The Italian from Tresckow was one of the best dragline operators in this area and also a good repairman. I learned a lot from that man. He was only a little, short man, but he had a big beard. He was also a leader of the Tresckow Skidoo Band. Italian fella, nice man—Louis Bellits. Later on I broke his son in to run a machine, return favor. But his son wasn't like his father, oh, his son was hotheaded. He was one of those excitable fellas, he'd swear right away and he'd get in there. I used to say to him, "Johnny, if you don't listen to me I ain't gonna show you a fuckin' thing!" I broke him in to run shovel; then he ran shovel for quite a few years after that.

While being a dragline operator I was known as the "Bomber," because I "bombed" large rocks into smaller pieces so they could go into a six-cubic-yard bucket. Sometimes a large rock would be encountered in my coal pit, hindering the removal of coal. So I would select a hard rock, as large as a refrigerator, one that would slide out of the bucket easily. Then I would hoist it up eighty feet and drop it down onto the large rock in the coal pit, thus cracking the big rock [into] manageable pieces.

When World War II broke out, they were glad to have me. I was married and had a couple kids. I didn't have to go [into the Army], so I got a job operating a shovel steady in '41 or '42 in this little area called Little Italy, about one and a half miles southwest of Nesquehoning. There's no town there anymore, but there was a nice pioneer town there.

They didn't start stripping right in that particular area until in the 1930s somewhere, in Little Italy itself. To tell you a story, when my father worked there at Little Italy, there was a steam engine house there. That was called the Little Italy shaft, and up the road a little further there was a mine called the No. 3 slope. He worked there for twenty-three years, but in Little Italy only ten years. When he was a steam fireman there, the coal

company started to undermine that town with deep mines; the people lost their spring water. That's why they had to move the town over to New Columbus.

The ladies used to come to the boiler house. The coal company always had a big reservoir, with water in it. The women used to come there with big buckets on their heads. Italian ladies carried the water that way, you know. My father admired them, carrying big buckets of water. He wasn't allowed to give them water, but my father would tell them when to come back, when the bosses wouldn't be around, and he'd give them water. He hated when people were refused water. My father was good-hearted that way. We were Slovakian, and the Italian people liked my father in that small town. They used to call him . . . my father knew a lot of cures for sicknesses he learned from the old people over in Europe. Good medicine too, better than we have nowadays. One time he delivered a baby that a midwife couldn't, didn't know what to do. I think the man is living in Lansford today, the baby that was born. My father knew how to get that baby out. There was no Cesarean them days. Baby had to come out the same way it first went in there!

I have to tell you this story about what happened here at Little Italy. My father had told this story many times. There was a man by the name of Davis, who was a hoisting engineer at Nesquehoning. That's a straight down shaft. My father was a fireman there, and this Davis was the hoisting engineer, see. He fell asleep at the controls. And the cage is coming up, the elevator. He dozed off. The men were getting hoisted up into the wheels of the tower; they would have got killed. By luck he woke up, heard them, and left them down. They ran after him with picks and whatnot. They wanted to really club the hell out of him for doing that, because he would have killed them. He was hoisting them up into the tower where the big wheels were—he fell asleep!

[I heard about other accidents.] I worked with a man from MaryD,° his name is John Kodorsky. He told me how his father got killed in a slope mine. They had a steam hoist. The men were coming up on a car, and I guess they didn't have cables them days, only had hemp rope, years ago, and the rope broke. The men went flying down, back into the mine again. That's how his father got killed.

[During World War II there were lots of opportunities.] Francis Mont-

° MaryD was a mining operation of Lehigh Navigation Coal located west of the company's main collieries and strippings in the Panther Valley.

gomery, one of the big superintendents of Lansford, knew my father was a hoisting engineer and fireman years ago; he asked me if I wanted a job hoisting engineer. I was running shovel on the stripping and I didn't want to take the job. He wanted me 'cause I guess some of their hoisting engineers probably had to go away during World War II. He knew I was available so he wanted me to get to be a hoisting engineer.

[During the war] we were busy. Many a time I ran the machine without an oiler because they didn't have anybody. They'd see a hobo walking on the road, they'd say, "Hey, you want a job?" Sometimes I had school teachers for oilers during their summer vacation, because they were needed. Some of them taught me in high school, such as Warren Ulshafer and James Vaiana, [from] Nesquehoning, and Andy Kalen, a football coach from Coaldale.

I figured if the boys were in the jungles laying in the mud and freezing in bad weather and everything, why can't I run this machine and grease it myself? So I did many a time. The contractor saved money because he wasn't paying two men, but I only got my regular shovel runner salary.[*] I would shut the machine down for an hour or so and I'd grease it myself. I did something for my war effort, can't say that I was just a slacker or something like that. I helped the production of coal, which was needed for industries all over the world. A lot of coal was going over to Germany and foreign countries for the troops to have for their fuel. I worked for Fauzio Brothers all during World War II and loaded thousands of tons of coal.

I worked for the Fauzio Brothers until 1949. Then I got a job between Tuscarora and Tamaqua. There was a big stripping operation there. I got a job there running bigger machines, more money. So I started work there. Ralph Peters was a contractor. Reading Coal and Iron Company owned the land there at that time. I worked for Ralph Peters for close to ten years. He had to pay royalty to the Reading Company for the coal, fifty cent per ton.

Mr. Peters was a remarkable and kindly man to work for. He always worked by UMWA union rules. Anthracite coal was "black gold" for Peters, and had made him a millionaire. In the 1950s, when he operated the MaryD breaker, his wealthy years, his secretary and partner was Charlotte Parfitt Hill. At that time he had married his secretary's sister, Catherine Parfitt, a much younger girl than he. She bore him two sons of whom he was very proud.

[*] Strip-mining in the Panther Valley was typically done by independent contractors who were hired by Lehigh Navigation Coal. Fauzio Brothers and Ralph Peters were two stripping contractors for whom Gabe Ferrence worked.

After the MaryD breaker shut down about 1953, Peters moved his nine shovels and dozers up to Scotch Valley, near Shenandoah, which was an unsuccessful venture. In 1954 he came back to near Tamaqua and discovered a bonanza coal vein, called the Primrose Vein. At sixty-five, when most men retire, he started his most ambitious venture. He leased the Newkirk mine tunnel and also coal lands from the Reading Coal Company.

In 1954 he started to build a hundred-foot-tall modern coal breaker. As I was temporarily unemployed at the time, Peters hired me to cut the timber down where the water dam was to be made. I had my own chainsaw then.

When he started to build the new breaker at Newkirk, Mr. Peters asked me if I knew of a good breaker builder. I said I thought I did and so I went to see James Frantz of Summit Hill (he is still living) and he and his carpenters got the job of building that coal breaker. The Frantz brothers were well-known carpenters that had worked for Lehigh Navigation Coal for many years. Later on Peters hired me to operate dragline shovels in 1955.

In the early 1960s, he and his partner Charlotte Hill had to declare bankruptcy, due to the depressed coal market and to an unsuccessful idea of machine mining, which was expensive and inefficient. I pitied Mr. Peters in his old age because he was indeed a great man and had provided many jobs for men in this depressed area. He lived in Schuylkill Haven and always had a Cadillac car. I had eight good prosperous years working for him. God bless him.

[While working for Mr. Peters] I discovered a vein of coal myself one time. I was running the dragline and I was moving the rock, and right below me on the next level was another dragline, a two-and-a-half-yard machine. I was making a shelf for him to put his coal on, 'cause he didn't have much room down there. He was on a thirty-foot vein; it was called the Primrose. So I was making this level spot for him; I wasn't digging very deep, and I hit this black dirt, what they call coal blossom—black, you could make records out of it. I said to my foreman, "Hey, Bernie, I think there's another vein of coal here." "Ah," he said, "can't be." I said, "Well, give me permission to dig down in there. There might be another vein." It was only about fifty feet from the other vein. So I dug down in there and the deeper I went the more lumpier coal I was coming out with, but there was about six feet of that black dirt on top of the coal that would block a breaker. It wouldn't slide in the chutes; it was like flour and sticky-black. So I piled it on a separate heap. The foreman said to me, "We'll get credit for it tomorrow." The next day the foreman came and Mr. Peters and they

were so happy, but, you know, I didn't get no bonus for that! We strip-mined that vein of coal; it didn't need any drilling. Two shifts would take the rock off, and one shift would take the coal out.

So I discovered that vein of coal. That coal was a basin formation and was about forty feet wide at its widest point and forty feet thick, and about seven hundred feet long. After we took all the coal out, after several months, it looked like a big hold of a ship. I started that in about April, and we took coal out of there all the way into November, then it pinched again. Out between Tuscarora and Tamaqua. Yeah, I discovered that vein of coal myself, that was really something. I got a kick out of that.

Then later on I come back in the valley, when they went bankrupt. The coal business went to hell. Then I got a job back here in the valley with Russell Seunder from Pottsville. I was operating a big dragline, a walker, one of those machines that walks. I worked for them for a couple years. Then they went out of business, also because the coal business was going down all the time. Too many competitive fuels—gas, oil, electric. My last job was with Bethlehem Steel, and then they sold out to the company now in operation, back to the original name, Lehigh Navigation Coal Company, owned by the Currans of Pottsville.*

The Fauzios were pretty strict contractors. Sometimes they violated the UMWA rules. I went with other contractors because I wanted to move around a little bit and I got on bigger machines, more money.

I worked for several smaller ones, too, in between. I even worked up at Dickson City. I worked up at that burning coal bank for a couple weeks. The contractor I was working for down here was Hill Stripping Company of Pottsville. The machine that I was operating was sold. They were slowing down and they strip-mined there for a while and then they sold out and went out of business. I loaded the machine up that I was operating—it was a three-yard diesel-power Osgood dragline—at ten o'clock in the morning on a heavy-equipment hauling trailer and later I'm deer hunting out here where Bear Creek Lakes is now, about ten miles from here. I hear this truck coming up the mountain. I'm wondering what the hell is coming so slow. Here's the same machine that I loaded up in the morning; it was three o'clock in the afternoon. I'm up in a tree watching for a buck deer with a bow and arrow. The machine was going out to Blakeslee and then from

* Bethlehem Steel had a separate division, Bethlehem Mines, that ran mining operations in the Panther Valley after Lehigh Navigation Coal closed down.

Gabe Ferrence along the abandoned route of the Switchback Railroad, 1996.

there it went up north up into Scranton and Dickson City. I worked there a couple weeks. The contractor wanted me to come up there and put the machine together again. Some parts were off it. It was too high for the highway, and too heavy, so they had to take the boom separate. I went up there and I helped put the machine together and then I broke his men in to run it. They never operated that type of machine. I operated a lot of different types of machines.

Why, there's hardly any machine that I never knew. I used to operate this big Miss Panther Valley. I used to be extra operator whenever the operator wouldn't be out to work. It was the biggest one we ever had in the valley. It was a giant Bucyrus Walker equipped with a two-hundred-foot boom and a fifteen-cubic-yard bucket. When the bucket was full of rock, that machine would lift thirty-five tons, because the digging bucket weighed fifteen tons empty. The boom was held up by nearly five thousand feet

of one-inch cable around the various pulley wheels. That giant dragline worked mostly in the Little Italy area. It was owned by Fauzio Brothers originally but then Bethlehem bought it. They used it only a couple years and they sold it, way out in the state of Indiana, in the soft coal region. They got just as much money for it as when it was new, on account of inflation.

[Strip-mining has changed a lot over the years.] The deeper we went, the more rock we had to move, and the more drilling had to be done. It got to be more expensive, also. What saved the coal companies a lot was the rotary drills. Originally they had the churn drills, pounding the holes down. When they got thirty feet in an eight-hour shift they were doing good. But these big modern rotary drills, with the Hughes drill bits, revolutionized not only rock drilling here in the anthracite region but in the oil industry. These drill bits are tungsten-carbide bits, cutting edges. The rotary drills could drill five hundred feet or more in a day. They're very fast and they have big, high towers.

For explosives they use fertilizer, ammonium nitrate, in pellets they pour down a hole out of a pipe. A truck comes in with a pipe and they pour down a hole and they mix fuel oil with it. It makes a powerful explosion. [The fertilizer] is poured into the holes just like a powder—pellets. Then fuel oil is mixed with it at the same time. First they put their blasting caps down there, the detonators. Sometimes they'll load a hell of a big area, maybe one acre, and they blast. All the men have to be out of the stripping. Oh, they probably blasted fifty holes or more, and the holes were nine inches in diameter, some bigger probably. They would have to have at least four men when they were loading those holes. They would put the explosive caps down first and then the dynamite powder. Then they would put tamping in from the explosive to the top of the hole on the surface.

The big electric shovels didn't take long to clear a rock cut. In maybe a week or two they would have all that rock cleaned out on a forty-foot depth. The dragline would dig at least fifty truckloads of coal each day if the vein of coal was a large one, like the Mammoth Vein here.

A job was usually done in two sections; while one upper level was being cleared of rock and coal, the lower level was being drilled and blasted. Switchback roads had to be made and maintained by dozers and road graders for hauling of coal and rock.

To drill those fifty holes would take a week or less. They used to take maybe a quarter of a mile section and they would take down forty feet of the whole area. Then they would come back and start drilling again; they'd

go down forty feet deeper. In the meantime, if there was coal right there, we'd be there digging the coal out with the draglines, but we were only allowed to go so deep because the rock wasn't shot yet. So that's the way we used to do it—forty-foot levels.

They usually had seven truck drivers on a shift, and three shifts; twenty-one men just on trucks for rock hauling. On the day crew they would have maybe two loaders that would load the trucks with coal. They also used loaders to load the rock that wasn't real big. They would load with a giant seventeen-cubic-yard Letourneau loader that would load the big hundred-and-twenty-ton trucks. In four scoops you'd have that truck loaded with a hundred and twenty tons, imagine that! Just move away with it easily.

The loaders are giant excavators equipped with huge rubber tires and very mobile with powerful hydraulic hoist systems. The loaders were also loading the finer rock and with the big electric shovels they'd be loading the bigger stuff. Sometimes they'd load rocks bigger than automobiles.

The average boom length on a Panther Valley dragline is one hundred twenty to one hundred forty feet. We could go down deep and reach out. A dragline is a very efficient machine for strippings work. It can dig at least eighty feet deep and reach out more than one hundred feet. It can also reach up and pull down rock or coal from a higher-level plane due to its long boom length and height. A dragline has large-capacity cable spools, called drums, hoist cable nearly four hundred feet long, and the drag cable that pulls and fills the bucket is about two hundred and fifty feet long. You can dig deep; you can reach far. When you get skilled at that, you can make that bucket do what you want it to do. See, when they'd be first breaking in, I'd say to them, "Hey, you be the boss of that bucket. The bucket ain't supposed to boss you." But you only have maybe a six- or seven-yard bucket. That's the biggest on a dragline here. Up at Freeland there are some of the world's largest draglines on strip-mine jobs, owned by the Pagnotti Corporation.

It took at least a year to break in to running dragline halfway decent. It took quite a few years to learn to run it efficiently, without any false moves, any moves that didn't do you any good.

The loader works fairly close to the pile, but we never swing a boom or bucket over top of the men or other equipment; it would be dangerous. The drillers and blasters and the fellas load the holes. But they didn't all work close together; they were working two jobs. Men are not allowed to work in close proximity to each other due to federal mine safety laws. If they weren't loading holes on one mountain, they'd be loading them over on the other mountain. They would go back and forth. So they kept them

going pretty well every day. Fauzio's and Bethlehem worked that way, and now the Lehigh Navigation Coal is working on the two sides of the Panther Valley here.

Let me tell you a story about draglines. In the early 1900s, when the first dragline shovels were brought to the Panther Valley, the old stick-shovel operators said, "It'll never work!" But when the shovel company men showed them what the machine could do, it revolutionized strip-mining methods. Most of the time we just pile the coal up on piles and the loaders then load the trucks. The giant rubber-tired loading rigs can load trucks much quicker than a dragline, due to their larger buckets and greater speed.

One day I was running the dragline out there on the other side of Tamaqua. I'm swinging over the road with a bucket full of rock, and here's a fella walking with his head down, right under the bucket. Shoo! I stopped swinging the machine and even so a couple rocks could have fallen off that bucket and killed him. It was Gene Pinter from McAdoo; he was a friend of my boss, Mr. Peters, and was a boxer in his younger days. He was down there on a visit. That's what you had to worry about, strangers coming around. He wasn't familiar with how dangerous those machines were. He'd see you digging here, but he didn't know where you were gonna go with the bucket. God, it was lucky that fella didn't get killed that day. I would have felt so bad because I never wanted to hurt any man.

Fauzios didn't have the rotary drills at first; they only had the pounders or churn drills, back in the thirties and forties. The dragline would throw the coal pile away from the pit and the loader could be loading the trucks behind you; you didn't interfere with each other. If there was no trucks there he'd be parked on the side somewhere and I'd go back to the coal pile. I had an oiler on the shovel with me. The shovels were usually on three shifts, sometimes two. We could get enough coal out on two shifts for the next day's coal run.

The union looked out for our interests, but John L. Lewis is baloney. I got a pension check yesterday from the United Mine Workers, thirty dollars a month. How about that? In the soft coal, men get six hundred. John L. Lewis let us down, here in the valley. They used to think he was such a great president. He was a dictator; he was no damn good. He had people in his own family working on the payroll that didn't even go to work, robbing the union funds. It's no good to have a man in there too many years because they get to be corrupt; look what happened to Hoffa.

[We needed the unions, though.] Coal companies were a lot to blame,

that's what happened to Molly Maguires. The coal companies were terrible. The people were like slaves. Imagine working ten hours in the mines. The men would go in when it was dark and come out when it was dark. Imagine. And low wages. Molly Maguires, at least somebody had the guts to do something about it; many people pitied them.

[I remember one strike,] but the deep mines were not involved—only the strippings and only for two days' duration. I caused one strike myself in 1949. I was operating a dragline and I made the mistake of quitting early. The Fauzio brothers found out, so they fired me—very unfair. They didn't want to take me back, so we had a strike for a day or two and went back to work. At least I worked more than half of my shift. They wanted to make an example out of somebody so I was the goat. That's what happened to me.

We were paid by the hour. But the shovel operators had pretty good conditions in the valley. We had what they called a monthly rate. If you worked five days you got paid for seven. That condition went way back to the 1920s. The first stripping in the valley was out there in Hacklebarnie, called the Hell's Kitchen stripping, when they had steam-powered shovels yet, many years ago. It was the first strip-mine in the valley. The coal used to be strip-mined up there with the steam shovels and it was hauled by a railroad from the mountain down through the Little Italy area to the Nesquehoning breaker.

When I first started work loading mine cars, [I earned] four dollars and sixty-two cents *a day*, not an hour! John Dolan and I were working buddies and had loaded mine cars from a chute located in Little Italy. [We worked a] seven-and-half-a-hour day, and then later on it was cut to seven-hour days. United Mine Workers got a shorter day. So I enjoyed that. Four dollars and sixty-two cents a day, a day's wage then for a laborer—wow!

[During World War II] when I started to operate a shovel, we were making around three hundred dollars a month, about a hundred and fifty dollars for a two-week period. That was pretty good. I mean, at that time even, you could buy something for that price. A hundred dollars don't go far nowadays on account of inflation.

On the strippings, there was times when we only worked four days a week or so. But all in all, we worked more days than the miners did. Then they had an equalization committee here in Panther Valley. There was quite a few mines here and they wanted each mine to have [the same number of] days of work, because some of the mines were getting more days and the

union was objecting to that. They wanted each mine to have a break so all miners could make a living. So there was started what they called an equalization committee.

They didn't bother us on the strippings with equalization. We had to work more on the strippings because we had to move rock in order to expose the coal. So contractors needed more days to be able to produce coal when the breaker was working. See, if the mine worked three days, the breaker only worked three days. See, same way. When the breaker did work, then we pushed our coal in there.

I don't remember any pressures against the strippings. We had no problems. When the demand for coal [increased] during World War II nobody complained about the stripping coal. In fact, the only time that there was complaints, sometimes the coal company would [purchase] coal from other areas outside the Panther Valley. They would get it at a lower price than the local contractors were producing it for, and the union objected to that— which is right, you see. They were looking out for the interests of the men in the Panther Valley. But [the company] would try to sneak it in once in awhile.

Evan Evans, the LNC president, had a slogan: "A coal car full more each day means extra pay." Because the mines were producing more coal anyway. You had Nesquehoning, you had Lansford, you had Coaldale, and you had No. 14, in Greenwood. Nesquehoning had No. 1 and No. 2 shafts (straight-down shafts). Later on, when Nesquehoning breaker was shut down, then all the coal went up to Lansford by mine cars; they had a railroad all the way up there from the Nesquehoning mines. Stripping trucks from the Little Italy area hauled coal directly to coal chutes, which were located at No. 5 and near the No. 6 breaker, and from those two ramp chutes the coal was loaded into mine cars. Steam locomotives then hauled the coal to the Lansford No. 6 breaker.

[The mine closings in the Panther Valley] didn't affect me because I was working for the other contractors and they seemed to be doing all right. They were producing coal and they were selling coal yet, for a few years, till the slump come along, after the war ended. But the valley didn't affect us out that way. There was strip mines out there, not as big as it was in Panther Valley here.

[To supplement my mining earnings,] in 1953 I bought a large, used sawmill from [Ralph] Peters and set it up on my property, which had about thirty acres of heavy timber. My son Ron and I cut lumber, which helped

to pay off my mortgage. I bought the property in 1954. At that time I was operating a sawmill here part time, and I needed a diesel engine for power. I had an old tractor which had only twenty horsepower and I needed eighty. So you can imagine I had quite a time cutting big trees with a saw, a big sixty-inch blade on the mill. The bigger the blade is, the more power you need. So I wanted that tractor to build a dam here and then take the engine out and use it on the sawmill. And they didn't give it to me.

[More recently I worked] over at Bethlehem Mines. I'm only retired since '91. I worked way past sixty-five. The young fellas would say, "When you going to retire, Gabe?" Ah, I'm in good shape, so. But I had a lot of lean years, that I didn't work steady. So I kept working to build up my Social Security to have a decent income when I would retire.

[The lean period included] a time when Newkirk Mine shut down, where I was running a dragline. There was a couple years that passed that I didn't have no job at all, just some construction and I worked at the Beltzville dam, just laborer. The big giant dam that's out there east of Lehighton, cost twenty million dollars. In 1969–70, that was the years. Then between there until '75, I only had some short construction jobs; then I got working steady for Russell Seunder. After they shut down, then I was idle again until I started to work for Bethlehem Mines in '75.

[While I was working in the strippings, my children were born.] We had three wonderful children, two boys and a girl. The first son was born in 1940, and my daughter, '42, and my younger son in 1949. They're all married now; they live in nearby towns. My younger son now has his own rug and linoleum business in the Panther Valley. My oldest son works at the nuclear power plant up at Berwick; he's an electrical inspector up there. My daughter's in the real estate business in Nesquehoning.

[None of them worked in the mines.] I didn't want them to, on account of the hard life that it is. You're out in all kinds of weather and unstable conditions, you know.

My mother died in '59 and my wife died 1960. Two important people in my life died close together. Wife died suddenly of a cerebral hemorrhage immediately after a simple hernia operation—died in the hospital at Coaldale.

[I was lucky as far as my health is concerned.] Strippings was fairly clean. I don't have any silicosis, thank God. I worked in the mines one time for nine months in 1952 as a mucker in the rock, in the tunnel of the Lansford No. 6 mine. That was enough of the mines for me. I saw forty different ways you could get killed down there. I didn't like the work in the mines,

Gabe Ferrence and his kittens, 1996.

but I had a wife and kids and I needed a job, so I took a job mucking in the
rock tunnel, down about eighteen hundred feet underground.

[Mucking can affect the lungs, especially for] the ones that worked there
a long time. In early years they didn't water the rock pile down, and the
poor guys had to be mucking in the dust. That wasn't so good for them.

I saw timbers in the mines down there at the turnout where the 600 tun-

nel [divided]; one went east, one went west. There were timbers down there three feet thick. Beautiful timber work, where they had to span both tracks. I admired that timber work. It was done by the miners. Some of the dates were chiseled on there with axes—eighteen hundred something, or early nineteen hundreds. Yeah, God that was really something, big long trees. A whole section of a big pine tree had to be used to hold up the top. Oak was so heavy and they couldn't get long, straight pieces. So they used the pine. Pine lasts a long time in the mines.

After the mines shut down, the ladies working in the factories helped to keep the home fires burning. Clothing factories we had here, quite a few in Panther Valley. Many men left this area and went to New Jersey for jobs; some lucky ones got jobs at Bethlehem Steel. As far as changes are concerned, only changes was the big strippings of the Summit Hill. The Bethlehem Mines and now the LNC company continue stripping yet, but they're slowed down something terrible.

[When the mines closed] the strippings did pick up somewhat because there was a market for coal, not as great as it was in their heyday, but the strippings took up the slack and kept producing anthracite coal all the way out to Pottsville, up toward Wilkes-Barre, [and] in Hazleton area, also. It was booming pretty good. The mines east of Hazleton there—there's some giant machines up there, some of the largest in the world.

[Since I retired I'm mostly around the farm.] There's about eighteen acres, yet. I lost thirty-three acres that went [to construct] Mauch Chunk Lake, broke my heart—valuable timber. I had to move my sawmill and everything. That's why the place is junked up like it is. Now I know how the Indians felt when land was taken off them.

[I used to have] forty-five acres—beautiful timber down in there—big hemlock trees, white pine, oak. Yeah, my father used to farm this—corn, oats, wheat, hay, cabbage, potatoes. I plowed this about ten years ago. I had corn in here, but the deer got more corn than I did! So we leave the horses here to graze once in awhile.

[My final thoughts?] I wish these politicians would wise up and see that the anthracite region is kept alive because someday we won't have oil and you're gonna need coal. We can make oil from coal. The industry should be kept alive not just for domestic use. In case of a war, you would need coal. Oil tanker ships would be sunk so quick as happened during World War II. If a bad war breaks out, what fuel would we have? You'd have to fall back on coal. Right here we have anthracite, millions of tons of coal under these

mountains. It's deeper but it's there. It can be deep mined again, or strip-mined. With the modern, big machines you can strip-mine it more economically than deep mining. I wish they would keep the anthracite coal mines in good shape and operating, and all public buildings should be heated with anthracite coal in this area. It's our local natural resource and it should be preserved as much as possible.

Anna Meyers beside a tree in her backyard, Summit Hill, 1996.

Anna Meyers

Summit Hill October 3, 1994

Anna Meyers was born in Mauch Chunk, just east of the Panther Valley, in 1907. Forced to quit school and start working at the age of fifteen after the death of her father, Anna worked in a garment factory in Mauch Chunk. After two years the firm opened a branch plant in the Panther Valley, and Anna moved to Lansford and worked there. After her marriage, with her husband in the Navy, Anna did war work, making bandoliers for the troops.

When the mines closed, Anna's husband did bundle work in an area garment factory, but a heart attack forced him to retire after only three years. Like Ella Strohl, Anna worked for many years after her husband's retirement. She became the main support of her family and continued to work at the Rosenau Brothers factory, affectionately known as Kiddie Kloes, manufacturers of the Shirley Temple line of girls' dresses. She recalls that others were doing what she did: "A lot [of] people went to the factories to work after the mines closed down. Well, mostly all the ladies."

Anna Meyers's narrative reflects women's experiences and attitudes more generally. It demonstrates a lifetime commitment to garment work, a pattern shared by many women of her generation. Moreover, Anna truly liked her work, commenting on the company parties and gifts for long-time workers and expressing real loyalty to the company and her supervisors. Still, she felt a strong commitment toward unionization, evident in the story she tells of union organizing at the Rosenau plant; she has faithfully preserved a notebook of newspaper clippings, now more than sixty years old, documenting that struggle. In her dual loyalty to her garment employer and her union, Anna Meyers speaks for many women of her generation.

✦

[I was born] in Mauch Chunk, September the twenty-seventh, 1907. My father's name was William Brauch and my mother's name was Dorothea

Interviewed by Mary Ann Landis.

William Brauch, Anna's father, upper Mauch Chunk, ca. 1912.

Dorothea Brauch, Anna's mother, upper Mauch Chu[...] ca. 1912.

Windbeck Brauch. Their parents were from Germany. My parents were born here, I guess in Mauch Chunk. My dad was born May the seventh of 1879, and my mother was born February the fifth, 1884. They got married on September the fifteenth, 1903, in Saint John's Lutheran Church in Mauch Chunk. [My dad] was an iron molder [in the Stroh Foundry]. [My mother] was a homemaker, but she used to do a lot of sewing at home, too. In later years, she worked for the Kiddie Kloes [in Mauch Chunk]. She worked in the factory and at home. They used to take trimming home, and do examining. You could bring the bundles home and then they'd trim it and then they'd carry it back to the factory.

[I went to school] in upper Mauch Chunk, in Asa Packer School. They tore that down to make the new school. Then we had to go down to lower Mauch Chunk on West Broadway, that was the high school at that time. I only was a freshman and then I had to quit because my mother and father died. They died two years apart.

My dad took sick. It was that terrible flu that was around when the war was, and it left him with weak kidneys.* He took sick and he died October 9, 1921. I can remember the doctor coming to our house and giving us all medicine—Dr. Henry it was at that time—and then there were oh so many people that had died from that. Lots of people died and it was in the middle of the winter and they couldn't bury people, because the ground was frozen so bad. They had a lot of people they had put in a vault to wait until spring so they could bury them. See, years ago, they dug everything by hand. They didn't have all these electric tools—diggers and that—like today. They just had to do pick-and-shovel work.

[My mother] took sick and she had what they call a spleen operation, and Dr. Bachelor from Palmerton Hospital operated on her. He told my dad, "Now, Bill, I operated on Dora. I learned it in college, but, it's the first operation that I did on a person of that kind." So he said, "She'll be able to live maybe, two, two and a half years." Today, they give you blood [from a blood bank], but years ago they didn't have that. It was only later that the people would give blood at the places where you can go and donate blood. But years ago, a person would lay beside the sick person, and then they would give blood transfusions like that, right from one person to another. They did it in the hospital to her, but when she came home, she only lived two and a half years and then she passed away, December 5, 1923.

[Having both my parents sick] was hard. I was only a kid, fourteen years old, and my father in the parlor. I had my mother in the dining room on a couch. That's where I used to take care of them.

I had one sister, two years older than I was. I remember she was in the hospital with appendicitis when my father died. She didn't even see him because Dr. Bachelor wouldn't let her come home from the hospital. Years ago when you had appendicitis, they would keep you fourteen days. But today, they don't do that.

This is when I started at the Kiddie Kloes. It was in the building where the Weiser Brewery was, years ago. That's right across the street from where the creek comes down. Up the street was the Stroh foundry on West Broadway in Mauch Chunk, and down the street was the brewery. They used to get a lot of water from the creek and from deep wells, too. Then the brewery shut down, and they made the Kiddie Kloes there on the second floor. The brewery building burnt down when the Kiddie Kloes was in it.

* This was probably the 1918 influenza epidemic, which claimed more than half a million lives in the United States alone.

Anna Brauch (*right*) and her sister, Marion, ca. 1914.

Ike, Issac Rodas was the manager. Mrs. Chambers was the floor lady. They would come up from Philadelphia until Mr. Rodas found a home [locally]. He brought his wife and two daughters up with him. Then Mrs. Chambers found a place to stay, and they commuted weekends back to Philly, to Rosenau Brothers, to report. Once a week, the truck would come and bring the work in from Philadelphia.

[After the fire, Mr. Rodas] opened up a place in upper Mauch Chunk on South Street. They moved up what little bit was left from the fire; I don't know if they got some of the machines out or not. But then William Middleman and Joseph McHale took over and ran the Kiddie Kloes.

They were treadle machines powered by belts from an electric motor at the beginning of the row. You only had about forty inches [to work in].

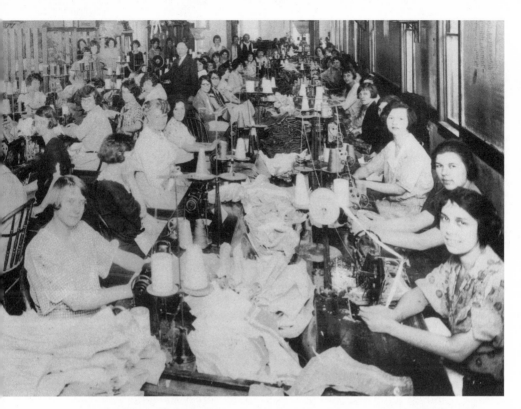

Rosenau Brothers factory, Mauch Chunk, 1923. Anna Meyers is sitting at the front left.

They used to have a yardstick right in the front where you could measure anything and you only had a couple inches past the yardstick until the next one would be hooked onto it.

That was my first job [at Rosenau Brothers in Mauch Chunk]. That's what I used to do. All this work would fall into a bin and then you had to cut your work out, bundle by bundle. Her work would fall in too, and then she'd take her work out.

At that time [1923], we used to have to walk to work. There was no way of getting there. A lot of these girls came from Nesquehoning and they used to come on a flatbed truck to work.

[I worked there] maybe two, two and a half years. Then I worked in Lansford. [I didn't get any] help at all. See, years ago, it wasn't like it is to-day that you could go and get help. You just had to get out and work. When my mother died, she told me to be good and be honest. I always tried to live up to that.

[In Lansford] the first place I moved was in Kline Avenue. They called

it Kline Alley at that time because it was all mud. It was paved in later years. I lived there with my cousin, but she was having children and really needed the room. So I came down and moved to East Abbott Street where I boarded with two old ladies.

I worked as a seamer, but I did other jobs in the very beginning until a seamer job was open for me. Mr. Duben was the boss at that time for Rosenau Brothers in Lansford. When I first worked there, it was a place on Patterson Street, right behind the Rialto corner.

Then that building got too little for them and they opened the second factory on East Kline Avenue. In 1933 they had the chance to buy the silk mill. That was the big building down in the west ward in Lansford. Then they moved everything down there. There's a factory there today.°

I used to be what they call a closer, on a knife machine. It had a knife. As you'd put the two things together, this would cut down, and then, years ago, they always made a French seam, then they turned the dress around, and then you sewed down again a second time. The plain sewer did that, see. Now today they have what they call superlock machines. A marrow machine, and also an extra needle goes down, so it marrows right here and the extra needle goes right down there; it's all done in one operation.

Then in later years I used to be a sample girl for Shirley Temple dresses. Shirley Temple dresses have lots of little ruffles and little ties on and little ruffles around the collars, and little petticoats. So we'd have to seam, real fine seam, go around that, and then another girl would do something else, and then a collar setter would do something else—like that, until the dress would be made. Each girl didn't make the whole dress. [There were] seven operations. You got a certain price for doing samples.

They did have pretty dresses. Rosenau Brothers made a good grade of dress, because all the little girls that went to school wore dresses at that time. Now today, it's all pants, slacks.

They used to send a certain amount of material in with each lot and then if you would have a piece of material that would be what they called a second, then they'd give it to the girl and she would cut a new piece out for you. Then that would be cast away or you could take it home or whatever you wanted to do with it.

[At first I earned] two dollars and sixty cents a day, thirteen dollars a

° The Kiddie Kloes factory finally closed in 1996, after more than sixty years of operation under successive managements.

week. Then it went up a little bit more, you got a little bit more. And it was all piecework. If you made more, you [earned] more. If you worked hard, you made more. If you didn't work hard, you just had to get what they paid you.

When we first started, I used to work from seven o'clock in the morning 'til six o'clock at night. Later on, when we got organized, then they didn't do that. Then it was five o'clock, four o'clock. Now, I guess, it's from seven to four, or maybe three-thirty, I don't know. I haven't been in the factory in a long time. But you used to work from seven to twelve and from one to six every day. Then they changed it, from seven to eleven and from twelve to four—four hours in the morning, four hours in the afternoon.

If you go upstairs [in the factory], on the next floor up, on the door of the wall, is the plaque of the Kiddie Kloes, when we were organized in 1933—unionized. The Kiddie Kloes was a good many years working before they ever were unionized. [In 1933] they used to march around trying to get us organized. Then finally, finally, the girls said yes, they would join up with the union. That's how they did it. You did what the crowd wanted, you know. Whichever way the crowd went, you went. If they thought that we would better ourselves by being unionized, why, they said, "Yes, we would get unionized."

I had eighteen years in before we were unionized, then I had to start over again.* Stanley Frank was there when I worked there and Farina [Kalny] was a boss over the girls. As long as you did your work right, you didn't have trouble.

When we became unionized, we were still under Rosenau Brothers. Mr. Rosenau was a very nice man to work for. Then, as the years went by, the work stoppage, like everybody was saying, this factory's closing down, that factory's closing down, you know. Well, we hung on as long as we could. Then we had to take in what they called [contract work]. You take maybe a thousand dozen from some firm, and then they'd take it into our factory and you had to make it. That's when it started to go downhill.

Then Mr. Rosenau [was] ready to retire. I remember talking to him and he said, "I'm going to leave it to my son. I don't know whether I'm doing

* Anna Meyers actually worked for ten years before Rosenau Brothers were unionized in 1933. The date was significant, because garment workers receive their pensions from their union and earn credits for their pensions only for the years in which they are employed under a union contract. Anna is referring to that aspect of the union contract when she comments that she "had to start over again."

the right thing or not. You know, the next generation doesn't work like we worked." When Rosenau Brothers first started, there were three brothers and one took care of the garment industry, the other took care of the money part, and the other man took care of the ordering and all that. And they built their business up. They were the biggest factory to sell Shirley Temple dresses at one time. They made lots and lots of money on that. They must have. Because, I mean, they wouldn't have worked for nothing, a firm like that.

[Rosenau Brothers had five factories.] They had one in Red Hill; they had one in Puerto Rico; they had one in Lansford; that was three. They had one in Ephrata. And I forget where the other one was.°

Every week the truck would come up and bring work in and take work back to Philadelphia, and then it was pressed down there and boxed and sent out to the customers. When he would bring the truck full of work in, it was all cut, ready and bundled up. They would unload it and then when you would get it, like, the first operation would take it and do their share, and so on they'd pass it on till the garment was all finished.

They used to have a little paste card and you would cut a ticket off and it would have a certain operation on it. And whatever you would make that day, like if you would make twenty cents on a bundle or thirty cents on a bundle, that would be marked on, then you'd paste that ticket on. Then at night when you'd go back out, they would have a box and you would put your card in the box. Then they'd know how much you made that day. My number was 5077.

I was doing ruffles; then I was at the beginning of [the work process.] When I did blouses, then the blouse had to be already fixed, finished, then you did the bottom part. So, every operation was a little different. When I did ties, that was like a first operation. When I did seaming on petticoats, that was a first operation because I'd do that first, then they'd come and shoulder it. These were the little petticoats that the girls wore under their dresses.

If it wasn't made right, they would send that back to the girl that did it and she'd have to do it over. They used to have what they called a floor lady, and then she'd come around and examine the work, and if there was anything wrong, you'd tell her: "Look at this, this isn't made right." And then she'd have it corrected for you.

° Ashland, Kentucky.

I used to sew a lot of sashes, well that was like a first operation. You had to make, sometimes, forty-eight in a bundle. Well, then you'd have to make forty-eight running one way and forty-eight running the other way, so that when they'd put it on the dress, like if you had a sash and you take the piece of material like this, and you'd seam it down. Then on this side, the next operation would be to put little pleats in there. Then when they'd sew it on the dress, that would be ready, a right and a left sash. You couldn't make a whole bundle all running one way.

With ruffles I was at the beginning. They'd send big rolls of stuff in, and you had to put that under your seamer. Sometimes I would put ric-rac on there and sometimes I would put lace on; sometimes I'd put wide lace on, sometimes I put narrow lace on. That would come through a folder, and as this would be coming through the folder, you're seaming here and then that would sew right on it. That was all done by machine. If you had lace, that they could call a beading on it, well that lace would run nice through a folder. But when you had a lace that didn't have that beading on, oh, you had all kinds of trouble, to make it that it would catch when you're seaming. [If] that didn't pass then, you either had to fix it or get your machine fixed.

They used to have timekeepers stand behind you—efficiency men, they used to call them. They would stand behind you, and when you opened a bundle, then they'd time you as to how long it would take to make that bundle, if your thread broke once or twice or three times, how long it took you to thread your needle and all that stuff. They used to time you. That's how they set the price. They were a good firm to work with, and if you listened, you know, you didn't have any trouble. But if you didn't do your work right, that's when the trouble would start. But I never had any trouble.

They used to have a nice Christmas party for us every year. They always gave us nice little gifts. It wasn't much, but it was nice. One year they would give you a fruitcake in a round tin. Another year they gave us little jewelry boxes for a gift. Another year they gave us an umbrella. One year they gave us pretty handkerchiefs in a box, nice linen ones. [Another year it was] cans filled with candy—dates with almonds in, covered with chocolate—that was made in Philadelphia. One year they gave us a nice big turkey platter for Christmas. One year they gave us a long little basket to put bread in.

Some days it would go real good and other days it would drag out. It all depended on what kind of work you had. [Sometimes you'd feel it in your] leg, from pushing the pedal all day long. Sometimes [it hurt] in your shoul-

ders, arms. [Also it could be hard on the eyes.] I didn't wear glasses until I was fifty-four years old. Now, I have to wear them to read or write letters or sign my name.

They heated [the factory] with coal in the very beginning. But they didn't have no air conditioning. They used to have fans. They wanted to put air conditioning in, several years when it first came out. But then a man came and he measured all the windows and everything. He said air conditioning would never work in that plant, because there are too many windows. So then they put big fans in. Many times it was terrible hot and lots of times it was terrible cold. Couldn't get the heat up, when it was blustery cold out.

They used to have big lights, but then when these fluorescent lights came out, then they put them in. Later on, the machines had a little bulb in, right on the top, and it would shine right down to where your needle was. But, for years, we just sewed with the big top light.

[I met my husband] on the dance floor at the Flagstaff [a local dance hall]. I went with him a couple of years before we were married. I think we went together about four years or so before we were married, September the twenty-seventh, 1939. I was married on my birthday.

[When I got married] I lived with a lady who had lost her son. And a lady who I lived with before, the company was going to buy their home and she had passed away and her children had to get out, so I had to get out too. So, mind, her children were all grown up. So the lady down the street from me, one night I was walking up from work, and she said, "Anna, did you find a place to stay yet?" I said, "No, I didn't." She said, "Why don't you go in and ask Mrs. Smith? She lives right next door to me here. I'm most sure she'll take you in because she just lost her son and she's very lonesome." So I went in and asked her. And, sure, she says, she'd be glad to take me in. So I just moved down the street a little bit. I moved in with her and then, that's the house where I lived when we got married.

[My husband, Bussie Meyers,] worked twenty-six years [at the] No. 9 [mine]. I think he started working in the mines April 30, 1935. [His father] was a mine boss—worked fifty-four years in the mines. He didn't always work at the same place, but the last years, he worked at No. 9. He got a watch from Lehigh Coal & Navigation and a chain and nail clipper from his rock contractor, Frank Pancheri.

Bussie's grandfather used to work in the mines, but I don't know what he did. Years ago they used to have to walk to work. That was around the time

when the Molly Maguires was here, and Bussie used to say, one time his grandfather was walking to work, and this man came up to him and held a lantern up to his face, and he said, "No, you're not the man we're looking for. Go ahead, go." That was the time that the Molly Maguires was shooting all the different men.

[My husband was born] September the thirteenth, 1910. On the Meyers side, I think they were German, but on his mother's side, I think they were Scotch Irish. They weren't Catholic. A lot of the Scotch people went to the Presbyterian church. He was born and raised in Summit Hill, but he lived in Lansford when we got married.

In the beginning he started in the rock work and he worked there about a year or so. Then he worked in the mines, patching on the motor for a good many years. Then he got a job as a lineman in the mines, fixing the overhead wires for the motors that pulled the coal cars. He also worked oiling the motors in the engine house. He worked on that until the colliery closed.

They'd all go home on strike. The miners sometimes used to, if just a little thing would go wrong, instead of trying to iron it out, among the men and the union officer, they'd say, "Domo, Domo."

[My husband] was never in a very bad mine accident. He used to get lots of headaches from being in the mines. When he'd come out in the fresh air, you know, then it would go away. He said, he never was afraid to go in the mines. Some men said they were afraid, they lived in fear, you know. He said he never was like that. When they would have high water and lots of rain, he would be called out on the pumps. The big pumps, they used to call it a bull pump, would have to pump so many gallons of water out a minute or in an hour, you know. He never was afraid in the mines, he said. He never had that fear like some people had.

He was Methodist, but when we got married, he joined the Trinity Lutheran church in Lansford. That's the one next to Saint Michael's with the clock on it. I kept working [after we got married]. We were only married two years, and then he had to go to war. He was in the Navy, on the heavy cruiser, USS *Quincy*. He went to France and later took President Roosevelt to the Crimean Conference and even went to the Pacific when they dropped the bomb on Japan. In all, he served twenty-six months and thirteen days. Then when he came back, he didn't have a hard time getting his job back. The No. 9 colliery had a list of all the men that went in the service and when they came back home they had their job back.

[I kept working during the war.] We worked on bandoliers. A certain group of girls they picked to work on bandoliers, bullet belts. When the war was over, why then we just started back on our old jobs again.

A lot of [the women, when] their men were in the war, they just kept on working. But some of them, when their husbands came back and got their job back and they got back on their own feet, then they quit, you know. But at one time the Kiddie Kloes had five hundred girls working for them, and now it's down to forty-five, or something like that.

We moved down here [White Bear, near Summit Hill] in '46. We lived in rent. We lived in there, and the elderly couple, they built this little house. So then, they didn't live here long, when his wife died. So he came down, and he said to Bussie, "You bought the big house off of me, why don't you put the big house up for sale and buy the little house off of me because it's just the two of you?" We said, okay, we'd do that. So that's what we did, and we were fortunate enough to sell it right away. We bought this little house. Then we built the front porch there, and we built the big back porch and the double chimney. We did some work for ourselves after we bought it.

Everybody used to go [to Bright's] because it was the biggest store and you could get everything. Down in the basement they had the groceries, and on the second floor they had everything, and then the third floor they had the furniture.

From the time we got married, we never carried a bill at Bright's. Now, some of the men used to go and they used to get everything at Bright's. When it came payday in the mines, all they got was an empty check. They didn't have nothin' left. Everything went in the store. It was like a company store. You could go and you could get anything you wanted there. But when payday would come, they got it first. The family didn't, that didn't matter. They got it first. So, we never lived that way. We said, if we want to buy something, we'll get it not out of the valley store.

They used to have very good clothes. Nice clothes and nice shoes and everything, but we would pay for it as we would get it. We never ran a bill there. Some people, my goodness, they didn't have nothing when payday come, they'd get the empty check.

[My husband] lost his job February 26, 1960, when the No. 9 colliery closed down [for good]. [Before that] maybe they'd only work three or four days a week, according to the demand for coal. [When the mines closed,] he didn't have no work. He had to look for work wherever he could find it.

Anna Meyers reading her Bible, 1996.

He worked in Scotty's in Lehighton as a boy on the floor—bundle boy, I think they used to call them. [They made] ladies' dresses. I don't know just what they're making now. They have several factories—Lehighton, Kresgeville. They made ladies' dresses; they didn't go into children's things. [He worked there] about three years, I think. He took a heart attack and he had to stop working.

A lot [of] people went to the factories to work after the mines closed down. Well, mostly all the ladies. They had seven garment factories around. Three used to be in Summit Hill. One was called the Pilgrim. The others didn't have no name; they just were factories.

They used to always say, years ago, it was the ladies that kept the families together when the war was, and when the men would always be out on strike, ladies would go to work and kept the families together. When they'd go on strike sometimes, they'd be out a couple months. Some of the men, I think, was glad, that they kept the home together, because there were lots of men that went to the war. There was nothing but for the ladies to go out and work.

[We never thought to move away.] [My husband's] mother and father lived here and he hated to leave them. They lived in Lansford; his father lived until he was eighty-four, and his mother passed away [when] she was seventy.

[The Panther Valley has changed a lot since the mines closed.] Oh my goodness, there used to be a lot of stores in Lansford. You'd go down Ridge Street, every store was taken. Now there's a lot of empty stores over in Lansford. There used to be a shoe store in Lansford; there are none there now. Sneakers you can buy, but as far as shoes, I don't think there is a shoe store in Lansford anymore. There used to be two nice restaurants. There used to be a good doggie place, they're all gone. The Porvazniks used to have big flower shop; now they closed. They sold out to another couple now, but they're carrying Porvaznik's name.

Most all the churches lost some members due to the collieries closing down. Years ago the PP & L° was in Hauto. When they closed down, that lost a lot of men, and they moved away. I think they worked yet a little after the mines closed, but then they closed down after that.

[The garment factories are all closing down now as well.] Years ago when the girls would come into work, they would work. Now today, when they hire a girl, maybe she'll sit there an hour and work, and then she'll get up and go to the ladies' room or she'll smoke or whatever she wants to do. [No,] these kids today won't work. They'll come in, they'll work maybe a week, and say, "It's not for me. I'm not coming back. I'm not going to come back and work no more." Children today are raised different than they

° Pennsylvania Power & Light was an electric utility.

were years ago. They think "I'm going to work like that for that?" That's their attitude.

Poor Feddo [a supervisor] used to always say to me, "Your chair's waiting for you, Anna, if you want to come back anytime." He always said that to me. I said no. Bussie said, "No, she worked long enough. I don't want her to go back to work no more."

Theresa Pavlocak seated at a sewing machine in the closed-up Kiddie Kloes factory (formerly Rosenau Brothers), spring 1996.

Theresa Pavlocak

Lansford October 13, 1994

Theresa Pavlocak was a miner's daughter and, like many of her classmates during the Depression, she had to quit school and work to help support her family. Her brother went to study for the priesthood, and she worked to help pay his train fare to and from seminary.

She tells a story of loss: the death of her first husband, crushed by a coal car in the mines; of a son, killed in combat during the Vietnam War; and of her second husband, victim of a brain tumor. When the mines closed, she moved to New Jersey, where her husband, a former miner, found work at Phelps Dodge in Elizabeth, and she worked in garment factories until finding a better job in a department store.

But the Panther Valley drew them back. With their home paid for and their son buried in Summit Hill, the Pavlocaks returned. Now living in an apartment building, Theresa meets with her friends in the Nutrition Center for meals and maintains an active social life. In her narrative, she reflects on the changes she has seen in the Panther Valley over the years and the values that have been important to her and her friends. Her narrative is striking in its optimism and lack of bitterness. In a lifetime that to outsiders seems filled with loss and deprivation, Theresa Pavlocak focuses on the positive and finds much to be pleased about. The mines closed, there have been family tragedies, but she has survived, and, like so many of her neighbors, she takes solace in networks of family and friends and cherishes the successes of those she loves.

✦

I was born in Lansford, September the twenty-first, 1915. My father was John Geusic. It was Geovich in Croatian, but they modernized it into Geusic because nobody could pronounce it, and you had an awful time spelling it. My dad came to America with his three brothers when they were all very young.

Interviewed by Mary Ann Landis.

My mother—her maiden name was Pauline Kopras—came from a neighboring village, but [she and] my dad never met until America. She came to America with her [future sister-in-law], never thinking she would marry the brother.

The three brothers came to America together, George, Steve, and John. They all moved into Lansford and stayed, got the job in the coal mines and when they got married, they all lived with the one brother that had the home. [Each couple] had a bedroom, and then the women cooked together in the kitchen. That went on until they had one or two children. Then they each went off on their own. They all lived in Lansford.

[In Lansford there were] very few Croatians—couple families. We were all related. My aunts all had large families. My aunt Theresa had twelve children; my aunt Gloria had ten. My mother had four, and the fifth one, the little girl, died when she nine months old, from chicken pox. My aunt Theresa had five boys in the military during the war. She was a five-star mother.

Now, my aunt had quite a few girls in the family, so you never got two girls in a bed. They'd have four girls in a bed. They had two or three bedrooms and they had eight or nine or ten children. My mother had four, and I was the only girl, therefore I had my own bedroom.

I still hold onto that bed! I was always alone, so my aunt's daughters used to come down on the weekend. They would take turns. One day Anna would come down, the next day Kitty or Katherine would come down. We were very close. We still are.

I was the only girl in the family and I had three brothers. Steve was the oldest; he's a priest now. I have a brother Joseph, and a brother Frank who lives in Wayne, New Jersey.

My dad worked in the Coaldale colliery as a contract miner. At first [my parents] rented a little company home. Then as the years went by, they bought a home a block away on Ridge Street, which was the main street. Twenty, twenty-five years later they moved down one block on the same street. That's where my mother and I lived.

I lived with her when I was a young bride for a little while and then, like anybody else, we had to leave the town on account of the job. Then we came back. We came back and forth a couple of times.

As a Croatian my mother couldn't speak Slovak or English. I started first grade and nobody there to teach me. There was a girl, two doors away; she was in fourth grade. So she used to come over to our house, and she taught my mother how to read and showed me how to write one and one are two,

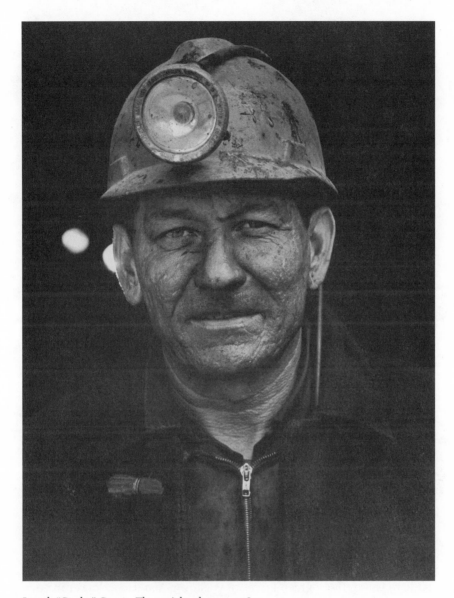

Joseph "Gimbo" Geusic, Theresa's brother, ca. 1967.

you know. Because my mother didn't understand it at that time, they didn't speak English. My dad couldn't read or write. My dad only had three grades of schooling in Europe.

I went to school at Saint Michael's and then I went to Saint Anne's High School, for two years. I had to quit because my brother was leaving to be a priest. He was stationed in Geneva, Illinois. The railroad ticket was fifty

dollars to come home every summer, and my dad couldn't afford that. I had to go to work to help out. Coal mines weren't working. So I worked in that factory for twenty-five years.

I guess I must have been about seventeen. I'm not quite sure now exactly when—probably '30, '31. [I worked for] Rosenau Brothers—Kiddie Kloes, Cinderella Frock. It was a wonderful factory, wonderful people to work for. They had three factories at that time in Lansford, one on Sharp Street, off the main street, one up on East Patterson, and then they had a factory in Kline Avenue. That used to be a pajama factory at one time. That's where I worked. We used to make the dresses, little panties with it—the Shirley Temple. Then they [combined them] into one down at the west end of Lansford, down by the ballpark, [in a building that] used to be the silk mill. At one time we had no union, so we didn't make a lot of money. But you made enough to put bread on the table; [that] made it easier for the parents.

[When I began] I didn't even know how to thread a needle, but we had a wonderful boss by the name of Agnes Babinitz, married to a Nichols. She was very good to the girls. She gave them jobs, trained them. I can't say enough good about her, because she was very good to me.

At one time, I think they had about three hundred, maybe four hundred girls working there.° They had the three floors down on the west end by the ballpark. They put us all in one building.

I didn't mind it. It was a job. You knew you were getting paid every two weeks and at that time, things were cheap. You put bread and butter on the table. The men had no unemployment [insurance]. So it made it easier for the parents. I cashed the check and I'd bring it home, or I'd drop off and tell [my mother] I had the pay, and then I'd go uptown and cash it and come back to work.

Of course we had very little to share. Payday, you'd come in cash a check, come home and give it to your mom, your parents. Maybe you'd get yourself hard candy, those green leaves or whatever. You had a drawer in your table, under the machine. You'd put that bag of candy in that drawer then you'd have that to put in your mouth while you're working. That's all you did. There was no such thing as having a lot of money. Most of the girls handed their whole pay in [to their parents]. Maybe your mother'd give you a quarter for a dance on a Thursday or Saturday. When things got better, then you got money to go to Lakewood.†

° At its peak in 1950, Rosenau Brothers employed 625 workers in its Lansford branch plant.
† Lakewood was a pavilion where big bands played for regular dances.

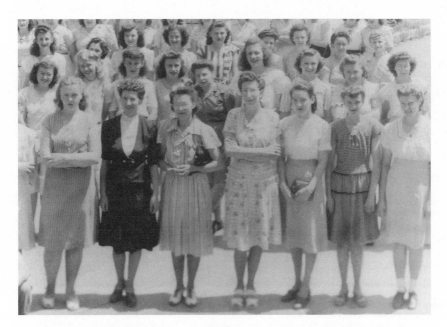

The Rosenau Brothers work force, Lansford, late 1930s. Theresa Pavlocak is fourth from the right in the front row.

[The union came when] I worked on Kline Avenue in 1933 or '34. [Rosenau Brothers] had a factory on Kline Alley and a factory on Sharp Street, off the main street. [Women] were picketing. There was a playground across the street, and I remember they were singing, about going out and striking. They were picketing and walking up and down with signs and all.

The coal miners were coming home from work. My dad found out I was out there picketing, and he got a hold of me and he said, "You go home. You need the job." That's how they thought at that time, because it was the bread and butter. But in time to come, they got organized. Before you know it they were all organized and everybody was in the union and Roosevelt put the minimum wage in.

[Miners like my dad] supported [the garment union], but they needed that help from that girl. They were glad to have the union but they were afraid, because the miner that had two or three daughters working in the factory, he had it good. He had three pays coming in—[more than] somebody that had nobody working in the Kiddie Kloes. That's when people started remodeling their homes. If they had three girls working in the family, they could remodel the home or buy a car. One girl would buy a car and they'd share it. You could see progress.

Then as the unions got stronger, the Amalgamated Union and the [International Ladies' Garment Workers' Union], they got the minimum wage,

and wages went up. So, it worked out fine. Of course, everybody grumbled. We all grumbled. But, you were glad you had the job. We made some beautiful dresses—Cinderella Frock, Shirley Temple. Oh God, they made thousands of them. They'd ship them into Philadelphia and they'd press them and put them on these big hangers, way up, and ship them all over the world.

When Roosevelt became President, that's when we got a minimum wage. I think it started at $2.40 an hour, then up to $2.60, $2.80, then $3.00, $3.20, and I don't know what it was after I left.[*] You had to work for it, piecework, you had to produce. We had some wonderful machine operators there. They were terrific. They were really good at it.

I was quality control on the floor towards the end. I used to examine the girls' work and see how big the stitches [were]. Then if the repairs came back, I was in charge of the repairs. I'd have a girl doing the repairs for me, and then we'd give her timework to repair one or two dresses; how many came back, we don't know. They produced an awful lot of dresses in one day.

I'll never forget one thing as long as I live. The girls used to mark the bundle numbers in the book.[†] Later on, I was quality control, therefore I was in charge of repairs. So, I'd go around and ask the girls, I look in a book, the bundling marked, and then I'd call my boss, Farina. We called him Farina—Michael Kalny, a wonderful person. I said, "Mike, nobody did this. Nobody claims they did it." He was comical. He got a hold of the dress: "You see this, girls? This bundle," he said, "I'm going to pass it up the aisle, and I don't want it come back down here on the motor. Because I'll know your stitch." He was clever. He was really something. He managed that floor. He was terrific. Him and Mary Swierczek—Mary Seaman was her married name—they were very good bosses.

[We didn't earn much but we had ways to have fun] because you didn't have to have too much money to have a good time in those days. You went to a dance for a quarter. At one time we used to go to the Sokol Hall, which

[*] The first federal minimum wage came in 1938 with the passage of the Fair Labor Standards Act and was actually $0.25 an hour. The minimum was raised periodically over time and no doubt reached the levels that she recalls here during her career in the garment industry.
[†] Garment workers typically received "bundles" of cut goods ready for sewing, and the bundles moved through the production process with each successive worker performing one or two related steps. Since women were pieceworkers and their pay depended on their output, they recorded their bundle numbers and at the end of the payroll period office workers totaled their output and determined their wages. As this story indicates, supervisors used bundle numbers when they found problems with the work and held individual workers accountable.

was, I think it was a quarter admission. Later on we used to go to Lakewood Park where the big-name bands were.

[Dances were] very popular. We had some of the best dancers in the valley, really wonderful. The Dorsey brothers lived in Lansford, up in Abbott Street. When they played, I went down. They were terrific. [Frank Sinatra,] oh God, he was the real thing—a little jazz bow tie on, sitting on the steps. This was when he sang with the orchestra. Just sang and sat on the steps there. Nobody even knew him. Later on I saw him in New York, when he made it.

There was a bar at every corner! On payday, all the men [were in the bars]! And wonderful food. Of course people didn't have the money like they have now. But the miners would work, come home from work, go to the bar, and have a beer or two and come home. [Drinking wasn't really a problem.] They drink more now than ever. They'd buy grapes and make a barrel of wine, and shower in the wash shanty and then come home and have something homemade.

There was no outlet of any kind [for women]. There was no bingo like now. There was nothing. What could you do? In the month of May, you had benediction, you had services in the evening. The children had to go and the parents would go with the children. People visited people. On a Sunday, your godmother would come up and visit you, and then on another week, maybe you'd go down to your aunt. Then they would come up and visit you. We were very close-knit.

Nobody had telephones. I remember as a girl, I lived next door to Chief of Police Cullen on Ridge Street. When we got a phone call, they'd call, "Mrs. Geusic, telephone." Then my mother told [her friends], don't bother the Cullens, because it was embarrassing, we couldn't afford the telephone. I think that was only $2.50 a month, and who could afford it?

All [we] did was jar, make chow-chow and you name it: jelly, homemade bread, different nut roll, poppy seed. Italian women did their thing. English women baked. My mother never knew how to bake a cake, because in those days in Yugoslavia, nobody made cakes. So my mother learned from Mrs. Cullen. She showed her how to bake a cake.

My mother only knew how to make kolach, like nut roll, poppyseed. Then Mrs. Cullen, next door, she'd be cooling the cakes off, like out the window, like a Fridigaire, and there'd be a cake about that high. She'd send over a piece of cake, my mother would send over apple strudel or whatever. Then she came over and showed my mother how to make a cake. First thing was a plain cake. My mother made the cake. Oh, we loved the cake.

Then before you know it, my mother showed her how to make nut rolls, poppy seed. We were all together.

I married when I was twenty-one in 1936. I married a fellow by the name of Michael Danshaw—[met him] at a dance in Tamaqua. My husband was a Tamaqua boy, but his mother and all, they were formerly from Lansford. The father was a railroad fireman and therefore they moved to Tamaqua on account of the hours that he worked. That's how I met him, in Tamaqua. We went together for three years and then we got married.

He worked in the bootleg coal. He worked as the bootlegger. Dig a hole in the ground, and get a rope and a bucket and go down and get the coal out. They got a ton of coal out maybe in two, three, four days. They would sell it, and that's all they made. There was no [other] work. That was before the war; there was no work anywhere.

If you didn't have job in the colliery, the men had no work. So they had WPA.* They worked on the roads. You didn't get welfare. We never got the welfare. We did it the hard way.

We got married in 1936, and I lived with my parents for a little while. [My husband] was unemployed when we first got married; there was no work, just the bootlegging stuff. Then he worked on WPA. From Jim Thorpe they hired you, it was a minimum wage. That's what Roosevelt gave the men, instead of welfare. So we rented a little home up on Water Street—ten dollars a month. He worked on the road, enough to put food on the table. You didn't have steaks, whatever, but you ate. You had enough to eat and all.

[Theresa and Michael Danshaw lived briefly in New Jersey, where their daughter was born, and then returned to Lansford; Michael found work at an explosives factory in nearby Hometown.]

Then war broke out, [and] that's when he went to the Atlas. Then [the Atlas company] transferred us. They built two hundred and some homes in Ravenna, Ohio. They moved our furniture; they paid for it. Beautiful cottages they built: two bedrooms, a bath—very nice—no basement, though, but lovely. They had it zoned, like where there were no children, they were in the first area. If you had one to three children you were in another area. And from three children up, you were up like where they had trees and brush where the children could play. It was lovely. He worked down there, and I did too. I worked in the dress factory.

So we went home to visit my mother. My mother was all alone because the two boys were gone. One was in Japan and Leyte. And my brother

* The Works Project Administration, a New Deal employment program that provided critical employment and income in hard-hit areas like the anthracite region during the 1930s.

Frank was in Pensacola, Florida. So my mother lived all alone and we visited my mom. My husband said to her, "Mom. If you can get me a job in a colliery, we're going to move back." He said, "Maybe when the war is over that job won't last, I'll be out of work again." She said, "Do you mean it, Mike?" He says, "Yeah." Because you couldn't get a job in the colliery at one time; you had to know somebody. We went back; we were gone about three weeks and the phone rang, it's my mother. She said, "Mike, you have a job if you want to come." Without any questioning at all, he said, "We're going." We put the furniture in the van and moved in with my mother and stayed until the brothers came home.

I only had one daughter. When she was five and a half, she was going into first grade. Her first day of school, we were going into church with his body in the casket. Her first day of school—[my husband] got killed in Coaldale colliery. [We'd only been back] a couple of months, and he got killed.

It happened on a Saturday morning, and the first day of school was Monday. I was in Bright's buying her shoes for the first day of school. He went to work that morning, Saturday morning. I was down buying the shoes for her, when they came over to me and they told me I'm wanted. They never told me why. They put me in the car. My mother lived on Ridge Street. Put me in a car and they stopped off at my mom's home. Took my daughter in and came out without her. They took me right down the hill, and pulled up in front of the hospital. Before they took me in to see him, Doctor Steel was the doctor at that time, they took me into a little room and they told me exactly what's wrong with him. He told me he wouldn't live, the two hips were crushed and one arm was practically mangled. They told me it's only a matter of time. All I remember, I fainted. That I know. I could remember that. When I came to, they took me over to him. Oh God, he looked terrible. So then they took him upstairs, and he lived until midnight. Then he died.

He wasn't a coal miner, he was a loader. The coal that the men had picked, whatever it was, they had these little cars where they filled up with coal. They were going with these cars over the rails, they were going around the curve and the fellow that was driving the motor, whatever they called it, was going kind of fast. This was a Saturday morning about ten o'clock. And ran off the tracks, and when the car pinned him up against the timber, they said he looked like Christ on a cross, because it caught the hips and the two legs and an arm. Till they pulled him out of there, it was quite a while. [He] lived like that until midnight. He was twenty-eight years old.

I had a brother going for a priest at that time. He was in Geneva, Illinois, about twenty-two miles north of Chicago. They notified him, and he came

home. I lived in the little home. I'd just moved into it, my husband and I, up here on East Kline Avenue on the five hundred block. My daughter was going to go to the first day of school Monday or Tuesday. They got him out of there and [he] died at midnight, and that was it. That was the end of my world.

They moved me out. They took me down to the seminary, to my brother the priest. I was there for two or three days. I came home, and they had me moved out. My mother moved everything out of that little home. I moved in with her, because she was alone. My two brothers were in the service. My dad was dead at fifty. He died from a tumor on the brain. So, I moved in with Mom, and that's where I stayed. She took care of my daughter, and I worked—same factory, sewing machine operator. They were making little dresses with little panties to match and I was what you called a joiner, putting the front top of the dress on with the front skirt. I did that for a number of years.

I never got over it. It lived with me forever. Till today I could feel it. You never get over that. But it gets easier as the years go by. It comes to you sudden, all the time.

Then I was a widow for ten years. I had a wonderful mother. She was terrific. She babysat my daughter. My daughter had a lot of loving care. My mother loved a little girl, because she had me and then the three boys. The boys got married, and my daughter and my mom and I wound up living together. I stayed with my mom until I remarried, which was about ten years. My daughter was fifteen when I remarried.

Michael Pavlocak had just buried a wife too. She had a little boy three years old or three and a half. Jimmy was born, and she died right after Jimmy was born. Jimmy must have been only about two-and-a-half, maybe three weeks old when she died, from a gall bladder operation. She was in a hospital and right after the baby was born she had to go back in, and after the operation she died.

He had an infant and a little boy, Michael. His in-laws were very good—the Maholick family, Aunt Steffi, Aunt Anna, and Aunt Rose. Aunt Rose took Michael. Aunt Steffi and Aunt Anna, they raised Jimmy; he was only two-and-a-half-weeks old when his mother died.

I knew [my second husband] as a Lansford boy. I met him after his wife died. He came home from the service and married his sweetheart, Mary Kostecky, a lovely woman. He married immediately, because while he was in the service, his mother died from a heart attack, and his father remarried and he had no home. He had nowhere to go. So he went down to his sister's. He stayed with his sister for a while, and then he called his girl-

Theresa Pavlocak (*far right, front row*), with fellow members of the AmVets auxiliary, early 1950s.

friend up, Mary, and she came down. They got married, I believe, within a month.

[It was] about ten years after his wife died that I got to know him. He worked at the strippings when his wife died, and then he worked in No. 6 or No. 4 colliery and then worked in the Coaldale colliery. After Coaldale shut down [in 1954], that's when we were married. He said, "We're leaving. We're not staying here. There's nothing here."

Jimmy was in third grade when we moved to New Jersey. [The mines] were closing one by one, and the GIs as they came home [from the Korean War], there was no work here. There was nothing here. The factories kept the town going. Then Bundy Tubing opened up in Hometown. If you were fortunate enough to get a job there, you were all right. They had small plants around here, but not enough jobs for everybody. So he worked at every colliery, and at the strippings. He was an oiler at the strippings. And he's leaving, he said, "There's nothing here. We have to go."

We owned a home at that time—rented the home out, moved to New Jersey. He said, "I'm not going to commute. We're going to move down." And we did. We wound up in Edison, New Jersey. He worked in Jamesburg, in Phelps Dodge, [making] copper tubing. It was a brand new factory

that was just built, and he was the third man hired. He worked there about twenty years when they shut down.

My daughter got married before we moved down. My daughter was fifteen when I married Mike. She graduated high school and went to Allentown Business School. Then she got a job in the Allentown *Morning Call* and met her husband at that time. They started going steady and got married. After she was married a couple of months, that's when we moved to New Jersey. I rented my home out. My husband said, "We're going to rent it out, in case we have to come back." So we kept the home for about a year.

[A lot of people from the anthracite region worked in New Jersey when we did.] If you went to New Jersey, you went to an employment office and you told them you were from Pennsylvania, they hired you right there. Because they were good workers. The Ford company, General Motors, all those companies [were there]. You go to the employment, you take a physical, if you pass, you have a job. There was more Pennsylvania there than anything else.

Sometimes three, four men got together, and they would take turns driving every morning. They would get up three, four o'clock in the morning, come to work and go home at night. Some of them stayed for the week. Four or five guys rented an apartment, and they'd do their cooking or whatever. Or they'd bring their food, the wives would make meals for four or five days, put them in the cooler with ice, bring them down there, and then they would eat. Four or five men would rent an apartment and eat together and take care of one another. Then they would drive home on Friday night.

I remember a gentleman. He traveled back and forth—never saw his children go to school. In the summer they were on vacation, and when he worked, he'd only come home on a Friday night. If he worked Saturday, he didn't come home until Saturday night. If he worked until four o'clock, he wasn't home 'till seven, eight o'clock at night with the family. They'd wait up for him to have supper with him. But he never saw them going to school.

We were lucky. We moved down there, and like I said, [my husband] had the job, he traveled between eight and twelve mile a day to work. It was in Jamesburg, and we lived in Edison, which was very lovely. You could have walked to Rutgers University from where I lived. It was Edison, Highland Park, and New Brunswick.

At that time President Kennedy was running for office. And we were making the Jackie Kennedy dresses, the plain dresses that she wore, the shifts. We completed a whole dress, put the zipper in, everything, and even the ribbon in the bottom of the dress. All they had to do was hem it. That's what

I did. [Occasionally] I went to collect unemployment, and when you said you were a machine operator, oh, that was terrific. You were never unemployed, because nobody wanted to do that work. They were all in factories like Westinghouse, these big factories, RCA, where you make more money.

I liked it, but I wanted to get out of that business. I only worked there a short time; I wanted to do something different. Then they opened up a store by the name of Great Eastern. They had an "employees wanted" sign, and we were shopping, my husband and I, and he went out to buy, and I ran up those steps and I put my name in for employment. Mr. Merson was the boss. He hired me right there. He said, "You can start tomorrow morning." Well, I started putting coat hangers on racks, filling shelves out, and then after the store opened, they put me in the ticketing office in the back, where they put the tickets on—the prices. They put me in charge of that. So I had four girls working for me in the back, and three stock boys. Maureen Morgan was my boss; she was a supervisor. As the truck came in, she had an office, and checked it all out, and then when they unloaded it, I took over. Then I would call the different departments through the intercom, "Come and get your merchandise. Your shirts came in," your blouses, whatever.

I loved that job. I worked there until the very end, until we moved away. Every day was a new experience. I didn't want no dress factory or nothing. You had to work too hard. You were going all day with the sewing. You had to produce—a lot of pressure. [The Great Eastern] was more like playing! Merchandise was coming in and you look at it and you ticket it, and you didn't have to kill yourself and you didn't have to work too hard.

[My husband's] factory, [Phelps Dodge], worked about fifteen or sixteen years, I think, and that's when they shut down. That's when my husband got another job—Squibb's and Union Carbide, where they made these big, enormous cable wires for ships and these big elevators for these high-rises in New York City. It was Okonite and then it was Squibb's. That's where my son's working right now and his wife's in the office; she's got a very good job.

We bought [a] ranch home; we got a twenty-year mortgage and I think our payments were very little. That home was eighteen or twenty thousand dollars. That wasn't a very big mortgage, compared to some of the homes there. We sold that home later on for double the money—double the money!

My husband worked shift work, and then he was steady day shift, so we did everything together. He'd peel potatoes; I'd get the supper ready. He'd wash dishes; I'd dry. He helped me clean. You had to work together. At that time, it was typical in New Jersey.

[My sons attended] Saint Michael's here and Saint Matthew's in New Jersey. When they left Lansford one was in third grade, one was in fifth. Right away we enrolled them. The next day, we went to Saint Matthew's. It was the church around the corner. We enrolled them and they went to school two days after we moved in there.

But it was hard. I had to work. My boys—Michael and Jimmy—had a paper route and they'd make quite a few dollars. We had a bowling alley, they claim it was the world's largest bowling alley, Edison Lanes. They had an awful lot of lanes. Our boys used to go there and pick those pins up. They'd make up to fifteen, twenty dollars a night. And they delivered papers.

As soon as they were old enough to drive, they'd get themselves a little car. But we would take maybe four or five dollars off [their pay], just to make them feel like they're giving something.

[Michael went to] Rutgers University, [to study] communications, for radio and TV. He was going to be a sports announcer. In that field you had to go to college. That's when they drafted him for Vietnam. He never made it home. He got killed. So, he never made it home.

After his brother got killed, my son James just fell apart. He was in the Navy, and he just fell apart. Didn't care for education, you know. Finally, as the years went by, he got an education. He has a nice job now; he has a lovely home now—beautiful children.

We built that ranch home, we had a twenty-year mortgage, and we were there for twenty-two years in Edison. The home was paid for. We only got a twenty-year mortgage because we were too old for a longer mortgage. The home was paid for and Michael was buried in Summit Hill, up here. My husband said, "We're going to go home. We're going back home." And that's what we did. We came here and bought a home. Sold [our New Jersey] home overnight, no problem. Moved out and that was it.

We bought the home right here [in Lansford]—East Kline Avenue—lovely home. We bought that and we were very happy, had a wonderful life. [Even without the mines,] the people educated their children. So the children grew up and they all got jobs. They went to Penn State, Lehigh, to different colleges, business schools. And the ones that didn't get educated got jobs in Allentown or wherever. They got a job and they bought homes here and married and raised children and educated their children.

People were proud; they didn't want no welfare. Not like now; people look for it. In those days, people were proud; they didn't want it. [When the mines closed,] I don't think there was any unemployment [insurance] at that time, when they first closed. I don't think so. You'd go out and you'd

get milk—milk and bread they gave you or whatever. It was very little, but people got along.

Then [my husband] developed a tumor in the brain and died and that was it—ten years ago. He had a buzz in the ear, that's how it started. A buzzing and then he was forgetful. Sometimes you'd tell him to go down, bring something down from the basement, he'd come up without it. He said, "I don't remember." Dr. Evans was the one that found it. He told him, "You'll have to go to Allentown." They operated on that head—took half of his skull bone out on the left-hand side. He had wires in through his whole head. Abcess running right through it like a sieve. He lived like that for a year. He had a horrible death—a whole year.

I went through a lot of changes [in my life. My husband worked a lot around the house;] my dad never did. No. The men used to pick the coal, chop the wood, cut the grass. I never remember him doing dishes or nothing. But he was a wonderful, wonderful dad.

At the time I was about forty, that's when things start[ed] changing around. Before that very few men did any work in the kitchen. But now, men are cooking like women, with the microwave oven, or whatever. I know my son, if he comes home first, he'll make the meal. If [his wife] comes first, she'll make the meal. It's different now.

We had it hard. Our boys went to Catholic school, so between my husband and the boys, I'd have twenty, twenty-one shirts in the wash. At that time, they weren't perma-press. You had to iron them. We had a big basement, like a rec room. We had a clothesline strung along there, and as you'd iron the shirts, you'd hang them on that rope there. When they dried up, then you'd take them up in the closet.

[Today I go to] Saint Michael's. My daughter goes to Saint Anne's. [Saint Michael's used to be Slovak.] Saint Anne's was Irish, but then as intermarriages came, [it changed]. Now my daughter [goes] there because she married an Italian fellow and they're members. Her children went there and to Marian High, Catholic.

[Kiddie Kloes is] in shambles now. The girls all married, most of them. I'm seventy-nine. I buried about four or five girlfriends already—within a couple of years. So, it's different. [Young women] don't want to work in factories now. Parents don't want their girls in there. They educate them. They're either nurses, beauticians, or they're working away from here—in Allentown, wherever.

Not enough women in the valley to do it. You don't have them. Most of the girls are educated, they're nurses or whatever. If they get married, a lot

of them move away. Their husbands work in Allentown. The boys are educated, they go to Marian High or Lehigh; all the mothers wanted their children educated. So they work for that education—Penn State. When the children got educated, now there's grandmothers, like myself and all, my son lives only in Jersey. But I have a girlfriend with a son in California, Milwaukee—they're all over.

My mother and dad always felt that you needed an education. Because my dad couldn't read or write. But my mother did. [Educating their children was] definitely their intention, but nobody could afford it. It was only the doctor's children that were educated, or a pharmacist's, or a lawyer. Ordinary man, if he had two or three girls working in the factory and they had one brother, they would educate that one brother. Then he would get up in the world and he would find work for the sisters' children. I have girlfriends, they go all over America because they have four or five children living away from here, they're going to California. They go to Texas, my sister-in-law went to Texas. They're riding for three, four days in a car. Quite a few are in Florida now, quite a few.

[When I first worked in Kiddie Kloes my thought was to] get married and have a life of [my] own and get out of here. I loved the people. I loved the togetherness. The people were wonderful—everybody got along. But you wanted better. Because you saw better. As you got older, you had more money and you could go to New York City, you went on vacations. You'd see people with these campers and all, you have nothing. That's how it started. Then the boys got educated; they left, they got jobs, and now the grandmothers and great-grandmothers are traveling all over.

[Those who never left didn't] know no better. You live like that and you don't know no better; you're happy with what you have. You're glad that you have a roof over your head. You have a table to eat on and a bed and you're clean and you have your church. And they're happy, very happy. They're the ones that educated their children.

They're the ones that are traveling now; they're going down to visit all of these children. It's wonderful. My neighbors have a daughter in Florida and a daughter in Washington, D.C., and California. They used to go visit all the time. Well, right now they can't do it, but see the world and you're happy for your children.

It seems like the children are all away from here and it's just a new generation coming in here—different people. We have quite a bit of welfare. There's a lot of new people moving in on welfare—in order to help them, for them to pay the rent. They get their rent and a few dollars, whatever

they get. If they're happy on welfare, I guess they stay there. Most of them don't want to, though. No. Like all my friends' children, they're all educated or they're away, they all have good jobs. My son, he has a good job.

[What do I see for the future of the Panther Valley?] I don't know. I have no idea. All the homes are remodeled. People really take care of them. They're well taken care of. People are wonderful. But I guess, maybe when the old people go—well, my generation—I really don't know.

Now they're starting to bring [new jobs] in. A lot of men commute to Allentown, Bethlehem. A lot of them travel, two, three hours. They come home, they make money and the wife's here, and they're happy. A lot of people will not leave the valley. No matter how hard, they love it here and they stay. And they're managing. You look at the homes around here, they're all remodeled. They're all taken care of. They have a lot of beautiful cars. But they worked for it. It wasn't given to them. They worked for it.

[The mid-rise has been here] ten years.* I should have moved here two, three years ago. It was too much for me [living on my own]. That's why I like it here. See, how I stagger. I can't be left alone, walking around the streets—no way. I go to the Nutrition Center. That opened doors for me. I'm going there since it opened in this building, downstairs in that big dining room. We ate here for a number of years. I used to come down here every morning to eat with all my neighbors. We'd walk down here and eat. Take turns with the dishes, every table would take turns.

[The Seniors Nutrition program has been going on] about ten years, which is a godsend. This way, people get a meal. In here there's quite a few women on wheelchairs. They can't cook. They bring the meal into them, and check them. My granddaughter used to come in here; she's a nurse's aid. She'd come in here, take care of the people, feed them, or whatever.

[Seniors are here in big numbers] because they're the ones that worked like I did. Like my neighbor, she's living in here ten years now. The girl over there worked with me. She's in here about eight years. They sold their houses; their children are married—they're gone. You can't take care of a big home when you're that old.

The people are wonderful—the women, the men. They're neighborly. I have no complaints. If I did, I'd be lying—really. Debbie Ryan, up at the Nutrition Center, you couldn't get a finer person.

* The mid-rise apartment building in the East End of Lansford offers elderly an alternative to living alone in the homes and duplexes that predominate in the community.

Now the Golden Agers, every Monday they have a meeting at one o'clock and they have a couple hundred women coming down there. They go to different shows. They're very active. I don't go on Monday because I go to the Nutrition Center with my crowd. We have a certain group; we have two cars between us. If you don't go with the driver, then you won't have a ride. We don't want to drop that. A lot of them go to the meeting on the Monday, and then they'll go to another meeting on a Tuesday, then they'll come up there to eat on a Wednesday. But see, we don't do that. We just go up there.

[It's been] ten years [since my husband passed away.] It's a long ten years without him, boy. It's hard. But you cope with it. I'm used to it. I bounce back. I tried to. I make an effort—you have to. If you don't, it's no good. I didn't want to admit it, I'm fighting that up there in that house all alone and cleaning and I'm not giving up, I could do it. You know? My daughter was telling me, "Mom, you can't do it no more." "I can do it." She said, "Sure the house is clean, clean crazy." I landed in Edgemont.° I had a breakdown. I was sick, overworked. Nobody knew what I was doing in there.

[In the old days when women had problems] they didn't talk about it. Everybody kept it to themselves. Now you have a different situation, you have your great-grandchildren. They don't get married, they live with one another. If you don't accept it, you're going to drive yourself to drink. So you accept it. You don't want to lose them, you want them to come to your home, so in order not to lose the children, you accept it. You let go and say, "They're living together, and that's it." You don't hold it against them. Otherwise you don't have anybody.

Oh my God, it's a whole new world! If I did that, what my grandchildren do, it's not that they're bad, it's the way of life. A whole new world—frozen TV dinners, you know. Boy, if you ever gave that to your husband, he'd throw it at you. But, I make them now myself. If I feel like cooking, I'll cook, I'll make a meal and I'll have it for two days. If I go up there to eat, then in the evening for supper, I'll turn it on and I'll warm something homemade to eat. Maybe a pot of barley soup or something, you know. Food—Lord knows, we love to eat.

I remember as a little girl, we had an Italian neighbor and they sent over spaghetti and meatballs, we didn't even want to taste it. That's how it was. That was when I was a little girl, mind, I'm seventy-nine. That's about sixty-

° Formerly a country club and residence for single managers employed by Lehigh Navigation Coal Company, Edgemont in more recent years has been a hospital and an old-age home.

Theresa Pavlocak in the Kiddie Kloes factory after it closed, with Marion Pavlik, last employee of the company, spring 1996.

nine years ago. So we didn't eat the spaghetti; we ate the meatballs. Then later on my mother got the recipe, and she started making it, and boy, before you know it we're spaghetti eaters! We're all eating spaghetti and the cheeses and all! You learn.

People cared for people. There's more of it now. I think the grand-children are going back to the grandmothers, to the great-grandmothers and all. They're skipping that one generation. Like my great-grand-children, I'm very close with them. They mean so much to me. The grand-children, they're already twenty, thirty, so they already have their life. But the great-grandchildren, they come in. They're so innocent, you know? I never thought I'd live that long. I thought I was a goner—[but] here I am. I went through a lot. I hope when the people hear [this, they] don't think I'm making it up or anything. This is my life.

Ziggie Whitecavage in front of the United Steel Workers of America local, Fairless Hills, August 1996.

Ziggie Whitecavage

Levittown April 8, 1995

The last two narratives offer very different views of the closing of the mines, for they present the stories of two individuals who moved permanently out of the region. Limited family networks made it easier for some residents to choose migration in response to the region's declining economy. Examining the backgrounds and experiences of people who left provides insight into the motivations of those who persisted. The stories of those who left and those who stayed are equally important in understanding the impact of economic decline on the anthracite region.

Zigmund (Ziggie) Whitecavage, son of a Russian-born miner and union organizer, quit school after the ninth grade to work in the mines. An excellent student, he had outstanding leadership skills and soon rose to secretary-treasurer of the Shenandoah General Mine Board. While working on the strippings, he represented mineworkers as a grievance man. With the mines operating sporadically and prospects for promotion within the union limited, Ziggie headed to the newly opened U.S. Steel plant at Fairless Hills in 1955. Drawing on his experience in the strippings, he drove heavy equipment at the steel mill and worked for almost twenty years, until his black lung caught up with him. He enjoyed an active retirement for twenty-three years, until he died of a blood clot in his lungs in May 1997.

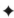

[I was] born in Shenandoah, October the sixth, 1912. My father was Anthony Whitecavage, and my mother—who died when I was two years old, of the flu epidemic—was Helen Wynoski. My mother was American-born and my dad was born in Russia, what they called Byelorussia—White Russia. He came over in [the] early 1900s.

[They met] in Shenandoah, at church, because she was a choir member there and if I'm not mistaken, I think he belonged to the choir, too. [That was] Saint Casimir's, a Roman Catholic church in Shenandoah. The masses

were observed in Latin, and naturally the sermons and stuff were given in Polish.

I was fluent in Polish. I had one year of Polish school, because you had to go one year to Polish school in order to receive First Holy Communion. You attended catechism classes and stuff, and after First Holy Communion, I went back to public school.

My sister and I were the only two [children] that survived. Two twin brothers died, but I was the oldest and my sister was next. [After] my mother [died], my maternal grandmother raised my sister and I, until [my dad] remarried [when] I was seven years old. When he remarried, the stepmother didn't want the girl. She didn't like girls, but the boy was handier around the house for chopping wood, cracking coal, hauling the coal, taking care of the ashes, like they called it. But my sister they put away in an orphanage. If you don't think that's heartbreaking, I went through it early.

[I lived in a] company house [with] my grandparents—three rooms downstairs and three rooms upstairs, with a basement for the coal bin and firewood—part of a double house. Most of the homes in that area were double houses.

I went to school in Shenandoah until the fifth grade [when] my father bought a home in Frackville. Homes were booming at that time and they were selling double blocks in Frackville, because I recall that they bought half of the double block for five thousand dollars. That was big money at that time.

I lived in Frackville for seventeen years. I went to school in the ninth grade. As I finished my freshman year, my parents made me go to work in the mines because they needed the additional revenue. In fact, the principal of the high school, my English teacher, my sixth-grade teacher, [and] my fifth-grade teacher all came down to the house and begged my parents to send me to school because I had great potential. I'll never forget that.

Oh, I loved [school]. My marks never went below ninety. [My best subjects were] mathematics and spelling. In fact I was a champion district speller there for a couple of years. They call me the walking dictionary up at the Union Hall. I not only spell the word for you, I'll define it. I've never lost that knack. No, the good Lord blessed me [with] a lot of brain material.

[My dad] was a miner [for] the Philadelphia and Reading Coal and Iron Company [the P & R]. He was a contract miner. I started to work with him as a laborer when I was fifteen years old. There was no question—no thought whatever—about sending people to college during that era because people were just plain, downright poor.

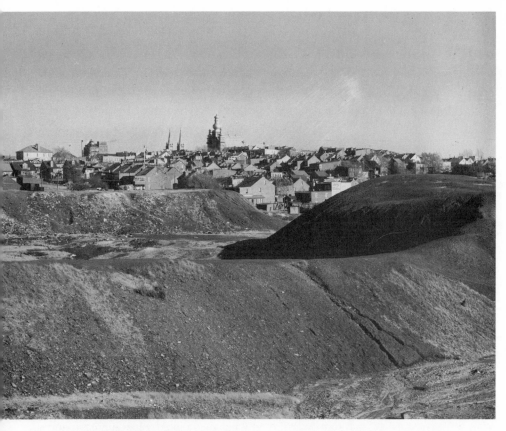

Shenandoah, Pa., hometown of Ziggie Whitecavage, 1938. Courtesy of Library of Congress.

My father was one of the first organizers in the union, the United Mine Workers of America. In fact, he was the one that organized what they called the nationality or ethnic locals—the language locals—because he was fluent in seven languages. He spoke and wrote Polish, Slavish, Ukrainian, Lithuanian—I think it was seven languages. That's where my dad started to organize, in Shenandoah.

I can recall I was nine years old when I used to do his notes in English for him. He'd dictate to me and I used to write and he would read these at the meetings. He had to be able to give it in English because as far as the other languages were concerned, just off the top of his head, I guess, he spoke to the people in whatever nationality they were. [I was] much better [in English than he was]. He would tell me and I would write it right down for him.

Within a few months I got my miner's papers, so I became a full-class miner. I mined with my father until they closed the mine down. That was

approximately two to three years, right after the 1929 crash. You remember the bank closings and all that?

In all probability, I guess they just lost out. They weren't competitive enough; some of them were independent mines, and they couldn't make it. I got ahead of my story there a bit because my dad worked for P & R in Shenandoah, but then I started to work with him at East Bear Ridge, what they called the Wildcat section of the Lawrence Colliery in Frackville. That's where the mine closed because it was too small. They couldn't compete with the P & R. The P & R pushed a lot of the other companies out of business.*

Madeira Hill was the name of the company that owned [the Lawrence colliery]. After I got away from mining, the Saint Nicholas breaker come in. It was a large preparatory plant, and they took care of maybe a dozen mines in that area. That was much later.

[I found the mines] very scary—very scary. We had what they called a carbide lamp, and you had to put the carbide into the little container and spit in it and screw it on and then strike your spark to light it. Well, if that light went out, you were completely in the dark. The battery lamps came in later.

About the time that I left, they were just getting the battery motors, bunch of batteries on a lokie, that's what they called it.† They transferred empties in and pulled the loaded [coal cars] out.

[At East Bear Ridge] you got on what they called a loading cage and it hoisted [you] down. By the same token [the] same cable that went down into the mine used to hoist up the loaded cars. We just had the one [level] [about] three, four hundred feet [underground]. That was an individual, smaller company than the P & R. Now, Maple Hill was the deepest around. I think it was twenty-one hundred and some feet. After you got down to that level, they had a slope driven down in underneath the ground, down into the next level. They were deep and large veins. In fact, they said the vein under the borough of Shenandoah was a hundred and twenty-five foot thick, which is a very large vein.

* The P & R was a major holding company that controlled the Reading Railroad as well as mining rights to tens of thousands of acres in Schuylkill County. It ran its mining operation through a subsidiary, Reading Anthracite, and leased a great many mines to local operators. As part of the lease agreement, the company required the operators to process the anthracite at one of the company breakers and to ship the coal on the Reading Railroad. Local antagonism toward the company for its monopolistic practices was widespread.

† Lokies were electric locomotives that operated within the mines, taking coal from the working faces to breakers that processed the coal.

The contract miner was the one that used to work at the face. They drove gangways in towards the vein because you didn't go right into the coal vein as it was. You just drove gangways, and they used timbers—two legs, and a collar across the ceiling—but they drove poles over these collars as they were taking this looser stuff away, which we scooped into railroad cars.

The gangway that I worked in with my father was what they called loose. You put your legs and your collar up, and then you drove poles up over the top to keep that loose material from coming down, because it would run forever, you couldn't keep ahead of it. You had to scoop. In fact, the contract miner used to sneak pieces of plank and stuff in, to contain it, on top of the poles that you drove. You know how they drove them in the ceiling, you had to drive from the sides, too, because there was a tendency to be loose material on both sides. Oh, that was terrific work. You knew you worked when you worked there.

You get so far and the contract miners would get paid by the footage— how far they drove. That's the way they got paid, until you got your gangway established. Then your contract miner would drive chutes up along the side, and they'd put a brake handle in that to contain the loose material that used to come down. They used to load this in the cars and the contract miner got paid by the cars that he loaded.

Bootleg mining came about because of the fact that they were shutting down these different mines, and people had no other industry to turn to, to go to work. They were forced into bootleg mining, which later they called independent mining. At one period there, they organized and had their own union. But, the majority of the people up there, that was one other way that they could make a living. That's why they turned to bootleg mining. Anywhere that a mine or any breaker or anything closed down, where there was a possibility of getting into the various veins of coal that still were untouched [men would set up bootleg operations]. A lot of bootleg miners took awful chances, used to cut into these barriers, because that was all pure coal. They used to bootleg that.

They'd rob the pillars.° That's what they called them, pillars. Up on the surface—and they'd go right down to the vein. But then they'd start get-

° Pillars of coal are left behind when an area is first mined to support the roof of the working area and to ensure against future subsidence of the earth above into the cavity created by the first mining. Coal bootleggers were commonly mining through an area for the second time, and to get out enough coal to make their work pay they were tempted to "rob the pillars," that is, to remove the pillars supporting the roof. If the pillars left behind were too slender to support the roof, cave-ins could easily result, endangering the lives of the bootleg miners and homes and streets on the surface above the mines.

ting to a dangerous point where they got cleaned out so much that they had a tendency to collapse, or cave-in, and cover them up.

It was very dangerous. You had no supervision, no one to go in and inspect and say that, "Well, this is a bad area," or, "This is bad air here," or whatever. There was no safety provisions there at all. You just took it upon yourself and you went in and did these things. I did [bootlegging], but not to a great degree. Whenever the tendency came to a pinch, or squeeze, you went out and earned what you could.

I was twenty-three years old when I left home. I was living in a boarding-house. It was a form of hotel. You got a room in there and that was it. Just a bedroom, you didn't do no cooking. You ate at outside restaurants around. There were hot dog, hamburger stands and everything, catch-as-catch-can.

I worked various places, doing all kinds of work, until the war broke out. Then, I went to Sun Shipbuilding and Dry Dock Company in Chester. I worked there for several years. In fact, I was married in 1942—Mary Kalinowski. She was from Shenandoah. We went to the same church and everything else together. I'm ten years older than my wife. And she was twenty.

From the shipbuilding I went into the service in '44. I came back in '46, honorably discharged as a sergeant. [I served] up in the Aleutian Islands.

[My wife survived on] the allotment that she got from me and she went to work in one of the garment factories up there, the Martin Shirt Factory. Her mother and father raised my daughter at that time. My daughter was born January the tenth, 1944, because they took me into the service in March of '44—the draft board. They didn't give a darn up there, whether you were married, thirty years old or anything like that. You had a possibility of getting away down in the cities. But up there, your communities were small and everybody knew everybody else's business. My wife used to take abuse when she'd go up to the general store where we dealt on the book. She'd take abuse from all those neighbors and would-be friends that used to call them, saying that, "Oh, your husband is down in the shipyard working," and their sons and their brothers and their fathers are away in the service. They finally complained enough to the draft board, so they took me in. I was thirty-one when I went in. Then, I get on to raising the family and that, after I come back from the service. We didn't have our son until four years later, which made him five years junior to his sister.

When I came back from the service I was on the 52–20 club for seven months, working odd jobs wherever I could pick something up, because [the] mining industry wasn't doing too much. You were granted fifty-two

Ziggie Whitecavage in the Aleutian Islands, ca. 1945. Courtesy of
Jennifer Hunter.

weeks at twenty dollars a week. That was from the government. It was, in
reality, a severance pay from the army. We got a three-hundred-dollar lump
sum. They called that a bonus. That's what we had to struggle along with.

I waited seven months, until I got [a job at the] Shen-Penn production
company, it's Philadelphia-Reading Coal and Iron. It's the outside strip-
ping, where they had these big Euclid trucks and the shovels, draglines,
dozers and everything like that.

I started off as a Euclid driver, but then they realized that I was capable
of being the grievance man, which is what they called a shop steward. I
represented the workers. I got enough of that education from my dad, who
had to represent the workers.

You get paid by the union for the amount of hours that you put in on the
different grievances or whatever business you have to do representing the

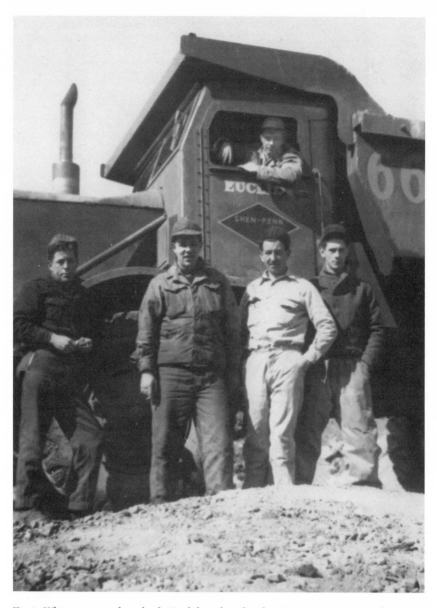

Ziggie Whitecavage in the cab of a Euclid truck at the Shen-Penn strippings, October 1946.

union. Then the union paid for that. The company paid you nothing; they didn't like to be associated with anyone that represented the union.

You attended meetings—whenever a problem came up or you had to bargain for a raise in wages or better working time or looking to establish the Occupational Disease Act, to take care of miners that had miners' asthma, which was an occupational disease—that was paid for by the

[union]. After lobbying for it for a while, and working with various political representatives, we finally got it through. We started to get miners a hundred dollars a month or a ten-thousand-dollar lump sum settlement. So, we had to take care of all that for the miners.

After getting in as a grievance man, I had to have steady day-shift work. Working on the Euclid was three-shift work. You alternated shifts. That would interfere with my attending meetings, so I worked myself into a steady day-shift job. I started to work with the charging of dynamite and stuff like that, which you could only do during the daylight hours. You had to watch; you couldn't go around with spotlights and flashlights trying to fill the holes up with the silt that we used to put in to tamp the holes. They had fuses running out of these holes, where they connected them all together and then they blasted pretty good areas. That would make the stuff available for the shovels to load in to these Euclid trucks, haul the debris away, and haul the coal directly into the preparation plant. That was steady day-shift work, that hauling of the coal, because that was tied in with the charging and blasting. So, many a time I worked and drove the coal truck.

As I said, in 1946, the Shen-Penn production company started their stripping; I started to work there. The following year I became a grievance man, or what they called a shop steward, taking care of the problems of the workers. From there on in, I was elected to be grievance man for the next nine consecutive years. In the meantime, I also became secretary-treasurer of the Shenandoah General Mine Board, which represented thirty-two locals.

The mine board heard all the delegates from these various locals coming in with their problems. They would describe what happened, what kind of settlements they made, and all that. We took these things into consideration and used to compile them. Whenever we had to get together to go for any kind of legislation or for contract, on contract renewal time, we had to have things that we had to propose and say that this is the things that we demand in this next contract, like a raise in pay, or shorter working hours.

[Contract proposals] came out of the [process] because, naturally, you heard what their problems were. You matched them to your own, and all that. And we discussed them. They appointed us on the political action committee, which did the lobbying in Harrisburg and Washington, D.C. We went down there with this knowledge all compiled. We knew what we were driving for and what we wanted.

[Around 1950] it was starting to deteriorate. We were lucky to get two days a week work. You got paid every two weeks. If we got five days' pay for a two-week period, that was considered tops. But you couldn't begin to

JOSEPH MACHULSKY, President

BUY VICTORY BONDS

EDWARD H. KRUTULSKY, Sec'y.-Treas.
111 East Coal St.
Shenandoah, Penna.

Edward Kristopolski
President
Zigmund Whitecavage
Secretary

SHENANDOAH GENERAL MINE BOARD
UNITED MINE WORKERS OF AMERICA

Shenandoah, Pennsylvania

8

July 15, 1952
321 West Columbus St.
Shenandoah, Penna.

John L. Lewis, president
United Mine Workers' Bldg
Washington 5, D. C.

Dear President:

We plan to write a history of our General Mine Board,
organized in the early days of our union in the Anthracite Region.

Recessing only a short time during World War I, our
organization has conducted weekly meetings since 1907

Our history will be told in a pamphlet circulated to
mine workers and friends in our area. It will also mark – and
we intend to note this – the Golden Jubilee of the Anthracite
Coal Strike Commission or the inception of the Anthracite Board
of Conciliation.

It is our intention to dedicate this history pamphlet
to you, Mr. Lewis.

We intend to show the people of our area some of the
highlights of our pioneer background and growth. We feel it only
fitting to dedicate such work to you, our unmatched leader.

Our intention is to use your picture and a message from
you in our preface to the history. We hope to have the pamphlet
ready for distribution on or about Labor Day, 1952. If this date
is too soon for our extensive research work, we will distribute
the history later this year.

We will send you a "Proof" of our entire pamphlet, if
you wish, prior to your message. We can reserve space at the be-
ginning of the history for your picture, the dedication and your
message.

Sincerely & Fraternally,

Zigmund Whitecavage
Sect-Treas.
General Mine Board
Shenandoah, Penna.

ZW/TB/

Letter from Ziggie Whitecavage, secretary-treasurer, Shenandoah General Mine Board, to
John L. Lewis, president, UMWA, July 15, 1952. Courtesy of Historical Collections and La-
bor Archives, Pennsylvania State University.

live like that. As you get older, you can't work in that industry too long. That is another thing that I found out through living all these years. That mining industry, if you hit the fifty-year mark, you were lucky—darn lucky. Accidents happen up there and they didn't think any[thing] of them. You had no protection. Those are some of the conditions we used to fight for.

There was some [underground mining], but not that much because they were all looking to the fact that they were going to strip-mine. They were dismantling breakers left and right. There were breakers being shut down every few weeks—a breaker here, a breaker there. At one time, there was a bunch of breakers up there, all around, but they dismantled them and got rid of them.

I still had enough drive in me. I wanted to get into the United Mine Workers organization, become a staff member, or one of the district officers, or something like that, where there was money. You understand. I'd work office work and stuff like that, representing the various locals, and I worked until 1955. I was supposed to go down as a staff member, I could show you, in this book, the two guys that went down—this Karlavage and Billy Rogers.

It was an autonomous local at Gilberton, but they were looking forward to this big shovel coming in there, and then opening up the local. Because they were non–dues paying yet. So this president of district nine called me in. And he said, "Look, Ziggie, I have some bad news for you." He said, "Political pressure forces me to send one Democrat and one Republican down as staff members to West Virginia." So he says, "You're gonna have to wait your turn." That's when I blew my stack. I says, "No, I'm not gonna wait. You're putting in a man here because of political pressure that has no autonomy and I have to wait. I've been secretary-treasurer of the Mine Board, I've been grievance man for nine consecutive years. I've been first vice-president of the Central Labor Union." I used to run most of the meetings when I was first vice-president.

He passed over me to put this guy in, so that's him. But here's the guy that went in, because he had a little more seniority than me. He's the one that went down. He became a staff member, and they went down to West Virginia.

I told the president, "You can stick it. I'm leaving." "Oh," he said, "you'll be back." I come home, I told my wife, "I'm going down to U.S. Steel. I'm gonna start in the steel work, because they have a future. They're gonna have pensions, they're gonna have better pay, better working conditions and what have you." I said, "I'm going down there. But, I'll tell you one

thing, I'm not going to become involved in union business." And I didn't. I come down here. I went in as a common, ordinary laborer.

The thing you have to take into consideration is that [at that time in the mines] you only had maybe four days' pay every two weeks, which would be approximately, eight, maybe nine, ten workdays at the most a month. I was getting $5.35 an hour when I left there.

I come here and I work for $1.49 [an hour] when I first started, as a laborer. But that didn't last too long—only eight or nine days. I got an increase in pay. I moved into burning, which is salvaging or cutting up material which made the stuff that they put in the charging boxes to charge the furnaces in the open hearth. That also was a daylight job, because otherwise you'd still have to work alternating shifts—three shifts a day as a laborer. When I went into this, I got a steady day-shift job out of it, because you did your burning on the outside. They had no lights to see what you were doing. I worked several years at that, and then I went into heavy equipment because my children were getting a little bigger.

I was getting two dollars, forty some cents an hour. I used to take a lot of overtime. But, it was steady. Plus, you had your pension to look forward to. You had your health insurance paid for. I mean, all these items come into place, being as I always believed in doing a lot of reading and I kept informed all the way down the line.

[I never got a mine pension.] The only thing that I got out of that was my Black Lung, which is miners' asthma. I helped get miners' asthma [compensation] in, and I know when it was reformed in 1969 to Black Lung, in the federal government. They in turn paid us out of Social Security for that, because Social Security had that much money.

I come down in 1955 and my wife moved down in '56. We moved into Vermillion Hills. [At first, I lived with my wife's] sister, down in the Pinewood section. [Her husband] was an outside contractor, building the steel [plant]. He also gave me a little nudge, every now and then, about coming down. [Then my wife's] brother [bought a home] at Vermillion Hills. [It] was a jubilee, which is a large home for a bachelor all by himself. It's plenty of rooms up there. My wife did all the housework, all the cooking, the washing and all that.

Then my brother-in-law got his home completed and he purchased it, because you could buy homes down here then, couple hundred dollars down, no problem. I used to tell my wife, "We have to get out on our own," instead of looking for any kind of conflict or anything like that. I want to es-

tablish a home for the kids, where they can go to school. So we come down here [to Levittown] in '57, when we purchased this home.

I didn't keep in touch with my stepmother and my father too much. But, we used to visit [my wife's] mother and father regularly. In fact, when they were sick, there was two weeks at a time she'd go up and stay with her parents, and I would take care of the children down here and still work. I did the cooking. I was a handy-andy.

[In the mines] that was all back-breaking work. The same thing over and over. You had to do so much scooping of coal, rock, and you are always in danger, because they had no safety people up there. Those are the things that we established down here. We got safety, was one of the main things we went after—the bargaining points. There's a world of difference in what that was. That was hard, back-breaking labor up there, and if you lived to be fifty, you were considered very lucky.

I went on to heavy equipment [at Fairless Works]. After I got on heavy equipment, that's where I stayed. I drove any piece of equipment you can picture. I even drove fork-lifts that weighed a hundred and twenty-five ton, carried sixty to sixty-five ton of iron on the forks—slabs. I worked on grade-alls that used to dig hot ladles after they get done pouring the hot steel. They set them down still cherry-red in there. Imagine the amount of heat that's coming out of there. But, what used to happen with them is the steel would penetrate between the brick lining, and burn down to the steel of the ladle itself, and create holes or something. Well, you'd have to dig out the burnt-out brick. The brick that you could salvage and leave in, you'd leave in. But you took out all the debris. You'd remove that, and then they'd set that ladle down in a hole. That would set there for maybe a day or so to cool off. [Then] the ladle liners could get in and work. They would line it [with] three courses of brick.

Plus, I ran the telescopic grade-all. It's a large grade-all that had a telescopic boom. It'd dig the furnaces out, where they cooked the steel, up on the main floor. Then you'd have all your fire brick on the side walls, in the back, in the front. They had cast-iron openings where the gate used to close to keep the heat and the material in there. Well, you used to dig those out and drag that all out.

[I worked for] nineteen and three-quarter [years, until] November the thirtieth, '74. I was sixty-two at the time and my miners' asthma started bothering me, and that was hard for me to breathe. So, when we had that reform of the Black Lung, when the federal government took it over, well

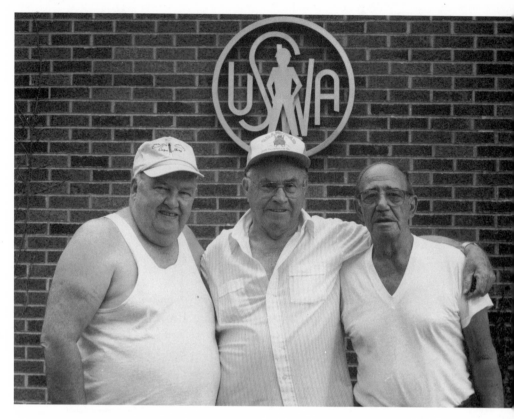

Ziggie Whitecavage (*center*) with Vincent Hentz (*left*) and Joe Schifano (*right*), two fellow anthracite region migrants, August 1996.

naturally the payments used to go up with the cost of living every year on that. I applied. First of all I went and I got checked out by the doctors, and they told me that I had a bad set of pipes down here. So three months prior to my sixty-second birthday, I went down to Social Security, filed for disability, and got it. Soon as I got that, my Black Lung come through, and that's what I retired on—started getting the pension [from U.S. Steel].

After my son and daughter got married, my wife went to work at the Lower Bucks Hospital. She worked there fifteen years. She retired and got her pension from down there. She went out a little bit later, because I went out in '74 and she went out [in] 1984—ten years later.

[Former miners] have a tendency to meet in bars, social clubs, service clubs. I don't know . . . it's inborn, I think. Once a coal cracker, right. You can see it even amongst people you meet up there. Most of them [at Fair-

less Works] were all coal crackers. They were soft coal from out around Pittsburgh or from the anthracite region. That never gets away from you.

Incidentally, did you know that United Mine Workers organized steel? In fact, on this staff program that I was supposed to get on and go to West Virginia, we were to stop en route, in Pittsburgh. They were having a problem in one of the mills there. We were supposed to stop there and talk to the workers—Clarksburg, I think it was.

[Our union was just as good as UMWA]—every bit, every bit. Look at the wages. Look at the conditions. Look at the pension. Look at everything that came from there. We have a health program in there, that for the longest while you used to only have to pay five dollars copayment. The health plan used to cover the rest of the medication that we needed. Now it's up to ten dollars copay.

Anytime that they have any possibility of sending people anywhere or even getting these trainee programs in for them, [the union does it]. They were right there, Johnny-on-the-spot. I'd say they were even a little better than the United Mine Workers. But you got to take into consideration the time period and all. It's vastly improved because [of] the way the steel workers were organized and the way they stuck together. They could afford legal help down here, which is something we didn't have back there. We had to do everything on our own, like we used to call it "strong arm."

The coal companies dominated everything up there. They wouldn't let other industry in. Prior to leaving, in 1950 I was one of the chief "beggars"—they called me up there. I was chairman of the soliciting committee of the Mine Board, Central Labor Union. We established, with the Shenandoah Chamber of Commerce, a program where we set a hundred-thousand-dollar goal. We assessed our people. We asked them to give a day's pay towards this drive, to get this money. We worked with all the business people, all the bankers, all the professional people up there. We drove that thing over the top in about three or four months and they got Purolator Filter. They built a plant down there for them in the Ringtown Valley. They couldn't build in Shenandoah or the outskirts, because it's all undermined. We had to look for a solid piece of ground. That's where they put the Purolater plant, which hired over three hundred people. That was one of the things we accomplished there. That's one thing they can't condemn a miner for. They had a heart of gold. They gave; if it was their last, they gave. Imagine, you assess a man a day's pay and he's willing to contribute to get somebody else a job.

Miners' Memorial, Shenandoah, fall 1996.

I read very few of the papers from upstate. *Pottsville Republican*, *Mahanoy City Record*, *Shenandoah Evening Herald*. That was our paper. In fact, the one cub reporter, his people owned the *Shenandoah Evening Herald*, that was the Daltons. Tom Barrett and Dalton used to cover the biggest part of our meetings. This Tom Barrett was top dog. I used to give him all the releases from all the meetings, from the Mine Board, Central Labor Union, from Shen-City Local.

Oh, if I'd have kept all them papers, in the years that I was up there—nine years in the Mine Board and that—I'd have volumes of what business was done. We even became involved in the politics of the town. If anybody was getting pressure, any kind of working people were being hurt, we became involved.

Chief Burgess they called him, but then they started calling him Mayor. This is why I say, "I know about politics." I know that they exist anywhere, even in the service. It has to. In order to get things accomplished, you've got to have politics. Gotta be involved with the politicians, let's put it that way.

[Looking back, I'm glad I left the anthracite region.] It's an entirely different atmosphere down here. You seemed to have all the freedom, all the things that you wanted to do, that you could do, with no restrictions. Back up there, everything was so close. Everybody knew everybody else's business. The over-the-fence gossip would kill you, quicker than anything. They were always looking to find some fault. Plus, the schooling was better down here. What the dickens, we raised two children, nine grandchildren, one great-grandchild, and we're [close]. The holidays, we're all here. We have more love in our family, with all them coming around. They respect and love us. I mean, love us! They're away all over the country and all that, they'll call us, talk to us. Every chance that they get to come, they're here. That's one thing we built up—lot of love and respect.

Gloria and Charles Rehill, outside their Levittown home, August 1996.

Gloria Rehill

Levittown April 7, 1995

Gloria Rehill grew up near Wilkes-Barre and, after completing high school, worked six years at a local supermarket. Divorced and supporting herself, she visited a friend in the Fairless Hills area and found inspection work at U.S. Steel. She soon married a hometown friend, but continued working. After about fifteen years, when affirmative action opened up new opportunities for women at the plant, she actively sought what had been previously defined as "men's" jobs and worked her way up to foreman.

Migrants lived very different lives and had far more economic security than those remaining in the anthracite region. In Fairless Hills they worked in relatively high-paying, unionized jobs, with well-financed pension plans. Living in newly built communities with migrants principally from Pittsburgh and the anthracite region, they built on the working-class, ethnic traditions they had forged in the coal region. Gloria Rehill's narrative speaks to both the changes and the continuities in the lives of anthracite migrants when the mines closed.

✦

I was born in Wilkes-Barre, Pennsylvania, in the alley of the Homeopathic Hospital. It was Sunday morning and [my parents] were held up with the train, and that's why I was born in the alley, on April twenty-fifth, 1926. My mother's maiden name was Edna LaRue. She married George Henry Miller, and they were wonderful parents. In my lifetime of being around them I only witnessed one argument that they had. If they did any arguing it was not in front of the children. I look up to them as heroes in my life. They taught us well and they raised us in a good Christian home.

There were four children: the oldest sister, Doris, then my brother Bob, then me, and then my sister Lois. My mother had twins between Bob and me that were born dead.

I went to Chester Street School in Kingston, until the fifth grade. Then we moved to South Wilkes-Barre, and I went to Franklin Street School

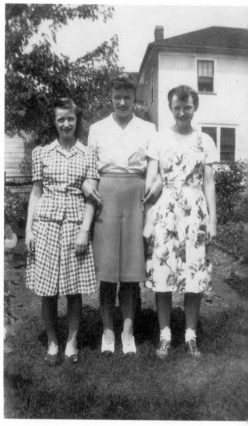

George and Edna Miller, Gloria's parents, South Wilkes-Barre, ca. 1942.

Lois, Doris, and Gloria Miller (*from left to right*), Sout Wilkes-Barre, ca. 1942.

until the sixth grade and to Meyers High School from seventh through twelfth grade.

I'd say I was a mediocre good student. I did better in high school. I always passed every grade. I flunked shorthand in my second year of high school, but they had a program that you could take two years of shorthand in high school, and I switched to that and I completed the course and didn't lose any credits. Like all kids, I didn't want to go to school. My father and mother let my sister Lois quit school and go to work for the Acme Markets when she was only about ninth or tenth grade. But my father would not let me quit school because I made good enough grades that he wanted me to complete high school. So I completed high school, because what my father said went.

My mother never had a job from the time she had children. She was always home. My father worked for the Columbia Lace Mills in Wilkes-Barre and was general foreman of the finishing end. My father was never in the mines.

In South Wilkes-Barre, some of our neighbors worked in the mines, and I can remember seeing them going in with their helmets on and carrying their buckets. My classmates' people worked in the mines.

I don't remember too many of [the boys in my class] going to the mines and I don't remember too many of them quitting [school]. I do remember a lot of them going into the service because we were involved in World War II. They went and joined the service and left. A lot of our class was in the service when we graduated.

[After graduating] I went to work right away. I was offered an opportunity to go to college, but my father wanted to send me to business school. I had taken a business course in high school and I wasn't interested in that. I wanted to go to college and be a history major, and my father wasn't interested in that. He said that you get a business education, and go to work in business. Consequently I went to work. When you were done high school, you were taught to go out and work to earn your living. So I went to Teller Radio, in Georgetown; they made radio parts for the war. I left there when my sister Doris died, in September of '44, I think. I worked there from June to September. Then I went to work in the Boston Store department store—Fowler, Dick and Walker—and I worked there until I got married in '47. That was my first marriage. Then I needed more money than I was making as a sales clerk. So I went to work at the Acme Markets. The president of the Acme Markets, the American Store Company at that time, was a member of our church, Central Methodist church on Franklin Street in Wilkes-Barre. My sister worked for the Acme Markets. I contacted him and got a job and I worked in the Acme Markets from '47 until '53, when I came down here.

[I worked as a] cashier, and you stock[ed] the shelves and did everything. In Wilkes-Barre you did everything that was required of you to hang onto a job. [Positions in] the chain stores were a good job. In fact, I'd say they were about the highest-paying job for a woman in that area.

When I took this job [at U.S. Steel] it was a lot more money. I came down [to Fairless Hills] with a girl that I worked with in the Acme Markets. She had just come down as a vacation, to visit her sister and her brother-in-law and her brother. She had no plans to go into the steel mills. I came down

here on vacation. Her brother and brother-in-law both worked at the steel mill and they encouraged me to be interviewed for a job.

I went out on the last week of my vacation, had an interview, and I was hired. I said, "I must give my employer two weeks' notice," which was par for the course at that time. They asked me to please only give one week's notice and then come down to work. So I went back and gave my notice and then came down in a week and boarded with those people.

I had divorced and was going with Charles [whom I married shortly after]. Charles was very close to his mother, and if we married, we would have to live in the home with the mother and father. That was down in the country, Hunlock's Creek, and I didn't think that was going to be a good situation. So we broke up and I was very susceptible to leaving the area. I took the job down here. It was a big step forward, because all my family was up there, everybody was up there. But I came down here and I went out with the girls on the crew that I worked with—midnight to eight. I met Charles again by accident in the bar. He came down here with his brother-in-law, Tom McNulty, who moved from Wilkes-Barre too. We met by accident, went back together, and got married in a month.

I loved my in-laws, as far as that was concerned, but I didn't think that was going to be a good situation because all that we would have in the house would be our bedroom. I wanted to redecorate the bedroom the way I wanted it and [my prospective mother-in-law] didn't want any part of it, so I could see what problems there were going to be. I had gone through one bad marriage and I wasn't going through two bad marriages.

Outside of my brother-in-law and Tommy Gallagher, who was from North Wilkes-Barre, I didn't know too many people from Wilkes-Barre. My general foreman at the time wanted me to go back and recruit people from that area to come down here to work, but I didn't want to do that. I didn't want to get involved in somebody else moving; if they wanted to move, let them. [U.S. Steel] advertised in that area for people to come down to work here. [The work force] here was mostly either from [the] Pittsburgh area or the Wilkes-Barre area. Very few natives worked out there; they all came from different areas. The men that came down went to the steel mills and brought their families with them, but I knew of very few women that left that area and came down here. [The migration was] predominantly male.

There was a couple of men that we knew about the mill whose families would not move down here, and they went back home their days off for years and years. I thought, that's such a hardship on them. Joe Tarasek was

never married but had family back home, and Chick Mahan, who I stayed with, used to go home on his days off all the time. He maintained a home up there. Several people that we knew went back and forth all the time. On your days off you shouldn't be traveling a hundred and twenty miles one way. That's tough. But their families just would not move here. They worked for years and years at the steel mill. [Eventually] they all went back home.

[Previously] this was all farmland here. I lived in Fairless Hills and I boarded with Chick and Frannie Mahan. I lived with them until Charles and I got married, and then we roomed with the Kleinfelders in Morrisville until our home was ready, because we applied for a home right away. We used to come out and look at it being built. We'd come and see how it was progressing. We had picked out our furniture, we moved in on a Saturday, and Charles had to go over because they weren't going to deliver it. They wanted to put us up in a hotel room for the night, and I said, "I've had enough being in rooms for a night. I want my house." So he helped them deliver the furniture that Saturday night. It was October the fifteenth, 1953. This September we'll be married forty-two years. We'll be in the house forty-two years in October. I came down in June, married in September—big changes in my life.

For most of the years that we worked [at U.S. Steel], women were limited to certain jobs. There were very few jobs. There was lines that they worked on to inspect. I worked most of the time on the tables, which they called hand assorting. They were known as tin flippers. You'd flip the sheet of tin and inspect both sides of it and put it where it was designated to go, whatever it was. They were the only jobs that we were allowed to do.

It was all considered production. There was either production or the offices, so we were considered in production. They were the jobs that we were limited to, until affirmative action, until I bumped labor. At one time there was four crews and I think there was around seventy-seven or seventy-eight women. Then it got down to just one crew—the daylight crew—and there were about twenty women.

I was interviewed in '71.* It was about 1970 when affirmative action come in. I didn't labor too long till they put me back on my job on the tables. I retired in September of '83 because Charles had been ill, and I

* Gloria Rehill was first interviewed in July 1971 as part of a steelworkers' oral history project. Interview transcripts from that project are on deposit at Historical Collections and Labor Archives, Pattee Library, Pennsylvania State University.

Charles Rehill, Levittown, August 1996.

could see it was going to be a long and enduring thing and he needed help.° I had my thirty years in June and I retired in September. [I get] a company pension because for the last five years I was a foreman.

The Carnegie Fund is very, very well funded. There's no worry, when you read about these companies going under with their pensions, USX is never mentioned. No, their pension is very good. If I had stayed, I have a girlfriend who just retired at the end of March, and she had forty-two years, and she will get a beautiful pension, a lot better than what we got. But Charles and I both have a pension. Charles went out [with] twenty-nine and a half years' service on a disability pension, and when I went out, they offered us the window. They gave us four hundred dollars a month

° Charles Rehill died April 1997 after a lengthy battle with diabetes that confined him to a wheelchair in his last years.

extra for going early retirement, because they were starting to downsize then, in '83, and they were getting rid of the higher-paid foremen and replacing them with college graduates coming out. We made a good living at the steel mill. I wouldn't have retired if it hadn't have been for my husband's illness because I had everything my own way. I always wanted to be the boss and finally got to be the boss.

[I was foreman in] tin finishing, tin warehouse. [I supervised work] that I had done or seen being done for all those years. There was very few jobs that I wasn't completely sure of, and the ones that I wasn't sure of, I learned, so that they couldn't fool me. There was a lot of resentment among the male foremen against me, and I just bedeviled them, absolutely bedeviled them. When I knew that they were resentful of me, I just gave them the works all the time, every chance I got.

[I supervised] mostly men. There was some resentment, but I laid back with the workers and with jobs I didn't know. I didn't try to push myself in and tell them what to do when I didn't know what I was talking about. I'd say to them, "Look, I don't know what this job is, and you can fool me if you want to, but you'll only fool me once." If I got in trouble, I went to workers that I knew could get me out of trouble and told them, "I'm in a jam. What do I do about it? I don't know what to do about it." They'd help you every time.

I had good relations. The only problem that I had being a foreman was the young workers coming up. There was no way to motivate them. Discipline didn't motivate them; money didn't motivate them. They're like the workers are today—very, very difficult. But I'd just send them home one time after another until . . . I never had one union complaint against me verified—never. I was a good worker when I worked; I never broke the rules; I didn't take advantage. When I went to be a foreman the people knew that, and I expected from them what I had given myself. I didn't have any trouble with the blacks; they acted up, I sent them home. I wasn't afraid of them. That tickled Charles, because one day there was two young blacks that pulled stunts on me and I sent them both home, one right after another. No, I wasn't afraid of them, and I didn't have anything to be afraid of because I never discriminated against anyone ever, when I worked or when I was a foreman—never. I don't believe in discrimination. I treat people as they treat me.

There weren't too many [people from Wilkes-Barre] that I knew, but later on, when you got to know people from different departments, they were

either from the Pittsburgh area or they were from the Wilkes-Barre [or] Scranton area. I think they just all blended. We were all aliens to the area, that's all. I met a couple of natives in our social life that were very bitter towards the people that had come down here. One was a post office worker from Bristol and he was very bitter. But everybody just seemed to get along all right—just the usual cliques. There'd be some girls that'd clique together and other girls who'd clique together and they were always warring amongst themselves—the normal things that happen in the workplace.

[We] went back almost every weekend that we were off together. The first seven months we were married, Charles and I didn't work the same shift and didn't have the same days off, so it was very difficult for us to go up. He'd go up on a weekend and then I'd go up with my brother-in-law. In the meantime, after we got our house, my brother-in-law, Bob Zimmerman, got laid off from the railroad and we invited him to come and stay at our house and get a job out the steel mill, and he did. He stayed with us until he brought his wife and his son down and they lived in a trailer. So if they'd be going upstate, I'd go upstate with them. About a year after that, my brother moved down here with his family and got a home in Kenwood. Then my mother and father were coming down all of the time to see all of us.

I was the pioneer. Me and my sister were the first two [to come down] because my brother-in-law got the job down here. I brought a lot of people down from Wilkes-Barre area. My brother did not go to the steel mill. He had been a salesman for a coffee company back home and got a job with Dugan's Bakery and from that he went to Cook Coffee. He's always worked as a salesman, going from house to house. Then, my father retired from the Nicholson Machine Company, because the lace mill had gone out of business. At fifty-six years of age through the mayor of the town he got a job at the Nicholson Machine Company and worked as a drill press operator. They'd come down every weekend and visit us all and they retired and moved down here and lived with my sister. Then they were living with my brother; my father became ill, and I brought my father and mother here after he came out of the hospital and he died in my home a short time later. Then my mother wanted to be where the children were. Charles and I never had any children. So she went to live with my sister. Charles's father had died and his mother would come down. I could see that neither one of the daughters wanted the mother living with them. So I said to Charles, "How about if we take the girls?" Charles and my life was completely different, because we'd come home from the steel mill and stop off at the bar and have a couple of beers and shoot shuffleboard and come home when

we just felt like it. He said, "Oh, I don't know how that would work." I said, "Well, they're not wanted there and it's frustrating seeing them being pushed around." So I said, "Let's try taking them." We had one bedroom made upstairs so we took the mother and my mother-in-law to live with us and we called them our girls. Of course then we had to change our life because both of them were chronically ill people. We took them to live with us and his mother died in '66 here at my house and my mother died in '72 in Lower Bucks Hospital, but she became ill here at the house. So our life changed; you have to be susceptible to change at all times.

In Wilkes-Barre, when you met somebody, you always knew somebody that knew somebody that knew somebody that knew something about the people you were dealing with. Here it was all strangers. There was no family ties, no knowing anything about anybody. You had to strike up your own friendships. I did form a very good friendship with Delores Dombrowsky who came from the Nanticoke area, and I formed a very good friendship with my dear friend Anne Trippe, from Trenton, New Jersey, who I'm friends with to this day and talk to her two or three times a week. I've formed a good friendship with Helen Kruba who came from the Hazleton area. She's just retired from the steel mill the end of last month. I have good friends and I'm in contact with them all the time. I was twenty-seven years old when I came here, but I learned things that I never heard tell of in that area. Married people running around. You didn't hear that stuff back home. The life and the people were more wild than back where we were born and raised. Like I said, [back there] everybody knew somebody who knew somebody. Here it was all strangers, virtually.

I didn't join a church or start going to church here until '64, right after my father died. That opened my eyes to a lot of things. I joined a church and became very active in that church in the seventies and I was the first female lay leader they ever had. [That was] Emilie United Methodist church on New Falls Road. I was the superintendent of the youth department of the Sunday school, and I was in the choir and I was very, very active. Then things at the steel mill changed and I had to work shift work and I had to give up my work at the church. [Since] my husband became ill, I'm more or less housebound. I don't get to go to church. But we support our church. We send our envelope in to our church the same every month as we do a bill. I firmly support the work of the Lord. The Lord has given me a prayer ministry since I can no longer be active in the church, and I get up early every morning, and I pray for three or four hours for everybody. I have my devotions that I say and I have that time with the Lord and I

Gloria Rehill, Levittown, August 1996.

won't give that up for anything. So when He shuts one door, He opens two more for you to serve.

When it was coming on time for us to be thinking about retirement, I asked Charles, "Where do you want to retire?" He said, "Right here, why?" I said, "Well, I wanted to know if you wanted to go to Florida or if you wanted to go back home or what you want to do." He said, "No, we'll retire right here." I said, "Then there's things that we should do to the house so we don't have any major repairs to make once we're retired." So we did. We installed air conditioning; we put on an extra room, and changed our oil to baseboard heat, and all of the major things that wouldn't hopefully go wrong after we retired. But he never considered going any place else.

[We didn't want to leave] because we put our roots down here. We have our friends, our family, our church affiliations, our doctors. Believe me,

there's plenty of doctors in mine and his life. We put our roots down here. This is home. We still refer to Wilkes-Barre as back home, [but] I haven't been back since 1972 [when I went] to a funeral and Charles hasn't been back since about 1977.

I get notices of [high school reunions] all the time, but I'm not interested. I didn't have any firm friends in school that I chummed too much around with. The girls in the neighborhood that went to the same school, we were always chummy. My sister Lois, who was a year and a half younger than me, we were best friends and are best friends to this day. My sister worked for the Acme Markets, transferred down here, [and worked] until she had her second child. We talk every day on the phone. So, my life was here and we have had a good life.

Most of [the married women in] our neighborhood here raised their families; they didn't work outside the home. [I was unusual, working in the mill.] I didn't really know too many of the neighbors. Charles did, because he was laid off a lot. He knew all the women [and] went to all the [Tupperware] demonstrations with them. I never bothered with the demonstrations because I worked turn work. Working turn work is an existence in itself.

[In] turn work there's three turns that they work around the clock. Eight to four, four-to-twelve, and midnight to eight. You went one week days, one week four to twelve, one week midnight to eight. So your body was constantly changing, your lifestyle was constantly changing, and then they established a seven, seven, six. You worked seven four-to-twelves, you worked six daylights, and you worked seven midnights straight and then you had five and a half days off. Well, by the end of seven midnights you needed five and a half days off, believe me, to get caught up. But I never minded turn work and I never had any problem with turn work because my body just assimilated to whatever turn I was on. I could eat good and sleep good any time of the day or night.

They worked what they called a twenty-turn schedule. They had one turn down for maintenance and repairs, the rest of the time they operated. It was booming up until about four or five years before I retired. They shut down the tin end altogether. Everybody floated, except the shipping. That was within the last five years because I was a foreman and I was in charge of the shipping to clear out the warehouse. We were down to about a hundred coils left in the warehouse when they went back up. They didn't think they were going to go back up at all, and today they are still operating. The rest of the mill is down, but they are still operating.

I tried always to work one turn. [As] shipping foreman, I worked daylight. Then when I went back on turns, I stayed four to twelve. I worked steady four to twelve or steady midnight. You could switch [turns] with the other foremen. None of the other foremen wanted four to twelve or midnight to eight, [but that] didn't bother me. There's no windows, so you don't know what it's doing outside, you just do.

We made a good living. We made good money between Charles and I. We made good money and we were happy and we just stuck right with it. I never thought about going back.

I was a staunch union supporter. I didn't go to the union meetings. My husband didn't want me to because very few women went. The men got kind of rowdy, but when it came to affirmative action, I went to a union meeting and I had plenty to say. I knew that was coming and I knew we were going to be entitled to make double our income, and I was one that wanted to double my income. I told my general foreman, "I'll work any job that comes up and if I can't do it, I'll tell you I can't do it. But I want the opportunity to work every job that I'm entitled to get." There came a job that I couldn't do and I went to him and told him, take me off it if, I can't do it.

Since I left there's been an influx of women from other parts of the mill to work in the tin finishing department. Of the original women that worked in the tin department I'd say there was maybe fifteen women and they labored all around. Some of them had retired; some of them were forced to retire because of disability. But there was an influx of women throughout the mill then in all the departments.

When I bumped into the labor gang and started taking the jobs [in] the early seventies, my earnings doubled. When I had the hooking job with the crane, my incentive alone was almost as much as I made as a hand assorter. That was just the incentive.

[As a] hand assorter I guess I made seventeen, eighteen thousand dollars a year. It doubled [my earnings] on those other jobs. Because I did bump those jobs and do those jobs, I got to be a foreman. I was one of the first women foremen, and I believe I was the only woman foreman that didn't have more than a high school education. The ones that were foremen, they were bringing them in as foremen. There was only two of us that I know of that come up from the ranks. The other was a truck driver and she didn't have near the amount of service that I had. She had studied blueprints and things like that. She had a college education. As far as I

know, I was the only woman that was chosen to be a foreman that didn't have more than a high school education. But I had plenty of rough roads.

[I got the nerve to assert myself] from my father. My father always taught us to stand tall and hold your head up and brace your shoulders and go at it. That's the way we were born and raised. We were raised to stick up for ourselves, and I always did.

[My husband] got laid off [many times]. He got pushed around throughout the whole mill. He worked in the coke works and the coke works went down; he worked in the open hearth; then he [was] called back to the coke works; then he'd be dumped out of the coke works again and into general service. He had a lot of layoff[s]. I had very few.

He did [drink]. There's the Tupperware demonstrations and they'd drink and I'd come home and he'd be half loaded. I didn't care. There was a great many demonstrations, and I wasn't into that. If I'd be off, I had my house to clean, shopping to do, and things like that—my own life. Later on in life when I took the two girls, I became a pretty good bowler. I was involved in the Bowling Association of Lower Bucks County and I bowled five nights a week. On weekends I'd go to tournaments. People used to say to me, "How does your husband allow you to bowl five nights a week?" and I'd say, "My husband drinks five nights a week, why shouldn't I bowl five nights a week?" So we had a perfect life; we had no problems whatsoever. He'd come home from work and then go to the tavern and then he'd come home for supper and then he was done. He'd go to bed or do whatever he wanted to do. He'd be home with the girls, and I went out bowling.

Oh, he cooked. He was a short-order cook almost all of his life, before he went into the steel mill. He did all of the cooking and I did all of the cleaning up and taking care of him. My husband's a wonderful man.

My friends all knew Charles did the cooking and taught me to cook. I didn't know how to cook when I came down here. I knew how to make coffee; that's all I knew. We shared our life very well. I was never a drinker, and I never hung in the bars. But he likes people and he needs people. He had his friends that he drank with, but it was never at night. He never went out at night to drink. He'd go right after work and then come home for supper and then he was in for the night. So our life worked out very well.

Index